PERFECT SPY

D0047948

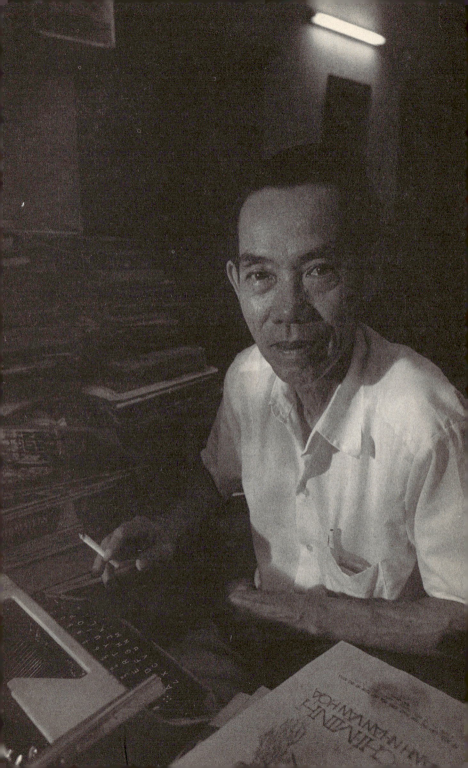

PERFECT SPY

The Incredible Double Life of
Pham Xuan An, *Time* Magazine Reporter
and Vietnamese Communist Agent

LARRY BERMAN

Smithsonian Books

Collins
An Imprint of HarperCollins Publishers

For Scott and Lindsay

FRONTISPIECE: Catherine Karnow

HarperCollins books may be purchased for educational, business, or sales promotional use. For information please write: Special Markets Department, HarperCollins Publishers, 10 East 53rd Street, New York, NY 10022.

First Smithsonian Books paperback edition published 2008.

Designed by Lovedog Studio

The Library of Congress has catalogued the hardcover edition as follows:

Berman, Larry, 1951–
 Perfect spy : the incredible double life of Pham Xuan An, Time magazine reporter and Vietnamese communist agent / Larry Berman. — 1st Smithsonian Books ed.
 p. cm.
 ISBN: 978-0-06-088838-1
 ISBN-10: 0-06-088838-5
 1. Pham, Xuan An, 1927–2006. 2. Vietnam War, 1961–1975—Secret Service—Vietnam (Democratic Republic) 3. Espionage, North Vietnamese—Vietnam (Republic) 4. Spies—Vietnam (Democratic Republic)—Biography. 5. Journalists—Vietnam (Democratic Republic)—Biography. I. Title.

 DS559.8.M44B47 2007
 959.704'38—dc22
 [B]
 2006051260

ISBN 978-0-06-088839-8 (pbk.)

08 09 10 11 12 ID/RRD 10 9 8 7 6 5 4 3 2 1

Praise for
PERFECT SPY

"Pham Xuan An was my colleague, teacher, and friend—and the person who saved my life in a long-ago war. I thought I knew him as well as any American, until I read Larry Berman's book. There were revelations for me on every page."
—ROBERT SAM ANSON, author of *War News: A Young Reporter in Indochina*

"An extremely captivating story, told in part by the spy himself to the author about his secret activities on behalf of North Vietnam."
—BUI DIEM, former ambassador of South Vietnam to the U.S.

"Larry Berman in his book—an insightful, overdue, authentic 'Shock and Awe' story—deftly humanizes the contradictions in An's life as a spy for Hanoi while at the same time working for U.S. news organizations to mask his grand deception. His admiration for the U.S. was overwhelmed by his love of his country—free of a foreign presence. One question haunting the pages of this book is, What would you have done if History had cast you in An's shoes?"
—BERNARD KALB, veteran journalist and former assistant secretary of state for public affairs

"One of the most fascinating figures in Vietnam during the war was Pham Xuan An. Larry Berman has unraveled the mystery of his strange double life in an engrossing narrative."
—STANLEY KARNOW, author of *Vietnam: A History* and winner of the 1991 Pulitzer Prize in history

"Read Larry Berman's well-researched profile and you'll understand why victory was never truly within the United States' reach."
—DAVID LAMB, author *Vietnam, Now: A Reporter Returns*

"No one knows how many people might have died as a result of An's clandestine activities. But Larry Berman has done a superb job of explaining the making of a master spy. There's plenty here for both supporters and critics of the Vietnam War to ponder."
—DAN SOUTHERLAND, executive editor, Radio Free Asia, and former correspondent for the *Christian Science Monitor* in Saigon

"Highly recommended."
—*Vietnam* Magazine

"Berman, in recapturing the atmosphere of Saigon during the war, has also documented the extraordinary group of American correspondents who were stationed in Saigon to report on the war."
—*Foreign Affairs*

Contents

Prologue

"I CAN DIE HAPPY NOW"

I FIRST MET PHAM XUAN AN in July 2001 at Song Ngu seafood restaurant, located on Saigon's bustling Suong Nguyet Anh Street. I had been invited to a dinner hosted by my friend Professor James Reckner, director of The Vietnam Center at Texas Tech University. Approximately twenty guests were seated at a long and rather narrow table, where the only chance for conversation was going to be with the person at my left or right or directly across the table. I spoke no Vietnamese, and the two Vietnamese academics seated on either side spoke no English. The only empty seat at the table was directly opposite me.

I began thinking this was going to be a long evening when I noticed everyone at the table rising to greet the thin, wiry Vietnamese gentleman joining us. I guessed he must be in his late sixties, and he had a certain self-effacing gentleness about him. I overheard Jim saying, "Welcome General An, we are so pleased you could join us." A few moments later we were seated opposite each other. The general had responded to Jim in English, so I quickly introduced myself as a professor from the University of California, Davis. Pham Xuan

An's eyes lit up. "You are from California! I once lived there and went to college in Costa Mesa. It was the happiest time of my life."

For the next two hours, An and I talked about a range of subjects, beginning with his two years at Orange Coast College, where he majored in journalism; his travels across the United States; and all he had learned from and admired about the American people. An told me he had visited Davis while interning at the *Sacramento Bee*. He recalled the personal kindness of publisher Eleanor McClatchy, and mentioned he had met the governor of California, Edmund G. "Pat" Brown, while attending a conference for college newspaper editors in Sacramento. An beamed with pride when telling me that his eldest son, Pham Xuan Hoang An, anglicized as An Pham, had also studied journalism in the United States at the University of North Carolina at Chapel Hill and had recently graduated from Duke University Law School.

Barely touching his food and always reaching for another cigarette, An asked about my current research. At the time I was writing a book about the secret Paris negotiations between Henry Kissinger and his North Vietnamese Communist counterpart, Le Duc Tho, during the Nixon presidency. An launched into a detailed and sophisticated analysis of the negotiations, providing me with new information and a fresh perspective. As he spoke, I recalled reading about a highly respected *Time* magazine reporter who turned out to be a spy for the North Vietnamese and surmised that my dinner companion was that person.[1]

An never said a word that evening about his job in espionage, focusing instead on the details of his other job as a correspondent for Reuters and *Time*. He spoke passionately about his trade and with fondness about his many American friends in journalism, mentioning many of the era's best-known reporters, including Robert Shaplen, Stanley Karnow, Frances FitzGerald, Robert Sam Anson,

Frank McCulloch, David Halberstam, Henry Kamm, and Neil Sheehan. He told me that his circle of friends extended well beyond journalism to include the CIA's Lou Conein, Colonel Edward Lansdale, and former CIA director William Colby, who had been the CIA station chief in Saigon. He also mentioned many South Vietnamese politicians and generals, including General Tran Van Don, Ambassador Bui Diem, General Duong Van Minh, known as Big Minh, who was the last president of the Republic of South Vietnam, and former prime minister and vice president Nguyen Cao Ky, who regularly sought An's advice on fighting cocks and dog training.

My dinner companion seemed to know everyone who was anybody during the war. As we parted that evening, An gave me his card, with a drawing of a German shepherd on one corner and a rooster on the other, asking that I call him the next day in order to continue our conversations about the Paris negotiations. After dinner, my friend Khanh Le, who works for the Vietnam Center at Texas Tech and whose family fled the Communist takeover in April 1975 just a few days after An's wife and children evacuated Saigon for the United States, told me that I had just spent three hours with Major General Pham Xuan An of the Vietnam People's Army, the recipient of four Liberation Exploit medals and six Soldier of Emulation medals along with the title he held to that day, People's Army Hero.

I was curious whether Khanh felt any animosity toward a man who had not only been his enemy, but who by living a life of deception had seemingly betrayed so many Vietnamese in the south. Khanh explained that he had not known An during the war. He did not know what to expect when a few years earlier he was asked by a mutual friend to meet An for coffee. Khanh discovered a humble and reflective man who never once displayed a hint of what he called

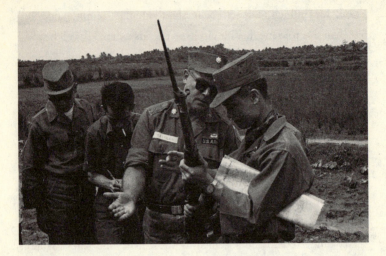

David Halberstam sent An this *New York Times Magazine* photo, writing below it, "Is Pham Xuan An A Great Problem?"
BETTMAN/CORBIS

"victor's arrogance." Khanh used the words "friendly and open-hearted" and wanted me to know that An lived a "simple life."

Both men lost something in the war. Khanh lost his country on April 30, 1975; An lost his brother, Pham Xuan Hoa, killed in a 1964 helicopter crash. Hoa worked for the South as an air force mechanic. An also lost his dream for what a unified Vietnam might become. Ironically, it was Khanh who was free to travel regularly between his home in Lubbock, Texas, and Ho Chi Minh City for extended visits with his family. General Pham Xuan An, Hero of the Revolution, had never been permitted to leave Vietnam to visit his many friends or family members in America. Both men were aware of what the other had lost; their friendship was testimony to the reconciliation between Vietnamese patriots on both sides of the war.

When I called An the next morning, he immediately suggested we meet at Givral. During the war, Givral coffee shop, located

across the street from the Continental Hotel and within earshot of the National Assembly building, had been the gathering spot for journalists, correspondents, police, and government officials—the place where rumors started, were tested for their staying power, and where everyone hunted for the best story line of the day. The rumor mill was known as "Radio Catinat" for the street Rue Catinat, but after 1954 changed to Tu Do, meaning "Liberty Street." After the war, the name changed again to Dong Khoi, or "Collective Uprising." Through all these name changes, Pham Xuan An held the title General Givral because it was here that he could be found daily, dispensing information, almost always in the company of King, his large and obedient German shepherd, his green Renault quatre chevaux parked in front.

For the next two years, that is, until An became ill, he and I met regularly at Givral. A rhythm developed to our meetings. I would arrive first to secure a window table and review my notes and questions. An would pull up on his old green motor scooter and walk directly to our table, not before receiving a warm welcome from Givral's staff. For the next few hours I would ask questions and take copious notes while An explained the nuances of Vietnamese politics and history. An would sometimes put his cigarette down, take my notepad, and write a name or phrase for me, so that I could better grasp his point. When I would ask if he was tired, An always suggested ordering lunch and kept talking. I soon came to appreciate the observation of An's friend and former colleague David Greenway that An "is a reminder to me of how much I saw of Vietnam but how little I understood."[2]

Then, in 2003, after five decades of smoking, An became seriously ill with emphysema. An was extremely superstitious and had smoked Lucky Strikes since 1955, when his American advisers taught him how to inhale and guaranteed that the brand name would bring

him good luck. "I have smoked for fifty-two years. Now I have to pay for it. It's still a good deal—I only got three and a half years of emphysema for all those years of smoking and never ended up in jail" is how An explained it. Astrology and numerology played a major role in An's life, as they do for most Vietnamese. Born under the sign Virgo, the sixth sign of the zodiac and the only female figure among the constellations, on September 12, 1927, An saw himself as having been protected by goddesses throughout his life and felt a reciprocal responsibility for protecting women.

I arrived in Saigon on the day An was hospitalized. Local newspaper reports hinted that he had only a short time to live.[3] I called An Pham, who confirmed the bleak prognosis. Before leaving Saigon, I handwrote An a personal letter, expressing as best I could my hopes that we would once again meet at Givral. I joked that he had cheated death so often as a spy, perhaps it was not yet his time to meet the Emperor of Hell, where An often mused he was first headed. I doubted An would ever read the letter.

Months later I received word that An was home, recuperating. He thanked me for my letter, said he was looking forward to our next conversations, and requested that I bring three books he was interested in reading. I was soon back in Saigon, but because An was still weak, he asked that we meet at his home, the former residence of a British diplomat on 214 Ly Chinh Thang. Surrounded by his precious books and papers, dozens of birds who seemingly never ceased chirping, two or three roosters who never ceased crowing, fighting cocks who still received regular training sessions, a hawk, fish, and two small dogs that had replaced the large German shepherds, we would drink An's special tea from China and talk for hours.

My book on the Paris negotiations had been published. I now wanted to use the story of An's life as a window for understanding the complexities of the war. I asked An why he had never written an

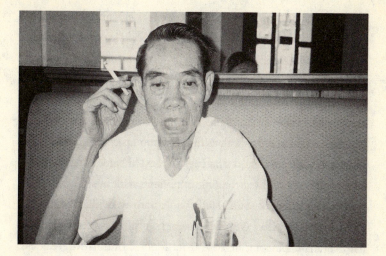

An during one of our many sessions at Givral.
AUTHOR'S PERSONAL COLLECTION

autobiography. Years earlier Stanley Karnow had encouraged him to do so, but An insisted he held too many secrets that if revealed would harm the living and the families of the dead, or so he believed. He would never write about his life as a spy, insisting he was just one cog in a vast Communist intelligence network. He seemed to view himself akin to a CIA analyst sitting in a Langley office, reading documents and filing reports. When I asked if I could write the story of his life, An said no. Still, our conversations continued, and the more questions I asked about what he had done in espionage, the more he told me. I was always taking notes and started recording our conversations. An kept talking.

I then got very lucky. As part of the thirty-year commemoration of Vietnam's victory in "the American War," Pham Xuan An emerged as a cult hero in Vietnam. Two officially sanctioned books about his life were published. *Pham Xuan An: His Name Is Like His Life* won an award in Vietnam for the best nonfiction book of the

year.[4] The subtitle was intriguing since in Vietnamese, An's name translates as *"hidden"* or *"concealed"* or *"secret,"* so indeed, his life really was his name!

An gave me the book inscribed with the wry comment, "This small book tells you about the lucky revolutionary of Vietnam because luck is better than skill." The book offered accounts of An's exploits in espionage as well as insights into his character. I became friends with the author, journalist Nguyen Thi Ngoc Hai, who facilitated my research by arranging interviews with members of An's intelligence network. Still, Hai's book portrayed Pham Xuan An doing no wrong. Like George Washington, he could tell no lie, and like Abraham Lincoln, he rose from humble origins to greatness. Another book written by two journalists, *Pham Xuan An: A General of the Secret Service,*[5] was translated into both English and Spanish, becoming a hot seller to tourists in Hanoi and Saigon bookstores. I began using some of the new details provided in both books as the basis for my questions to An.

An was again hospitalized, this time spending five days on an artificial lung. His wife, Thu Nhan, consistent with Vietnamese tradition, placed many of his documents, notes, photos, and other materials into a coffer so that An could be buried with his secrets. While in the hospital, the English version of *Pham Xuan An: A General of the Secret Service* was serialized in a Vietnamese newspaper and made available on the Internet. The final installation, titled "The Greatness," offered an official party summation of An's hero status: "If anything can be drawn from his life, it should be the lesson of patriotism. Vietnamese have always been fervent patriots, but no foreign aggressor ever considered this a significant factor. They could not understand their opponent and were thus doomed to failure. Had they understood, they would never [have] attempted the invasion. Pham Xuan An is a great intelligence agent."

Once again, An sidestepped his meeting with the emperor. Returning home with just 35 percent lung capacity, he looked terribly frail. Yet An's mind, memory, and sense of humor were as sharp as ever. He joked with me about his new GI haircut, made necessary because he could not raise his arm far enough to comb his hair. He constantly complained that Thu Nhan had made a mess of his materials and he was now too weak to put everything back in place.

I asked him how he felt about his new popularity. "Now they know I have not done anything wrong and I will die soon. I have not betrayed them. They tried to change my way of talking for one year and my way of thinking for much longer. What can they do? They cannot take me out and shoot me. They told me that they do not like my way of talking and that I am different. Even today, they do not know how much information I have and what I know. Still, I have proven my loyalty to them, so now the people may find out about me. I had the courage to return from the United States, and this is a lesson for our youth. I am considered a good model to many young people about my love for the country."

An oxygen tank was stationed nearby, and about two hours into our conversation, An said he needed to lie down and take oxygen. He invited me to browse through his library. I found an original 1943 copy of the *Indochina Geographic Handbook*, written by British naval intelligence, which An used to assist many families (his brother enemies) to escape in April 1975 by advising them on favorable sea currents and shipping routes.[6] There was the post-JFK assassination issue of the *New York Times Magazine*, dated December 1, 1963, on the subject of the biggest problems facing the new American president, Lyndon Baines Johnson. A photo in the bottom right corner of the magazine showed three men in uniform accompanied by a Vietnamese journalist, cigarette dangling from his mouth, taking notes. The caption read, "One of President Johnson's first acts was to reaffirm the United

States' policy of aiding South Vietnam's war against Communist guerrillas. Here, an American military advisor and a South Vietnamese officer examine a captured Vietcong (guerrilla) rifle." The young war correspondent David Halberstam had sent An the article, writing just below the photo of An, "Is Pham Xuan An A Great Problem?"

I began reading the personal inscriptions in An's books. "To Pham Xuan An—My friend, who served the cause of journalism and the cause of his country with honor and distinction—fondest regards," wrote Neil Sheehan. "For my dearly beloved An, who understands that governments come and go but friends remain forever. You have been a grand teacher, but a gigantic friend who will always be part of my heart. With love, and a joy in finding you after all these years," wrote Laura Palmer. "For Pham Xuan An—A true friend through troubled times we shared in wartime. My very fond regards," wrote Gerald Hickey. "To Pham Xuan An, a courageous patriot and a great friend and teacher, with gratitude," wrote Nayan Chanda. "To Pham Xuan An, the present finally catches up with the past! Memories to share and to cherish—but most of all a long friendship," wrote Robert Shaplen. "For Pham Xuan An, my kid brother, who has helped me to understand Vietnam for so many years, with warm regards," wrote Stanley Karnow.

The inscriptions from An's 1958 and 1959 college yearbooks at Orange Coast College were equally intriguing. "An—I have so enjoyed knowing you. I know that you will be very important when you return to your country—you have great intellect in journalism and philosophy. You will always be with me in my thoughts," Lee Meyer. "Goodbye An—it was a great place to know you and work together last year. I hope that you will become what you wish in this world—perhaps we will meet again—when we become famous reporters," wrote Rosann Rhodes.

I then decided to press my case one final time. I beseeched An

to recognize that his story should be told by a historian like myself and not just by journalists in Vietnam, where the censorship boards he ridiculed still operated. I played my trump card by saying it was only appropriate that a professor from California, a state of such fond personal memories, should write about his life as a strategic intelligence agent during the war, his career in journalism, his years in America, his friendships—the story of war, reconciliation, and peace. Knowing that he would never agree to reveal deeply held espionage secrets, I did not press this point.

Pham Xuan An looked me straight in the eyes and said, "OK," telling me that he respected my previous books and he hoped young people in America could learn from his life about the war, patriotism, and his admiration for the American people. He promised to cooperate with only one caveat, reserving the right to say "That is not for your book because it may hurt that person's children, but I tell it to you so you can see the rest of the picture, but please, never tell that story or give that name." Through our last day together, An remained very concerned that something he might say would have adverse consequences not for him, but for others. In every instance I have honored his request.

He also told me that he did not want to read the manuscript until published, citing a Vietnamese phrase, *"Van minh, vo nguoi."* When translated, the phrase literally means "my writing, other's wife"; that is, one's writing is always considered better than others,' just as someone else's wife is better than one's own. One always longs for something one does not have. An was telling me that he could always find something in my writing that he did not like, but he would not sit in judgment of his biographer's conclusions since he had chosen not to write his own story.

I was immediately consumed with a sense of urgency. An was very weak and always spoke about death. "I have lived too long

already" was his mantra, always said with a smile on his face. Now that I had authorization, I decided to visit as often as possible, never knowing when he would be gone. I think it was because An knew his end was nearing that he opened up more and more, providing me with documents obtained during the war, dozens of personal photographs and correspondence, access to members of his network, friends in the United States, and, most important, a visit to the back of his home filing cabinets—old and rusting metal chests in which dozens of mildewed documents were stored.

In late 2005 Pham Xuan An made two decisions that demonstrated my status as his biographer. Ho Chi Minh Television began production of a ten-part documentary on his life. The screenplay for the documentary had been written by Nguyen Thi Ngoc Hai, author of the award-winning biography. I was interviewed for the program, but An insisted that the producers also tape an hour-long session with me and his other Vietnamese biographer, Hai Van, the journalist who wrote *Pham Xuan An: A General of the Secret Service*. In order to set the scene, the film company arranged for me to take a car from my hotel to An's home, and the taping began as An greeted me at the front gate.

That evening I went to dinner with the production team. Hai Van and I traded stories about An, although I suspect both of us were not showing our hole cards. I had several conversations with Le Phong Lan, the producer of the documentary, who was especially curious about An's time in the United States. I later asked An why he had insisted on my participation in the filming. He gave me a quizzical look implying, how was it possible I did not understand? He knew that I had been conducting research in several archives where I had already uncovered new materials on his life; he was also aware of the dozens of former colleagues and friends I had interviewed. I was already formulating an independent interpretation that went well

beyond the permissible in his own country. That's all he wanted at this final stage of his life.

The second decision was more personal, with important ramifications for my book. An asked if he could use my minicassette recorder to tape farewell messages to some of his old friends in the United States. Too weak to write or type, An wanted to say thank you and good-bye. He also asked me to transcribe three of these lengthy messages (which turned out to be veritable oral histories) and told me that I could use whatever he said as background, unless he had already told it to me during one of our sessions, in which case it was for attribution. If the recipient gave permission, I could use it all for attribution. An also asked that I return personal letters sent to him in the 1950s by the first American family to show him the generosity and goodwill of the American people. An and the Brandes family allowed me to make use of the letters in this book.

LIKE SO MANY young people who joined the Viet Minh revolution to fight French colonialism, Pham Xuan An held a vision for Vietnamese independence and social justice. He fought *for* liberty and *against* poverty; as a spy he sought neither glory nor money for himself, but everything for the people of his homeland. He did not like being a spy. It was his national obligation, and while he took it seriously, there was little joy derived from this type of work. His dreams for the revolution turned out to be naïve and idealistic, but I believe the power of his life story is driven by the noblest of goals for Vietnamese nationalism.

The Communist Party recruited An and turned him into espionage agent X6, a lone cell member of the H.63 intelligence network in Cu Chi, known as "The Heroic Unit of the South Vietnamese Liberation Army." The party instructed An to choose a career in journalism as

the best cover, raised the money to send him to the United States, and developed a carefully scripted artificial life history to support his cover. Party records created his alias as Tran Van Trung in order to protect him. An told me that this was his destiny and that one cannot fight his life course. When young he had studied Voltaire. "You need to be indifferent to pain and pleasure," he said. "I was only seventeen or eighteen. I followed what they told me to do."

Pham Xuan An became a spy when Communist Party leaders recognized that the United States was well under way in a process of replacing the French colonialists in Vietnam. Once again the Vietnamese people were not going to be allowed to determine their own future. Not losing Vietnam to "Communism" was seen as vital to the security interests of the United States. It was about the cold war, containment, and dominoes; it was never about the Vietnamese. Only death and destruction would follow.

An's mission as a spy was to provide strategic intelligence reports about U.S. war plans and send them into "the jungle," as he referred to the chain of command. As an analyst, An's model was the CIA's Sherman Kent, author of *Strategic Intelligence for American World Policy*, the bible on strategic intelligence.[7] An learned about Kent and received his first lessons in intelligence from the legendary colonel Edward Lansdale and his clandestine team, who arrived in Vietnam in 1954. Building on these early contacts, An established perhaps the best and most informed list of sources in Saigon and consequently provided Hanoi what it needed most—an understanding of American tactics and battle plans. During the early stages of the American buildup in Vietnam, An was the most valuable of all agents operating in the south precisely because he had already established an almost impenetrable cover. His early reports were so accurate that General Giap joked, "We are now in the U.S.'s war room."[8]

An was adept at disentangling the complexities of Vietnamese pol-

itics for American reporters in Vietnam, but he was equally valued by Vietnamese politicians, military commanders, and intelligence officials—on both sides—because he could explain the Americans to the Vietnamese. His name appeared on every list of accredited MACV (Military Assistance Command, Vietnam) correspondents from 1965 to 1975. He never had to steal top-secret documents because he was always being provided with classified materials by his sources in order to explain the broader political or military context.

Perhaps his best institutional source for all the years he worked as a spy was the South Vietnamese Central Intelligence Organization (CIO), patterned after the American CIA. An had been a consultant in the creation of the CIO and maintained close contacts with his friends in that organization. "They considered me as a colleague and friend, and whenever I needed something I obtained it with a request," said An. It seems that no Vietnamese anti-Communist intelligence agents saw through An's cover. He fooled everyone, Americans and Vietnamese alike. "We used to have lunch together at Brodard. I never suspected anything," recalled Bui Diem, the former South Vietnamese ambassador to the United States.

Ironically, when the war was over and Vietnam no longer divided, there were some within Vietnam's Security Police Office, the Cong An, who believed An's ties with American and Vietnamese intelligence had been too close. Perhaps their hero had survived for so long only because he had been working for all sides, making him a possible triple agent. An only compounded matters by speaking fondly about his many friends in the CIA and CIO and so critically about his lost dreams for the revolution.

An's value came not just in the information he obtained, but in the interpretation of that information. In the intelligence field, the term used is *intellection*—the processing of information into judgments that are given to "users" or "customers" to make policy deci-

sions.[9] An was an astute analyst and demonstrated very early the capacity to distill complicated military plans into readily digestible reports for his superiors. Through it all, An understood that one slipup would bring instant capture and likely death. "What can one say about a life in which one must always be prepared for death," is how An described his years as a spy.[10] "An had a start date for his assignment, but his mission would end only when his country was united or when he was captured. Another heralded spy and friend, the CIA's Lou Conein, tipped his hat to An for "pulling it off all those years, for maintaining his self-control and never making a slip." Conein's admiration was of "one professional intelligence officer towards another man who played a similar role. You can't help admiring a guy who is that skillful at his job."[11]

What makes An's life story so incredible is that he apparently loved living his cover; being a correspondent for a free press was a dream come true in his vision of the revolution. For over twenty years An lived a lie that he hoped would become his reality—working as a newspaper correspondent in a unified Vietnam. He admired and respected the Americans he met in Vietnam as well as during his time in the States. He just believed that they had no business being in his country. "His friends were the treasures of his heart," wrote Laura Palmer.[12]

At first, nothing was more difficult for me in writing about An's life than trying to understand these friendships. In order to survive, An deceived or simply did not tell those closest to him about his mission, yet hardly anyone rejected An when they learned he had been a Communist spy. What kind of man can forge such enduring friendships based on a falsehood and, when the deception is unveiled, leave so few feeling betrayed? Only a few friends ever felt they had been used as source material for An's political intelligence reports to Hanoi.

An believed that he did not engage in any acts of personal betrayal against Americans. He insisted to his last day that none of his American friends ever suffered personally or professionally because of what he did. On the contrary, most of them benefited from An's help, and by the 1970s (if not before) just about every one of his Americans friends had come to see the war in a way that was basically the same as An's view of it. Given that An had not actually betrayed his friends and given that these Americans were sympathetic with his basic understanding of the war, most of his friends had no reason to be upset when they learned about his spying, years after the fact. I am interested in how a deep cover mission like An's unavoidably created moral tensions in a spy. An lived in constant fear and regularly faced self-doubts with respect to using friends for intelligence purposes. How he resolved these dilemmas is part of the real mystery in An's life.

Still, any account of the life of an acknowledged master spy needs to explore the fact that there were plenty of other people—both Americans and Vietnamese—who suffered as a result of Communist intelligence activities. Members of An's H.63 intelligence network "killed many American and puppet troops, destroyed many tanks, armored vehicles and jet fighters of the enemy."[13] The issue of assessing the impact of particular acts of espionage is a tricky one, but if it is in fact true that An is the greatest Communist spy of the war and that the claims of his "heroic" intelligence network are accurate, then his actions did bring suffering and death to many, albeit often in indirect ways.

The aftermath of the war brought extreme loneliness for An. Cut off from his American friends and unable to work as a journalist, An dutifully put on his uniform and attended monthly party cell meetings. "The group is getting smaller and smaller as my friends die, but I still go regularly once a month and confess things like 'this week

I had a visit from Professor Larry Berman, and we spoke about the race for the Red House and things like that,'" said An with a smile. When I asked An if anyone really cared that he had confessed our meetings, he responded, "Look, everything I confess they know already because security knows these things. They have their ways. The confessing is a test to see if you are being truthful and loyal, so it is better to tell them what they already know. Besides, everyone knows I am frank, and they know how I feel about all this anyway. I am too old to change and they are too scared to change, but each year it gets better. Maybe in another fifty years it will be OK."

An remained an Americophile throughout his life, and happily, he lived long enough to see a new chapter open between the United States and Vietnam. At the invitation of both the United States ambassador to Vietnam Raymond Burghardt and United States consul general Emi Lynn Yamauchi, Pham Xuan An was aboard the USS *Vandegrift* in November 2003 along with other dignitaries on the occasion of the first port call by an American navy ship to Vietnam since the war ended in 1975. One of An's prized possessions is the photo given to him by the American consulate office showing An with consul general Yamauchi, Commander Richard Rogers, and An Pham aboard the *Vandegrift*. An recalled for me how proud he was on this day—he had lived long enough to celebrate the joyous occasion of reconciliation and cooperation between America and Vietnam. "I can die happy now. I served my country, my people, and reunification." An Pham later told me, "I'm glad he could have that experience. It showed that the process of normalization was proceeding well, and it meant so much to my father."

On that day An was in civilian attire, and the only one from the Vietnamese delegation to recognize him was a colonel who approached him and asked in Vietnamese, "Excuse me, are you General Pham Xuan An?" An looked up and said, "Yes I am." The

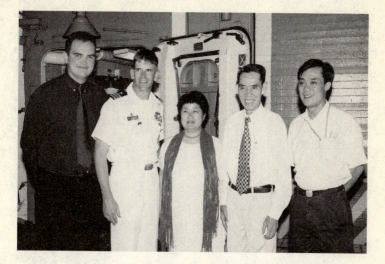

"I can die happy now," is how An described his feelings aboard the USS *Vandegrift* in November 2003.

COURTESY OF THE U.S. CONSULATE GENERAL OFFICE IN HO CHI MINH CITY

colonel said, "Nice meeting you, sir," and with An surrounded by so many high-ranking American dignitaries he jokingly asked, "Which side were you a general for?"

Without hesitation, An answered, "Both sides!" The colonel looked uneasy. "Just kidding," said An. In telling me this story, An concluded, "You see, that is why they can't let me out; they are still unsure who I am."

Chapter 1

HOA BINH: SPY AND FRIEND

For Pham Xuan An—who taught me about Vietnam and the true meaning of friendship. To you, the bravest man I have ever met, I owe a debt that can never be repaid. Hoa Binh.

—Robert Sam Anson, inscription inside his book
War News: A Young Reporter in Indochina

August 1970

The ninety-minute flight from Singapore to Saigon must have seemed like an eternity for young Diane Anson. The previous day she had received official notification that her husband, *Time* magazine correspondent Robert Sam Anson, was missing somewhere in Cambodia. The official "date of loss" was August 3, 1970."[1] No other information was forthcoming. Bob could already be dead and his body never to be recovered, as was the status for *Time*'s freelance photo journalist Sean Flynn and Dana Stone, working on assignment for CBS, when both disappeared in early April just outside of Phnom Penh.[2]

Cambodia was becoming known as the graveyard of journalists.

In September alone, twenty-five journalists would lose their lives in
Vietnam's neighboring country, among them several American and
international reporters and crew members near the small village of
Takeo, an hour's drive from Phnom Penh. Looking at her young
daughter and infant son on the seat beside her, Diane refused to think
that their father's name had been added to the list of those dead.

Diane Anson hated America's war in Vietnam. She and her hus-
band had met at an antiwar rally on the campus of Notre Dame
University. "Vietnam was the reason we'd met," wrote Anson. "I'd
seen her on a picket line at a campus demonstration protesting Father
Hesburgh's annual blessing of the ROTC. Diane was one of the few
girls who had shown up and the angriest of the dozen or so of us
who were there. The passion on her face made her, I thought, quite
attractive."[3] Anson had been carrying a sign, WAR IS GOOD BUSINESS,
INVEST YOUR SON. A week later they eloped and were married in Las
Vegas.

All of that seemed so long ago as the plane set down at Saigon's
Tan Son Nhut Airport. Diane went directly to Time-Life bureau
headquarters located in the Continental Hotel. Cradling her fif-
teen-month-old son, Sam, in one arm and holding the hand of her
two-and-a-half-year-old daughter, Christian, she went from desk to
desk, pleading for information from reporters, who had no news at
all. Bob's colleagues at the bureau tried to say the right thing, but
everyone felt helpless, sensing he was gone forever. She now feared
the worst for her twenty-five-year-old husband, the youngest cor-
respondent on *Time's* staff.

Diane was sobbing uncontrollably by the time she reached the
office of her husband's good friend, Vietnamese reporter Pham
Xuan An, who could not take his eyes off the two young children.
An's thoughts flashed to a day weeks earlier when Bob Anson had
asked to meet at Givral in order to read over a letter of resigna-

tion he planned on submitting to *Time*'s bureau chief, Marsh Clark, known throughout Saigon for his enthusiasm for the war. Clark's father had been a United States senator; his grandfather Champ Clark had served as Speaker of the House. Anson viewed Clark as "perhaps the most American man I had ever met."[4]

Bob Anson thought things were going to work out so much differently when he accepted the assignment to Vietnam. He had the label of "Time Inc. comer," and like most young correspondents arriving in Vietnam, this was his opportunity to establish his reputation as David Halberstam, Malcolm Browne, and Neil Sheehan had done in the early 1960s, when the war was small. But after just a few months in-country, Anson could not get his stories into the magazine, while the two senior resident Saigon correspondents, Clark and Burt Pines, seemed to have little trouble getting their material approved in New York by Henry Grunwald, *Time*'s editor.

THE COMMUNISTS' TET OFFENSIVE in January 1968 revealed that despite 525,000 troops, billions of dollars, and an extensive bombing campaign named Rolling Thunder, the rate of the war and the capacity to sustain it were controlled not by America's superior technology, but by the enemy. In effect, the United States faced stalemate in Vietnam and was no closer to achieving its political objective than at the outset of Americanization in 1965. All of this was having an effect on the psyche of Lyndon Johnson. In a background briefing for foreign reporters, LBJ was asked about peace feelers or signals from Hanoi. "Signals," exploded the president. "I'll tell you about signals. I got my antennae out in Washington. I got my antennae out in London. I got my antennae out in Paris. I got my antennae out in Tokyo. I even got my antennae out in *Rangoon*! You know what signals all my antennae are picking up from Hanoi?" The world press

was hushed. "I'll tell you what the signals from Hanoi are saying: 'Fuck you, Lyndon Johnson.'"[5]

In the aftermath of Tet, Johnson faced a request for an additional 206,000 troops. Before committing himself, Johnson appointed a task force under the direction of the new secretary of defense, Clark Clifford. "Give me the lesser of evils," Johnson instructed Clifford. When Johnson later convened a meeting of his foreign policy advisers to discuss the report, Clifford took the lead in trying to persuade the president that his current policy would not accomplish the purpose of sustaining a viable South Vietnam that could live in peace. "We seem to have a sinkhole. We put in more—they match it. I see more and more fighting with more and more casualties on the U.S. side and no end in sight to the action."[6]

Addressing the nation on March 31, 1968, Johnson spoke of achieving peace through negotiations and called for a partial bombing halt. He asked Ho Chi Minh to join him in working toward a peace through negotiations. The United States was "ready to send its representatives to any forum, at any time, to discuss the means of bringing this ugly war to an end." Then, in a dramatic gesture toward national unity, the president renounced his chance for reelection: "I shall not seek and I will not accept the nomination of my party for another term as your president."

By the time Richard Nixon took office in January 1969, U.S. military forces exceeded 540,000, the bulk of them ground combat troops. Over 30,000 Americans had lost their lives, and the war had cost $30 billion in fiscal year 1969. Over 14,500 U.S. troops had been killed in 1968 alone. Nixon was determined that Vietnam would not ruin his presidency. By March 1969 he had a plan of action. The United States would start winding down its role, seeking terms for a negotiated settlement premised on mutual withdrawal of troops from South Vietnam. The Nixon plan to "de-Americanize" the war

became known as Vietnamization, which involved building up the South Vietnamese armed forces so that they could assume greater combat responsibility while simultaneously withdrawing U.S. combat troops. The U.S. military role would shift from fighting to advising the South Vietnamese, buttressed with a massive influx of military equipment and weaponry. Perhaps most important, Nixon changed the political objective for U.S. intervention from guaranteeing a free and independent South Vietnam to creating the opportunity for South Vietnam to determine its own political future. Vietnamization and negotiation were the twin pillars for achieving what Nixon called "peace with honor."[7]

ANSON PERSONALLY VIEWED THE WAR as "murderous and immoral." There appeared to be a general consensus on how badly the war was going everywhere except within the Saigon bureau of *Time* and corporate headquarters in New York, where final decisions were made on weekly magazine content. When Anson raised questions with his editors about Vietnamese self-determination, he was characterized as a naïve, hotheaded war protester. When he submitted a story with *Viet Nam* spelled how the South Vietnamese spelled it, Marsh Clark told him that *Time* was an American magazine and Anson needed to spell *Vietnam* the American way. The frustration boiled over at a bureau dinner hosted for one of *Time*'s roving editors, John Scott. The dinner conversation focused on the great progress being made in the war. Anson thought it all sounded like the MACV briefings known as "five o'clock follies," where reality was temporarily suspended by dazzling displays of numerical progress. The war managers could always see the light at the end of tunnel; just one more corner to turn until we reached the so-called crossover point in this battle of attrition.

Anson could not take any more. "But you're missing the main point," Anson interjected. "Which is, what the fuck are we doing here in the first place? Look, the Vietnamese have been at this a long time, all the way back to 1940—against the Japanese, remember? They beat them, and they beat the French, and they're going to beat us, no matter what we throw at them. These guys are patient, they're determined, and history is on their side. Maybe you haven't noticed it, but colonialism hasn't been doing so well lately."

When Burt Pines interjected that "maybe you misspoke yourself. You can't possibly believe what we are doing here in any way equates with colonialism," Anson took the bait: "You're absolutely correct. I meant to say 'neo-colonialism.' As in neo-colonialist criminal war of aggression, which, forgetting the immorality of it, which I can't, is what this little exercise in American foreign policy is all about." When the guest of honor, John Scott, asked, "Are you saying the Communists are right?" Anson replied, "I'm saying it isn't ours to decide. It's for the Vietnamese to sort out. All we're doing is hanging around to kill a lot of people, our own and theirs."

Anson did not regret what he'd said, but he now braced himself for the worst, knowing that Marsh Clark was not going to give him a free pass on this one. The next day started innocuously enough when Clark asked Anson to prepare a report on North Vietnamese intentions over the next few months. Word of the prior evening's exchange had obviously circulated fast, evidenced by *Time*'s Saigon office manager Nguyen Thuy Dang's sly remark, "You should have no trouble. You seem to like the enemy very much."[8]

Clark soon played his payback card by sending a confidential letter to his bosses in New York, who in turn sent the letter to "All Correspondents and Editors Worldwide" working for *Time*. "I don't want to denigrate Bob Anson's judgments on Vietnam, because he's only been here a fairly short time. Before he arrived, Bob felt that

the war in Vietnam was immoral, that Vietnamization of the war was simply a prolongation of an immoral war, that the concept of anti-communism in South Vietnam is not worth talking about, and that Vietnam, Southeast Asia, and even Asia are inevitably lost to the inexorable forces of 'National Liberation.' Nothing that Bob has observed here has apparently swerved him from these previously held convictions."[9]

Who could blame Bob Anson for wanting to resign after reading what he knew was Clark's open invitation to go away. That was why he had gone to see one of his best friends in Vietnam, Pham Xuan An. Like most correspondents in Saigon, Anson admired An's contacts at the Presidential Palace and South Vietnamese General Staff. An seemed to know everyone and everything that went on in Saigon and was always ready to help American reporters understand his country. An could sometimes pick up a security tidbit that was only hours old. "Bureau rumor had him as a former secret policeman under Diem, an agent of the French Sûreté, an employee of the CIA, a spy for the South Vietnamese intelligence, or conceivably all of the above."[10]

But there was something else that drew Anson to spend time with An. He was an eloquent teacher about a place that Anson, like most correspondents, knew little about. Vietnam was a country, not just a war, rich in history, with lessons that so few took time to learn. "There were some people who found it difficult dealing with An, largely because of his custom of responding to questions in a very Vietnamese way, which is to say by starting at the fifteenth century and tracing his answers forward from there," recalled Anson.[11]

An admired Bob Anson for the very qualities that had caused Anson such problems with Marsh Clark. He possessed the type of fiery independence that An recalled from the many Americans he had met during his two years in California. He was passionate in his beliefs and not afraid to speak against the tide. An admired this

spirit, recalling the day Anson challenged his *Time* colleagues about the large American flag hanging outside the bureau office on Han Thuyen Street. *Time* was an independent news organization, not an official government office building, Anson argued. There should be two flags side by side—the American flag as well as that of the Republic of Vietnam. His colleagues reluctantly acquiesced, but when Anson saw that the American flag was much larger than the Vietnamese, he went to *Time*'s office manager, Mr. Dang, and challenged him to get a larger flag of *his* country so that the two flags would be at least of equal size. Mr. Dang complied. An watched all this, admiring his young colleague's fight over what was a symbolic issue. "It showed me he understood that many Americans and some Vietnamese had forgotten what the war was about," An told me. "Many Americans thought that our history did not matter because they had a better future planned for us."

An explained to me that "of course" it was better to have Anson's voice inside the bureau walls because from An's viewpoint, Anson understood the Vietnamese people, culture, and history more than *Time*'s other reporters, especially Marsh Clark and Burt Pines. *Time* needed more people like Bob Anson, and "it would be very bad to lose him. Too bad that Frank McCulloch was not still here, because he came to Vietnam thinking just like Marsh Clark but ended up leaving thinking just like Anson."

Conspicuous for his distinctive shaved head, Frank McCulloch was known as "Buddha" to Saigon's street vendors and shoeshine boys. McCulloch first came to Vietnam in January 1964; his tenure overlapped seven Vietnamese heads of government. At the peak of McCulloch's four-year stay, the Southeast Asia bureau of Time-Life was filing 50,000 words a month via teletype. He inspired trust from sources, respect from colleagues, and loyalty from staff. He has been called a journalist's journalist.[12]

McCulloch identified several stages every reporter went through in Vietnam: "The first stage: very upbeat, Americans can save these people and they really want to be saved and will be grateful for it. Second stage (usually about three months later): we can do it but it's harder than I thought and right now it's being screwed up. Third stage (perhaps six to nine months later): you Vietnamese (always the Vietnamese, never the Americans) are really screwing it up. Fourth stage (twelve to fifteen months later): we are losing and it's much worse than I thought. Fifth stage: it isn't working at all, we shouldn't be here, and we're doing more harm than good."[13]

As McCulloch reached the last stages of the reporter's life cycle, he filed a story about the massive 1965 buildup of troops in Vietnam, which he learned of from his contacts in the marines four weeks before it became public. (An would receive his second Exploit medal for reaching the same conclusion in his reports to Hanoi.) McCulloch's bosses in New York refused to run the story because it had been personally denied by the president. Time Inc. editor-in-chief Hedley Donovan later told McCulloch he had received a call directly from Johnson. "Donovan, this is the President of the United States.... You've got that little bald-headed guy walking around in the tropical sun with no hat on. He's addled. You better get him out of there."[14]

McCulloch's views by the time he left Vietnam in late 1967 were not much different from those of Anson, evidenced by his June 3, 1967, commencement address at the University of Nevada. "I know a Vietnamese officer who for a quarter of a century has been at war, is a thoroughly competent professional killer, yet who remains strangely untouched by it all. He is a gentle and thoughtful man, and one day I asked him what he saw in the future. He shrugged and smiled. 'Perhaps,' he said, 'we will next have to fight the Americans.' And seeing my shock, he went on to explain. 'When I was 19,' he

said, 'the Japanese came and told us they were our friends and would liberate us from the white man—and they were not liberators, and we had to fight them. When that war ended, and the French came back, they told us they came this time not as masters but as friends. And after nine years, until 1954, we had to fight them. Then the French left. But the Communists did not have to come—they were already here. And they, too, claimed to be our friends, and since 1955, we have had to fight them. The strange thing is, I did not really want to fight any of them, and I think that most of them did not want to fight me. Now you are here as our friends and liberators. And what I wonder is this; have any of us learned anything out of what has gone before?' I could not answer him."[15]

Hanoi's multipronged strategy was always to chip away at American public opinion. An understood that having Anson inside *Time* could only help because he was trying to portray the war as An saw it, not as an illusion of progress, but as a bottomless pit. An insisted that he never tried to influence Anson's thinking. "You know," An told me, "Anson spent a lot of time outside of Saigon and in the villages, speaking with local people. He learned more out there than he ever learned from me." Anson later told me, "I never got the sense I was getting manipulated by An. He could be critical of either side tactically too. And I was already against the war by the time I arrived."

As An listened to Diane's pleas for assistance in finding her husband, all he could think about was that day in Givral when he'd talked Anson into tearing up the letter of resignation. If he had not done so, the Anson family would today be together in Singapore or vacationing in Bali. Instead, a few weeks after their talk in Givral, Marsh Clark called Anson into his office, where a large map of Indochina covered much of one wall. Pointing to Vietnam, Clark told Anson "That one is mine to cover." Pointing to Cambodia and Laos, he said "These two are yours." He ended the conversation by telling Anson

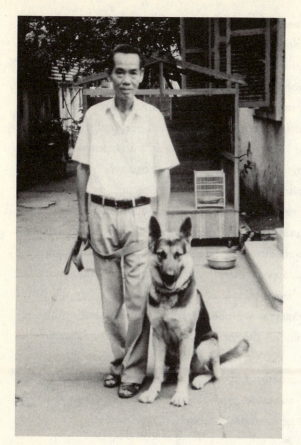

An was always seen in the company of King, who also stood watch while An wrote his secret reports and photographed documents.
PHAM XUAN AN PERSONAL COLLECTION

to pack his bags and get to the airport. "I don't want to see you here again."

An tried consoling Diane by assuring her that he would do whatever he could, but he privately thought his friend was gone and he was responsible. Anson would not have been in Cambodia had he resigned. An promised Diane that he would continue checking with sources and did not discourage her from posting trilingual photos on trees along the roads where Bob had traveled before he disappeared.

After Diane and the two children left the bureau office, An thought a great deal about his friend Bob Anson. He knew that what needed to be done could imperil his mission. Hanoi's top espionage agent in Saigon was about to risk his cover to save the life of an American correspondent. An knew that if Bob Anson was dead, the Vietnamese people had lost a true friend. Feeling the overwhelming burden of responsibility for his friend's disappearance, An was determined to find out if Anson was dead or alive.

Vietnam and Cambodia had long been unfriendly neighbors, but the situation grew even worse in March 1970 when a pro-Western junta headed by General Lon Nol deposed Cambodian prince Norodom Sihanouk. Sihanouk had been a neutralist, making concessions to appease both Communist and non-Communist sides by allowing the Americans to secretly bomb Viet Cong and North Vietnamese sanctuaries inside Cambodia, but also allowing the Vietnamese Communists to use Cambodia's port city of Sihanoukville to ship in supplies destined for those same sanctuaries.[16]

Within a month of the coup, Lon Nol organized a pogrom against the Vietnamese ethnic minority living in Cambodia. *New York Times* reporter Sydney Schanberg observed Lon Nol's troops killing two Viet Cong suspects and hanging their charred bodies upside down in the town square—sending a message to all who might consider aiding the Communists. When his colleague at the *Times* Henry Kamm tried telling the commander that treating bodies in this manner violated the Geneva Convention, the commander laughed. One government general, Sosthene Fernandez, a Cambodian of Filipino ancestry who later rose to become chief of the armed forces, began using ethnic Vietnamese civilians as protective shields for his advancing troops, marching them in front into the waiting guns of the Viet Cong. "It is a new form of psychological warfare," he said.[17]

The Nixon administration had always feared that if Cambodia became a Vietnamese Communist base, Vietnamization would be impossible. On April 30, 1970, Richard Nixon announced that six thousand ARVN (the Army of the Republic of Vietnam) troops, supported by U.S. advisers, artillery, and fighter bombers, had invaded the Parrot's Beak, a dense jungle area in southeast Cambodia, extending into South Vietnam and rumored to be the location of COSVN, the Communist Party's Central Office for South Vietnam, in an effort to neutralize North Vietnamese use of Cambodian territory. In his speech to the nation, Nixon announced, "Tonight, American and South Vietnamese units will attack the headquarters for the entire Communist military operation in South Vietnam. This key control center has been occupied by the North Vietnamese and Viet Cong for five years in blatant violation of Cambodia's neutrality." The president, who a year earlier had promised to end American involvement in Vietnam, had expanded the war into neighboring Cambodia.

The day after Nixon's national address, An sent Anson a package, providing him with an English translation of a captured Viet Cong enemy document. This was the type of document reporters had easy access to, but An provided additional commentary for his colleague, who had just returned to Saigon for the weekend. The document was a July 1969 "battle plan" captured in October 1969 in which the North Vietnamese predicted that with Vietnamization failing, Nixon would turn his attention to Cambodia. An circled one paragraph and underlined the last sentence, writing across the page, *"You damned Americans. You read, but you never learn."*

Here is what An circled for Anson: "If our attacks in all aspects are not sufficiently strong and if the Americans are able to temporarily overcome part of their difficulties, they will strive to prolong the war in South Vietnam for a certain period of time during which

they will try to de-escalate from a strong position of one sort or another, and carry out the de-Americanization in a prolonged war contest before they must admit defeat and accept a political solution. In both these eventualities, especially in the case of a prolonged de-escalation, the Americans may, in certain circumstances, put pressure on us by threatening to broaden the war by expanding it into Cambodia."[18]

The Cambodian incursion brought horror to the ethnic Vietnamese living in Cambodia. The Lon Nol government began whipping up anti-Vietnamese fervor. One of the Lon Nol pogroms occurred at the town of Takeo, reputed to be a Communist stronghold because it was the site of the many protests against Lon Nol's regime. Over two hundred civilians, including many children, identified by the Cambodians as Viet Cong, had been rounded up and placed in an internment center at Takeo. The Vietnamese were being guarded by three paratroop battalions. Anson was in Cambodia covering the story, and each morning he and his stringer, Tim Allman, would drive from Phnom Penh to Takeo in order to check on the Vietnamese detainees.

The plan worked for a while, but one evening the Cambodian soldiers opened fire on the entire group of Vietnamese. It was a massacre. The next morning Anson and Allman arrived in their rented white Ford Cortina. "The bodies were piled one atop the other in huge pools of coagulating blood. At first I thought that everyone was dead. But as we mounted the pavilion steps, nearly slipping on the congealed globs that had washed over them, I saw several forms move and heard the sound of moaning. Reflexively I started counting; two dozen men and boys were still alive, lying in the midst of perhaps three times as many corpses," recalled Anson.

Except for moans from the wounded and the sound of buzzing flies, there was complete silence. An old man with one of his legs

blown off tried explaining what had happened: "They say we are all Viet Cong, but we are only shopkeepers. You must take us away or tonight they will kill the rest of us. Please, you must take us."

Anson was kneeling next to a boy of about eight. "His face was chalk-white. I laid my hand on his chest; I could barely feel it rising and falling. Pulling back a bloodied sarong from around his torso, I saw a line of half a dozen holes extending from his hip to his ankle." He and Allman made the decision to drive the boy to a hospital in Phnom Penh and rally the other reporters to come back for the rest of the wounded. Anson believed the soldiers would soon return to finish the slaughter.

Anson and Allman placed as many of the wounded into the car as possible and sped to Phnom Penh. The French hospital agreed to accept the children. Allman remained with the children, promising to return to Takeo as soon as he knew their prospects for recovery. Anson headed to the hotel for visiting journalists. "Down at Takeo, they're shooting the Vietnamese. Get the others," he shouted to the assembled press corps.

Henry Kamm of the *New York Times* and Kevin Buckley of *Newsweek* offered to drive Anson back to Takeo; by the time they arrived the squad of Cambodian soldiers had returned. "We have nothing to hide," boasted the soldier who appeared to be in charge. "We did what we had to do. They are all Viet Cong."[19] When Anson asked if there was a hospital nearby, he was told, "Yes, but it is not for this filth." Anson demanded they stop killing the innocent children. The Cambodians laughed, saying they were just killing Viet Cong.[20]

It was getting dark. By now Allman had returned with the Cortina and loaded the car, and many other reporters had arrived on the scene to cover the story. Anson pleaded with each of them to take a child back to Phnom Penh. "You can't get involved in your story," said the highly respected senior correspondent from the *Chicago*

Daily News, Keyes Beech, who had received the Pulitzer Prize for International Reporting in 1951. "You take these people and you're getting involved. That's not your job."

Anson could find no one to take a child, until Kevin Buckley came forward and said, "I want to help." He was the only one. "The other reporters watched us for a while, then one by one headed off," recalled Anson. Buckley, Anson, and Allman crammed five children and three adults into the Cortina. Allman drove them back to the hospital and promised to return by daybreak. There were still people alive, and Anson knew it would not be safe to leave them alone. They needed protection and witnesses. Kevin Buckley volunteered to stay with Anson: "In for a dime, in for a dollar."[21]

It was nighttime and the Cambodians were preparing for their final slaughter. Anson was scared, sensing that the presence of two American reporters was not going to deter the Cambodians. It was then that a car could be heard approaching. Bernard Kalb from CBS had driven up from Phnom Penh along with his crew in order to get his friends out of Takeo. "You really think that the two of you standing here is going to stop these guys from doing whatever they want to do? If they want to waste these people, they're gonna waste them, and the only thing that's gonna happen is that you're going to wind up dead."[22]

Anson refused to leave, saying he could not abandon the remaining Vietnamese children. Kalb put his hand on Anson's shoulder in an apparent gesture of comfort and reassurance, but instead the larger man grabbed Anson in a headlock and with the assistance of the camera crew dragged him into the car.

Henry Kamm, who would receive the 1978 Pulitzer Prize for his reporting on the boat people of Vietnam and refugees from Cambodia and Laos, published a front-page *New York Times* article about the massacre writing that Anson had taken one of the badly

wounded to a hospital in Phnom Penh. News stories about the massacre sparked outrage in Saigon, particularly among South Vietnam air force pilots. These pilots, who had regularly attacked North Vietnamese positions in Cambodia, "now took special delight in strafing and bombing Cambodian villages in retaliation."[23]

BOB ANSON WAS ALIVE but facing imminent death. In his own harrowing narrative, Anson describes being captured by North Vietnamese troops across the river in Cambodia a few miles from the town of Skoun. He had ignored two or three checkpoints along the way. "He had been so reckless," An later told me. "He always drove too fast, took too many risks for a man with such a young family."

There were big differences between Vietnam and Cambodia when it came to covering the war. In Vietnam, reporters traveled on U.S. or South Vietnamese military transport and were surrounded by armed troops and support. In Cambodia, reporters rented automobiles like the Ford Cortina or Mercedes diesel sedans. There was no military backup. If the car stalled, you were stuck. No one was coming to pick you up. "The primary goal in covering Cambodia was to travel to the combat areas and back without being shot or captured. To do that, you had to drive from Phnom Penh down long, empty highways with no security to wherever you believed a battle was going on. You didn't know what you would find when you got there, if you got there."[24]

Anson was pitched into an already existing hole, given a trenching tool, and told to dig deeper. He assumed he was digging his own grave. Hoping he would be shot in the chest and not his head, he prayed that his body might be found. He thought of Diane: "She was a young woman far from home, with no marketable skills and

two tiny children ... God, was I sorry for what I had done to them."
He thought of his missing colleagues Sean Flynn and Dana Stone;
he said his Hail Marys. He was told to stand aside the ditch. An
AK rifle pressed against his forehead, the metal click of the trigger
locked, urine streamed down his leg. Anson cried out his final words
in Vietnamese—"*Hoa Binh, Hoa Binh*." There was silence, followed
by the return of the Vietnamese word for peace, "*Hoa Binh*." Anson
was not to die on this day.[25]

The next days were filled with terror. His captors did not believe
he was a journalist, thinking him to be a downed American pilot.
Anson had been carrying his reporter's notebook containing notes
from a recent interview with a Green Beret. He had jotted down
in large block letters *USAF* as part of the details of the American
bombing campaign in Cambodia. These letters were easily recogniz-
able to his captors. The next few days and nights were spent walking
and running through jungle terrain along the Ho Chi Minh Trail,
his hands always bound. He thought the North Vietnamese might be
taking him to Hanoi, where he would join other pilots at the Hanoi
Hilton, if he lived that long.

The forced march brought them to a small village where Anson
was taken for an interrogation conducted by an officer who spoke
English. Anson was told to provide every detail of his personal
and professional life. He was to hide nothing. The details of his life
spewed out, background, family history, education. At one point
the interrogator asked if Anson's daughter, Christian Kennedy
Anson, had been named after John Kennedy, the president who
had first sent troops to Vietnam. No, Anson cleverly responded,
she had been named after Robert Kennedy, the one who wanted to
end the war.

Anson identified himself as a reporter from *Time*, a noncomba-
tant, and provided contact information for verification. "Ah," his

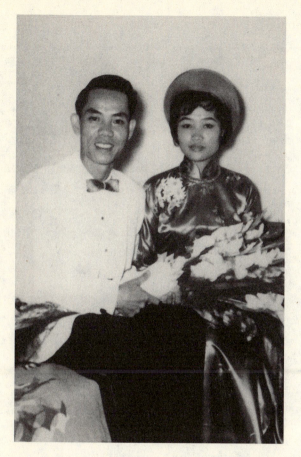

February 25, 1962 wedding day photo of Thu Nhan and An

PHAM XUAN AN PERSONAL COLLECTION

interrogator said. "A very important American publication. Not so important, perhaps, as the *New York Times* but more so than *Newsweek*. Would you not say that is correct?" "Yes." I laughed, imagining what Arnaud [de Borchgrave's] reaction would be if I ever had the opportunity to tell him.[26]

Back in Saigon, Pham Xuan An had returned home from his emotional meeting with Diane Anson. That evening, after his young children were asleep, An placed some grains of rice with a bit of water in a spoon and began heating the contents until the rice

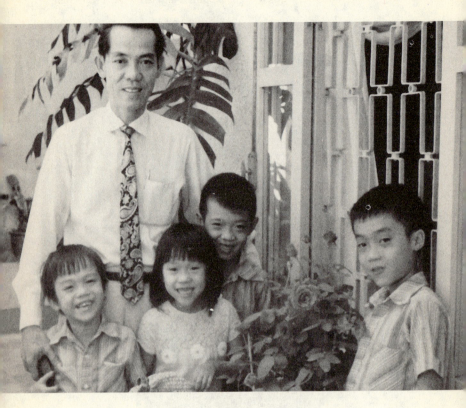

An with his four children. Hoang An (An Pham, the eldest, far right), Hoang Vu to An's right, Hoang Anh, the youngest son on An's left, and Thanh Binh, An's daughter.

liquefied. With his large German shepherd and his wife, Thu Nhan, standing watch, An dipped the tip of a pen into the liquid and began writing on ordinary wrapping paper. Within minutes the ink vanished, but An kept writing, just as he had done every few weeks for the past decade.

Thu Nhan had been working in a Saigon handicraft center close to Givral when An first saw her. "When I first met him, I thought he was intellectual, well educated, and had very good manners," Thu Nhan told me. "He was also very social and liked to joke a lot." After a six-month courtship, they were married on February 25, 1962. "Many, many journalist friends were at our wedding," recalled Thu Nhan.

Six months later, An told his wife that he also worked for the revolution, which touched a chord in her own heart. "When I was in primary school, I loved very much history lessons, lessons about uprisings in my country against foreign aggressors ... There was already in my blood love for my country that made me like and remember until today songs and poems that kindle and glorify patriotism."[27] Thu Nhan was prepared to do anything in support of her husband's mission. "When I learned that my husband was carrying out secret activities for the revolution and charged with very heavy and dangerous tasks in order to gain independence for the country, I immediately accepted my husband's cause in order to work with my husband in a way that would be most effective and safest, as we often say 'if husband and wife are in agreement, they could dry up the East Sea.'" Thu Nhan frequently accompanied An as a lookout when he delivered documents or "stayed up almost all night with my husband to photograph documents under two 500-watt lamps when necessary, doing everything to ensure my husband not be distracted by frivolous matters or matters related to our children and family."[28]

Thu Nhan told me that An had given her explicit instructions that if he was ever captured, she was not to request his release or ask for

assistance because he would never betray sources and was prepared for death. "He carried a suicide pill," Thu Nhan told me, confirming what An had told me on several occasions. "Being a woman, I was much scared and worried. I was in a constant state of being ready to deal with the worst, and had a constant feeling of 'a fish on the cutting board.'"

An believed in luck, and this was Bob Anson's lucky day because An was scheduled for a rendezvous the next morning with his long-time courier, Nguyen Thi Ba, who would be awarded the title Hero of the People's Armed Forces in 1976.[29] She had been handpicked by the ever-cautious An, who believed that only a woman courier could protect a Virgo from evil tidings. Twelve years older than An and always chewing a betel nut, Ba was not likely to draw attention to herself. An had already rejected nine previous couriers before evaluating Ba.[30] "Before meeting An for the first time, I was told 'He likes no one,' so be prepared for rejection," Ba told me. "He was very particular and demanding." Recalling their very first meeting, Ba explained that she pretended to bring flowers to a temple. By a prearranged code, An greeted her as "sister Ba, number seven," and she responded with "Hello brother An, number three." If the two numbers in the reciprocal greeting equaled ten, they would both know the other was with the revolution.

From 1961 to 1975 Ba worked as An's sole intelligence courier.[31] "Each month I would meet with An three or four times to receive documents from him," recalled Ba, whose code was Female Spy B3. "However, when the situation was urgent we might have to meet five or six times a month. When I went to receive documents from him, I usually pretended to be an itinerant street merchant, sometimes selling vegetables, sometimes selling odds and ends, in order to be able to blend in with the crowds. If the documents he was giving me were on film, An would roll them into very small rolls and hide

them in bars of soap or conceal them in meat rolls." Ba wanted me to understand that the word *nem chua* (raw meat wrapped in banana leaves) best described how An concealed the film.[32]

Anson's luck was that Hanoi was expecting An's detailed analysis of Nixon's Cambodian incursion as well as an updated report on ARVN morale and training. An decided to send only one message along with some canisters of film. He issued specific instructions about an American reporter, a colleague at *Time* and a friend of the Vietnamese, who had been captured. If Bob Anson was not already dead, An demanded that he be set free, no questions asked, explaining that he was an American who had saved the lives of Vietnamese children at Takeo. An was taking a major risk because if Ba or any member of the network team carrying his message was captured, his cover could be blown immediately.

That An was able to make such a demand reflected his personal assessment of his value as an intelligence officer. During the Tet Offensive of 1968 he had been told by his direct supervisor, Tu Cang, who had been sent to Saigon to work with An on identifying infiltration routes into the city, that he had been awarded a special medal for contributions to the victory at Ap Bac in 1963 and that his reports were highly valued by their superiors. It was Tu Cang who wrote the report enabling An to receive this medal. "You know, this was the first time I hear anything from them about my reports, when Tu Cang told me about the medal for Ap Bac. I knew I could never wear that medal until the war was over, but I decided to play the medal now" is how An explained it to me.[33]

The next day An set off to Saigon's bird market with his German shepherd beside him. An was renowned as Saigon's best dog obedience trainer and bird purveyor, and the animals provided excellent cover for a spy. An had even trained the dog to pee at trees serving as dead letter drops for message exchanges. An could disappear for

Nguyen Thi Ba was An's sole liaison agent during the war. She was later elevated to the status of Hero, October 2006. AUTHOR'S PERSONAL COLLECTION

This picture was published with the title "The Female Intelligence Courier of a Hero Spy." AUTHOR'S PERSONAL COLLECTION

a few days, and everyone assumed he was at the bird market or off training or purchasing dogs.

The market was always crowded, offering monkeys, civets, ocelots, rabbits, dogs, cats, fish, and all types of birds. An surveyed the cuckoos from Africa, the pigeons from France, the owls, parrots, skylarks, pheasants, and canaries. Knowing that Ba would soon make contact, An waited by the bats. Within minutes, Ba and An struck up a conversation, perhaps about how to make the mixture of bat's blood and rice wine that served as an ancient remedy for tuberculosis. An described to his acquaintance precisely how to cut the throat of the bat and extract the blood for the concoction.[34]

Sometime during the conversation, An offered Ba something to eat; perhaps she would take some for later because he could not possibly eat all these spring rolls wrapped in plain paper. Ba thanked him and gave something in return. Then they went their own ways—Pham Xuan An back to *Time* and Nguyen Thi Ba toward Cu Chi, at the outskirts of Saigon, where a sophisticated support network was awaiting her delivery of spring rolls. Also in the package were instructions from An establishing the time and location for their next rendezvous. Ba told me that "each month we set an official time for our meeting and two supplemental times, each ten days apart. Everything was preset for the tenth, twentieth, and thirtieth of each month, but the dates changed each month so there was no pattern. If there was something very urgent, I knew the place his children went to school, and I would wait there until he dropped them off. All he needed to do was see me, saying nothing, and he would know that there was an urgent need for information and he would contact the base."

Ba usually took An's package only as far as the village of Soc Mon, halfway to Cu Chi, where she would transfer it to another

courier. "I only went to Cu Chi a few times," she said. There was never any other type of communication between An and Ba; no phone calls, no shortwave radios, no letters. She was illiterate at the time and did not know where he lived. They were truly one of the oddest and most effective espionage teams in history.

The trip to Cu Chi, some thirty kilometers northwest of Saigon, was a dangerous one because of the large American buildup and checkpoints in the area. Below the ground was a vast cobweblike tunnel complex connecting villages and districts that stretched from Saigon to the Cambodian border. The tunnels were originally designed as hiding places for the Viet Minh in their battles against the French, but by the mid-1960s Cu Chi had become a self-contained complex with living areas, storage deposits, ordnance factories, hospitals, and headquarters for military intelligence. American intelligence knew of the tunnels' existence, and the district of Cu Chi became one of the most bombed, defoliated, and devastated areas of the war.[35] "There was almost nothing there. The area had been sprayed so many times with chemicals it looked like a dead area," recalled another courier, Ha Thi Kien (Tam Kien 8).[36] Virtually the entire population of Cu Chi had long before been relocated to a so-called strategic hamlet, with the exception of the villages in Ho Bo forest, long known as "liberated" and under Viet Cong control. An rarely visited the tunnels after 1969 with the intensified efforts by Americans to locate the Viet Cong base at Cu Chi. It was just too dangerous for him to be traveling there because he could get caught or killed in an American attack.

At Cu Chi, an iodine solution was poured over the wrapping paper so that An's instructions could be easily read. Beneath the layer of spring rolls were several canisters of film as well as the details of the next rendezvous—the dates, times, and places. An was always in control of these details. The most important parts of An's reports

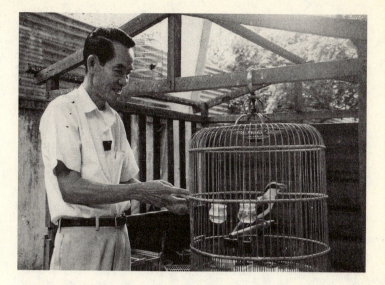

An collected rare birds, providing excellent cover so that he could disappear for a few days without anyone questioning his whereabouts. PHAM XUAN AN PERSONAL COLLECTION

were sent by coded radio transmissions to COSVN headquarters; the film and report summaries carried by an armed Viet Cong unit to the regional intelligence bureau, eventually making their way to Hanoi. "Many died protecting my reports," An told me. "They were very brave, and I did not know any of this until after the war."

There was little else for An to do but wait to learn about the fate of Bob Anson.

AFTER WEEKS OF CAPTIVITY, Bob Anson was awakened in the middle of the night by one of his interrogators, who informed him that his story about being a journalist for *Time* had checked out. It would take a few days, but he would soon be released. The interrogator wanted to know why Anson had not told them everything

during questioning. Anson could think of nothing he had withheld, but before saying so, his captor asked, why had he said nothing about Takeo? "We have a tradition in Vietnam. Someone who saves the life of one of our children is owed a blood debt. The Front gives you its thanks. You are to be releasedYou are one of us. A soldier of the revolution."[37]

Bob Anson was overcome with joy but also puzzled. He had not thought to disclose Takeo because it seemed irrelevant to his confession. Still, he put aside all questions and thought only of being with Diane and his children. Nine days later, as he left captivity, his fellow soldiers of the revolution gave Anson a gift of Ho Chi Minh sandals with soles made from a truck tire and straps from inner tubes. "We use only the best. American made. Four-ply," said the Vietnamese soldier.[38]

Seventeen years later Bob Anson returned to Vietnam for personal closure. In a late-night visit to An's home, he was greeted by his friend wearing the uniform of a colonel in the Vietnamese army decorated with the equivalent of a Medal of Honor. "All along!" Anson gasped. "Yes, all along," said An, smiling. An would later tell me that Anson was followed by dozens of security agents. "He thought no one followed him, but the next day I had a visit from security. I told them the truth about Takeo, and they left me alone."

"So tell me, how are Christian and Sam? And please, how is Diane?" was the first thing An said to his friend. "Seventeen years, and he hadn't forgotten a detail," thought Anson. "Seventeen years, and he still knew how to put me at ease. The skill must have made him a master at his craft."[39] After ninety minutes of friendly conversation, Anson finally asked how it was possible for his captors to learn about Takeo. For the first time An admitted to Anson that it was he who had notified the Front of his friend's captivity and the

details of his heroism at Takeo. But that night he would tell Anson only part of the story, saying that a member of the Front had come to his Saigon home to check out Anson's confession about working for *Time*. This is the account Anson provided in his book *War News*:

"But why? We were on different sides, you and I."

"An looked at me thoughtfully, as if disappointed that after all his teaching I had failed to grasp his most basic lesson. 'No, we were friends.'"

There is one final page to this story. An was not prepared to share the complete truth with Anson in 1988. It was still too dangerous for him to disclose his modus operandi as a spy. Eighteen years later An told me what really happened. No member of the Front visited him at home; that could blow his cover. Besides, almost no one in the Front knew about his mission, and the Front was not going to risk losing An over a single American.

Bob Anson was released because of the secret report An had written about Takeo that Nguyen Thi Ba and another courier carried to Cu Chi. It was that simple. Anson owed his life to good luck about An's previously scheduled rendezvous with Ba, to his friendship with An, to his own personal courage in saving the Vietnamese children at Takeo and to the effectiveness of An's H.63 network. "He did not have to try to help those children, but he did," An told me. "And he stayed in touch with them afterward, making sure they were safe and placed in good care. He was a good man, but also a lucky one."

Chapter 2

THE APPRENTICESHIP OF A SPY

VC infiltration of press is considerable.

—Journalist Nguyen Hung Vuong speaking with
his colleagues Robert Shaplen and Pham Xuan An[1]

MR. PHAM XUAN AN
ORANGE COAST COLLEGE
COSTA MESA, CALIFORNIA

Pham Xuan An smiled as he read the return address: Mills C. Brandes, 2329 South Joyce Street, Arlington, Va.

It was April 1958. An's first year as an undergraduate at Orange Coast College was coming to an end. So many good things had happened in his life since the evening of August 16, 1957, when An and the Brandes family said their good-byes at Saigon's Tan Son Nhut Airport. Mills Brandes had just completed a two-year undercover assignment in Saigon and was departing on an extended family vacation before moving to Arlington so that Mills could begin a new assignment in Washington, D.C.

Mills's primary concern during the short drive to the airport had not been with his own family's imminent departure, but rather with that of his young Vietnamese friend, who was scheduled to leave Saigon in a few weeks for Costa Mesa, California, to begin journalism studies at Orange Coast College. Mills and his wife, Janet, had already purchased a new suitcase for An and again reminded him that Southern California had none of Saigon's stifling humidity. Mills was expecting An to keep up with his English lessons and had arranged for a colleague, Conrad Dillow, to replace Janet as An's primary tutor. Before saying their final good-byes, Mills handed An a list of friends and family he could contact once he reached California.

Mills first met An in 1956 while on assignment from the State Department, working in the hydroelectric area, or at least that was his cover story. A close friend of the legendary CIA operative Lou Conein, Brandes was really working undercover to assist the government of Ngo Dinh Diem in defeating the Communist Viet Minh insurgency.[2] Conein and Brandes had been members of the same detachment in the Office of Strategic Services (OSS) during World War II. In 1954 Conein went to work for Edward Lansdale's covert mission in North Vietnam, organizing a paramilitary anti-Communist stay-behind group that would prepare for the sabotage of industrial assets as well as overseeing a psywar campaign.[3] It was on Conein's recommendation that Brandes came to Vietnam and joined the battle against Communism. "I never knew that" was An's surprise response upon learning from me that Brandes had been working undercover. "I knew Mills Brandes was a fierce anti-Communist, but I did not know about him and Lou Conein. I knew Conein very well too. We often drank Black & White together, especially with Bob Shaplen, and I knew he was very well connected with the CIA, but I did not know this," said An in a tone of professional respect for his friend's cover.

An always considered the Brandeses his "first American family." Mills and Janet made every effort to include An in their activities. After putting her three young children to sleep, Janet would sit for hours practicing English with An, who became especially attached to Jud, Julanne, and Mark. "For the very first time in my life, I had young American children to teach me how to deal with other American children; how to relate to them," recalled An, who also took Mills and Janet home to meet his parents and siblings. Fifty years later Julanne Brandes Owings told me, "Even today I remember him as a special friend; few people I knew in my childhood treated me with more respect and kindness than did Mr. An."

Mills once asked An if he would join the family as a guide and translator for an extended trip throughout southern Vietnam. The long car rides in their Land Rover were usually spent with the entire family helping An practice English, highlighted by two remarkable stories that fifty years later both An and the children recalled for me in precisely the same way. The first occurred during the ride from Ban Me Thuot to Nha Trang along the coast on Highway 1. "We saw a mountain, and very high up on top was a silhouette of mother and baby," recalled An. "I told them the story of that silhouette, and Janet Brandes had me write it so that she could correct my English. There were two young children, a brother and sister, who one day got into a terrible fight. The brother took a knife and hit her on her head, cutting her badly. There was so much blood and he was so scared, he ran away forever. The family searched but never found him. He had gone to another village and lived there, never to return. He became a fisherman, and one day he met a woman whom he married, not knowing it was his sister. They had a baby son. They were very happy. One day she was combing lice eggs from her hair and asked her husband for help. He saw terrible scars on her head and asked what had happened. When he heard the story he realized he was

her brother and was now guilty of incest. His conscience disturbed him so much he ran away, never to return home again. His wife was so distraught she took their son up the nearby mountain to await the return of her husband, since every day fishermen went out early and returned late in the day. They waited and waited. She climbed higher and higher. One day she died, and God turned her and the baby into stone, waiting for their husband and father to return. To this day, fishermen from central Vietnam, Qui Nhon, look toward the lady and recite the Prayer of the Vietnamese Fisherman—'Lady, we pray you to blow the southwestern wind . . . your husband is living now in Qui Nhon, we are following him, so please blow the wind to help us get out faster.'" An chanted the prayer for me in Vietnamese and then wrote it in his native language. When I discussed this story with the Brandes family, Jud pulled out his photo album to show me a picture of the stone rock.

That trip was most memorable for another story; it was the day Mills took a wrong turn onto a remote road and the car was suddenly surrounded by armed Viet Minh guerrillas. The children were terrified. An first reassured everyone, telling the family to stay calm while he went to speak with them. No one was to make any movements or to say anything. After several minutes of animated conversation, An returned to the car and instructed Mills how to get back onto the main road. Whatever he said worked because the guerrillas quickly disappeared into the adjacent forest.

That evening Mills assembled his family and told them to never forget that An had saved their lives. "If not for him we would have been killed" is what the children recalled their father saying. To this day the Brandes family speaks with eternal gratitude for what they consider an act of friendship and courage, a debt that can never be fully repaid. When I asked Jul and Jud for their father's reaction upon learning that An had been a Communist spy, they said, "Father told

us that Mr. An is our friend, I won't judge him. We loved Vietnam, we loved An, we understood nationalism, the Vietnamese were our friends. An did what he had to do, it was his country, his family. He built friendships for the future. He played the game as smart as he could."[4]

An told me that when he spoke to the Viet Minh, he said he was serving as a tour guide for this young American family and they were now lost because he did not know the local roads. "I said they were a threat to no one and that Mills did not work for the government." I somehow doubted that was all An told them and prodded him. "There are some things that even after fifty years I cannot talk about," he said in a tone indicating we should move on to the next subject.

STILL HOLDING THE unopened letter in his hands, An thought back to the day he had seen Mills Brandes pedaling a cyclo up one of Saigon's steepest hills while the thin and frail Vietnamese driver sat as the passenger. An had never before seen a Caucasian pedaling a cyclo, but was even more astounded to see the driver as the passenger. Once they reached the top of the steep hill by the Grall Hospital, the two men exchanged places, with the cyclo driver taking Mills home to 213B Cong Ly. Mills later explained to An that even by Saigon standards it was such a hot day, and since he was such a large man, Mills felt badly for the frail cyclo driver. An would never forget the lesson: "You know, this is a very human example that sticks in my head until the day I die. The first time when Americans show me the compassion and how generous they were."

An always looked forward to updates from Mills, but this letter brought disturbing news. "I hope you don't mind our consulting you on these matters concerning Vietnamese-America relations,"

wrote Mills Brandes. "We do so because we are interested in these relations and because we know that you will give us your honest opinion. After all, you are the one person who taught me and my family most of what we know about your country."[5]

Enclosed were four articles, including "one on the discovery of several communist newspapermen in Vietnam by the Vietnamese government." Mills warned An that these arrests

"point to the existence of the communist menace and also to the awareness of its existence by some people. We don't have any 'full time' propaganda people in this country, only the 'free press' which you are learning about now. Many times I feel that our country is fighting with its hands tied behind its back. Let us hope that this unwillingness on our part to meet the communists with U.S. Government sponsored propaganda is not mistaken as being cowardice by our friends.

"I must admit that I have met more people in your country and others, in the Far East who are 'wise' to communist strategy and tactics than I have here at home. I am only one person and this may not be a fair sampling either at home, or abroad—probably isn't. If, some day, my people are allowed to understand world communism for what it really is—an insidious plot for world domination which is completely controlled by a few madmen—then communism will be destroyed. I don't think that our people yet realize this menace in its true meaning. Further, I don't believe that we know yet our most powerful weapons with which we can destroy it—truth, honesty, and individual integrity."

From the letter An learned two important things. First, that back home there had been a crackdown by the Diem government against those suspected of having VC sympathies, and second, his cover

An loved playing with the American children he met in Vietnam. Here he is sitting with Captain Frank Long's children. Another young friend is on the right.

was still intact. An's mission in the United States was to learn all he could about the American people and their culture so that he could return to Vietnam under the cover of being a newsman. Many members of Hanoi's politburo, closely monitoring the resources being channeled into Vietnam from the United States since the defeat of the French at Dien Bien Phu in 1954, had little doubt the day would come when the United States and Vietnam would be at war. Before his departure, An was instructed to make every effort to integrate himself into the American way of writing and thinking: "If you can't do this, you will not succeed," warned his mentor Muoi Huong. "When you go there, you have to study American culture thoroughly and understand the American people completely. Only by doing so can you do your part."[6]

In doing his part, An became an admirer of the American people, their values, and their culture. These feelings had roots in Vietnam from his first interactions with Americans like the Brandes family or Master Sergeant Frank C. Long and his three children, Amanda, Peter, and Kathy. He admired their compassion, independence, and even their good intentions. Wherever possible, he tried explaining Vietnam to his American friends and his country's long history of opposing foreign intervention. "I always hoped the United States would open its eyes and help the real Vietnam," An told Henry Kamm.[7]

An became a member of the Communist Party in February 1953 at a ceremony held 350 kilometers from Saigon in Vietnam's southernmost province of Ca Mau. The most senior Viet Minh commissioner in southern Vietnam, Le Duc Tho, presided over the ceremony and afterward took An aside for a private conversation. Tho had been an early member of Ho Chi Minh's circle and one of the founders of the Indochina Communist Party. He had already spent over ten years in French jails, including forced labor at Poulo

Condore, later called Con Son, a prison island known for its brutal conditions. While imprisoned in Nam Dinh, he wrote the poem "Cell of Hatred," using the words, "Rage grips me against those barbaric imperialists, so many years their heels have crushed our country ... a thousand, thousand oppressions."

Almost thirty years later Le Duc Tho would get the better of Henry Kissinger in the negotiations to end the war. The men would share the Nobel Peace Prize, which Tho refused to accept on grounds that real peace had not been achieved because of American and South Vietnamese duplicity. At their very first secret meeting, in Paris on February 21, 1970, Tho challenged Kissinger with the same type of fiery speech he used with his new recruits that evening in the U Minh Forest: "If our generation cannot win, then our sons and nephews will continue. We will sacrifice everything, but we will not again have slavery. This is our iron will. We have been fighting for twenty-five years, the French and you. You wanted to quench our spirit with bombs and shells. But they cannot force us to submit ... you threatened us. President Nixon also threatens us. But you have read our history. We fought against the French for nine years. We were empty-handed. Myself, I participated in this resistance war against the French, without knowing military things. Yet we won ... This is not a challenge. I am frank. We are a small people. We cannot challenge anybody. We have been under domination for many years ... I am convinced we will win."[8]

"Mr. Six Hammer," as Le Duc Tho was dubbed by his cadres, warned An that when the war with France ended, the United States would not allow the Vietnamese to decide their own future. New imperialists would replace the French colonialists, but this new war would be a long and destructive one. An was instructed to prepare himself for whatever mission the party assigned him for the defense of his country.[9]

A decade earlier, An could not have imagined becoming a member of the Communist Party. Following the French surrender to Hitler, Japan occupied Vietnam. An was a teenager living in the southern port town of Rach Gia, where he witnessed firsthand the brutal treatment of French prisoners as they were chained together on forced marches and beaten by their Japanese captors. "I never liked the French, because the French colonialists' children mistreated us Vietnamese children. But the Japanese cruelty disgusted me. The Frenchmen were thirsty. I went to my father, and he said, 'Boil some water and take it to them.' When I did, the Japanese slapped the Frenchmen in the face."[10]

On August 6, 1945, the first atomic bomb exploded over Hiroshima; three days later a second strike hit Nagasaki. Japan soon surrendered, ending World War II. Shortly thereafter, Ho Chi Minh's Viet Minh forces entered Hanoi and took control of the government, touching off the August revolution.[11] On September 2, before a crowd of 400,000 supporters in Hanoi's Ba Dinh Square, Ho issued the historic Vietnamese proclamation of independence invoking Thomas Jefferson's stirring words, "We hold the truth that all men are created equal, that they are endowed by their Creator certain unalienable rights, that among these are life, liberty, and the pursuit of happiness."

Ho told his followers that "this immortal statement was made in the Declaration of Independence of the United States of America in 1776. In a broader sense it means: All peoples on earth are equal from birth, all peoples have a right to live, be happy, and be free." Professor David Marr has explained that Ho intended to contrast the American declaration as well as the 1789 French Declaration of the Rights of Man and of the Citizen with eighty years of French colonialism.[12]

After reading just a few sentences of the Vietnamese indepen-

dence declaration, Ho stopped to look directly at the throng of supporters and asked, "Countrymen, can you hear me clearly?" A roar came back, "Clearly!" Vo Nguyen Giap later wrote, "Uncle [Ho] and the sea of people became one."[13] An would later tell me that "no leader in the South, Diem or Thieu, not anyone ever had this bond. We always exploited that basic truth."[14]

Ho concluded his speech with a plea to the Allies to support Vietnamese independence: "Vietnam has the right to enjoy freedom and independence, and in fact has become a free and independent country. The entire Vietnamese people are determined to mobilize all their physical and mental strength, to sacrifice their lives and property, in order to safeguard their freedom and independence."[15]

When Ho finished, Vo Nguyen Giap, the minister of the interior in the new government, told the throng that "America ... is a democratic country which has no territorial ambitions. Yet it bore the greatest burdens in defeating our enemy fascist Japan. Therefore we consider America a good friend." Some in the crowd carried signs that read, "Vietnam Honors Truman."[16]

The United States was emerging from World War II as a preeminent world power. Vietnam quickly became a pawn in the new cold war. Policymakers ignored the fact that Ho received the translation of the Declaration of Independence from Archimedes Patti of the Office of Strategic Services (OSS); that he had helped rescue American pilots and furnished intelligence reports on Japanese operations, earning him the position OSS agent 19, code name Lucius; and that Viet Minh militia had also joined with the OSS Deer Team for training and exercises near the Chinese border.

It would not matter. The loss of any country in Southeast Asia to Communism was defined as having disastrous effects on U.S. geopolitical interests. Late in 1945 Ho made one final grasp for American support, writing President Harry S Truman and Secretary of State

James Byrnes that Philippine independence offered a model for emulation: "It is with this firm conviction that we request of the United States as guardians and champions of World justice to take a decisive step in support of our independence. What we ask has graciously been granted in the Philippines. Like the Philippines our goal is full independence and full cooperation with the United States."[17]

It was not to be.

An and a generation of Vietnamese joined the revolution to fight France's last, futile grasp at recapturing its colonial grandeur. An recalled being in Cantho when Ho delivered his speech. "I was very excited. I wanted to join and fight for my country and defeat the French. I was just one of many and it was a natural response." As children, An and his friends had endured flag ceremonies at school in which first the French and then the Vietnamese flag were raised and schoolchildren would sing *"Maréchal, nous voilà,"* the best-known song of the Vichy government in honor of Field Marshal Henri-Philippe Pétain. Under French colonial rule, Vietnamese were referred to as "nhaques" (*nha que*), meaning peasants, hicks, or country bumpkins.[18]

As a young boy, An knew nothing about Marx or Lenin, but he dreamed of independence for his country and an end to the type of inequalities created by decades of colonialism. Born in 1927 in Binh Truoc village in southern Dong Nai province, An traveled everywhere with his father, whose assignments as a land surveyor took him to the most remote areas of southern Vietnam. When his father saw how inattentive his son was to school and studies, he sent An to live with relatives in Hue in order for him to understand the difference between those who have something and those who have nothing. An lived among the poor in Hue, people so destitute they used rat fat for candles because they had no oil for lamps. He

An is in the lower right bamboo baby chair. His father and mother are to his left. PHAM XUAN AN PERSONAL COLLECTION

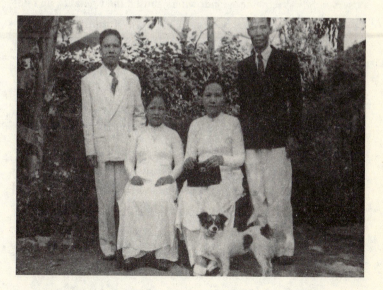

An's mother and father are on the right, with the small dog in front of them. PHAM XUAN AN PERSONAL COLLECTION

As a nine-year-old, An was required to carry this card.
PHAM XUAN AN PERSONAL COLLECTION

observed how Vietnamese landowners abused their tenants, and he came to admire the dispossessed. "That's why I have such respect for America. They taught me to help the underdog," said An.[19]

In October 1945 An dropped out of high school in Can Tho in order to enlist in the equivalent of Viet Minh boot camp and was soon fighting against the French in the jungle. When French cruisers shelled Hai Phong Bay in November 1946, full-scale war broke out between France and the Viet Minh. On December 19, 1946, Ho issued his appeal to compatriots throughout the country: "We would rather sacrifice everything than lose our country, than return to slavery. Compatriots! Rise up! Men and women, old and young, regardless of creeds, political parties, or nationalities, all the Vietnamese must stand up to fight the French colonialists to save the fatherland. Those who have rifles will use their rifles. Those who have swords will use their swords. Those who have no swords will use their spades, hoes, and sticks. Everyone must

endeavor to oppose the colonialists and save his country. Soldiers, self-defense guards, militiamen! The hour of national liberation has struck! We must sacrifice to our last drop of blood to save our country. Whatever hardships we must endure, we are ready to endure them. With the determination to sacrifice, victory will be ours! Long live an independent and unified Vietnam. Long live the victorious resistance."

An would not carry his rifle or even a stick into this battle. He was forced to return to Saigon in 1947 in order to care for his tuberculosis-ridden father. There, he became an organizer of student protests against the French and later the Americans. An vividly recalled the day in March 1950 when the USS *Richard B. Anderson* visited Saigon, bringing supplies for the French in their battle against Viet Minh forces.[20] He was one of the organizers of street demonstrations against the visiting American ship docked in Saigon harbor.

An's career as a demonstration leader was quickly curtailed when his immediate supervisor, Dr. Pham Ngoc Thach, told him that he had another job to do in the revolution. Dr. Thach, an early close associate of Ho Chi Minh, ordered An to desist from participating in all street protests in order to reduce the chances of getting arrested or drawing undue attention to himself. An was puzzled and frustrated by these instructions and wondered what role the revolution had in store for him. He was soon summoned to the Viet Minh base north of Saigon in Cu Chi, where Dr. Thach informed An that he was being assigned to Vietnam's first class of strategic intelligence agents.[21]

An had little interest in being what he considered a mere "stool pigeon."[22] But the decision had been made. "Senior leaders have entrusted you with the job because they firmly believe that you will do this job well. You will also learn much in the process."[23] "I had no

choice," An told me. "My country gave me a new mission. There is nothing else to say. That is the explanation for my new job."

Hanoi sent two agents to Saigon who provided An with the basics of intelligence work, but real education would come on the job. An had been working as a bookkeeper and accountant for the Caltex oil company but soon took an assignment to work as a French customs inspector, where he was to report on the dispatching of French troops in Vietnam and the resources being provided by the United States to France. He was also to learn whatever he could about the personalities of the French and Americans in Vietnam. "I was to observe and then write up some reports, not too much," said An.

An quickly turned his attention to efforts under way for building and training a new force structure for the South Vietnamese army.[24] The Military Assistance Advisory Group (MAAG) in Saigon had been established in 1950 "to supervise the issuance and employment of $10 million of military equipment to support French legionnaires in their effort to combat Viet Minh forces."[25] Within a short period, MAAG was also assigned responsibility for improving the South Vietnamese Army units as rapidly as possible. A skeleton staff was established with offices in MAAG for a new binational training organization that was given the name Training Relations and Instruction Mission (TRIM). One of TRIM's responsibilities was to assist and advise the Vietnamese military authorities on rebuilding the Vietnamese armed forces. TRIM was composed of 209 French and 68 American officers (121 additional American officers would be assigned as the French departed), not one of whom could speak Vietnamese and less than ten of whom spoke French.[26]

An first learned English from missionaries in Can Tho during the Japanese occupation. He was then befriended by a Mr. Webster at the British Embassy in Saigon, who spent hours practicing with him. Then a Mr. Newell worked with him so that by the time An

An (bottom, right) loved this picture of his first holiday party with colleagues at Caltex Oil. Pham Xuan An personal collection

A dapper An, 1953. Pham Xuan An personal collection

The master schmoozer, here An works on the military attaché in
Saigon. PHAM XUAN AN PERSONAL COLLECTION

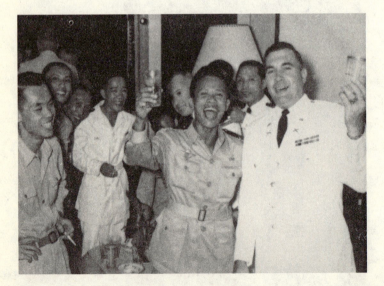

An (at left) with the 6th light infantry division.
PHAM XUAN AN PERSONAL COLLECTION

arranged a transfer to TRIM, he was among the most proficient of the Vietnamese, thereby enabling him to establish himself as a valuable asset to the Americans and Vietnamese, building relationships with dozens of future South Vietnamese commanders and influential Americans.

An became part of the 25th ARVN Division in February 1956, operating in the Mekong Delta with the aim of destroying the Viet Minh infrastructure. "I actually served in three armies," said An. "The French during the transition; the Vietnamese as an NCO, where I helped set up the first light infantry division; and the Liberation Front Armed Forces."[27] When An was promoted to one-star general in 1990, he told the Communist leadership, "I was familiar with five armies—the Viet Minh, the French, the Viet Cong, the Americans, and the South Vietnamese—that I should have five stars. I don't think they understood my sense of humor."[28]

An recalled his two American adviser counterparts, Hicks and Glenn, with great fondness. "They were good men who wanted to help the people of Vietnam, and we had good talks about my country. They also helped me practice my English and then taught me to smoke the right way. I never knew how to inhale, and then they showed me and gave me the Lucky cigarettes. They did a good job," said An with a smile.

The Combined Arms Training Organization (CATO), replaced TRIM in April 1956, and served as an operations staff for the chief of MAAG, which controlled all field detachments assigned to Vietnamese schools and commands. An transferred from TRIM to CATO and was now responsible for processing the paperwork and conducting interviews with the South Vietnamese officers traveling to the United States for command training. Among those processed by An were the future president of South Vietnam Nguyen Van Thieu (then a lieutenant-colonel), the future chief of the Joint

General Staff (JGS) Cao Van Vien (major), future general and commander of I Corps Nguyen Chanh Thi, and future marine commander Le Nguyen Khang (captain). "I was in charge of procedures for their trips to America and worked as a liaison man between them and their families, informing their families of their return so that they could go to meet them. As such, we gradually got to know each other," An told me.

These early relationships later proved indispensable. One of An's carefully developed strategies was never to get too close to anyone he knew or thought to be a Communist sympathizer; instead he sought out and attached himself to the most ardent and recognized anti-Communist figures in order to protect his cover and gain insights into American thinking.[29] He started with Colonel Edward Lansdale, who arrived in Saigon in June 1954, the interlude between the defeat of the French at Dien Bien Phu and the signing of the settlement in Geneva, which partitioned Vietnam at a nominally temporary "line of demarcation" between North and South at the 17th parallel. The Viet Minh took control of the northern zone, and France and an alternative Vietnamese state controlled the south. The French forces would withdraw from the north and Viet Minh forces from the south, with free elections scheduled for 1956. Under the terms of the Geneva Agreement, any civilian would be permitted to move from North to south and south to North prior to May 18, 1955. About ninety thousand Viet Minh cadres went north at the same time as nearly one million Catholic refugees were coming south.

Lansdale was director of the Saigon Military Mission (SMM), a CIA unit separate from the regular organization.[30] Vietnam now had two CIA teams in place, one under the station chief, responsible for conventional espionage and working undercover as diplomats attached to the U.S. embassy; the other, Lansdale's Saigon Military

In Hue, An practiced English with Mr. Newell.
PHAM XUAN AN PERSONAL COLLECTION

Mission, handling paramilitary activities and working undercover on assignment to MAAG for Indochina.[31]

Already a legendary figure for his role in defeating the Communist Huk rebellion in the Philippines and making a national hero of Ramon Magsaysay, Lansdale was told by Secretary of State John Foster Dulles to "do what you did in the Philippines." "God bless you," added his brother, CIA director Allen Dulles. Operating with the cover title of assistant air attaché, Lansdale sought to create a non-Communist national government in the south.

It was at Vietnamese army headquarters that the CIA's Rufus Phillips first met An, who was working as a staff assistant to his cousin, Captain Pham Xuan Giai, helping with translations and related activities as a general staff secretary in the psychological warfare Department for the Joint General Reserve. Phillips had arrived in Saigon on August 8, 1954, just before the Geneva Accords went into

An enjoys a night of socializing and work with French information service personnel, 1954. PHAM XUAN AN PERSONAL COLLECTION

effect. For his service to the Saigon Military Mission, Phillips would receive the CIA's Intelligence Medal of Merit. Giai had already attended the French army's psychological warfare school and then the American psychological operations school at Fort Bragg, North Carolina. He was the head of G-5, which was the general staff office responsible for troop information, training, indoctrination, and for psychological warfare, or psywar—a combination of propaganda targeted at the civilian population and psywar against the Viet Minh. "It was because he worked for Giai that Pham Xuan An got introduced first to Lansdale and then to me," recalled Phillips.[32]

Phillips, Conein, and others in the Lansdale shop took an immediate liking to An because of his unassuming nature and wry sense of humor. That he spoke English better than almost any other Vietnamese made him very useful. Nothing An did for Lansdale or Phillips involved high-level work or access to secrets of any

kind. An was merely fertilizing the human intelligence component in development of his cover, learning to schmooze and make small talk with Americans, putting them at ease and gaining their trust for access down the road.

An told me the following story of how he first met Lansdale. An was working alone in the G-5 office when one of Lansdale's assistants came over and asked for the names of all G-5 employees. Later in the day when Giai returned, An told his cousin that he had given Captain Roderick the entire list. "Oh, An, you are so stupid. You know nothing about intelligence. How could you just give our list to Lansdale?" An ended his version of this story by telling me, "You see, after that Lansdale liked me very much right away because I helped him with that list, even though I did it by mistake. After that he always joked with me, 'An, you would make a terrible spy.'"

Rufus Phillips and An developed a special friendship that lasted until the very end of An's life. "I think An was one of the most acute and balanced of all the Vietnamese I knew as a perceptive observer of both the Americans and the Vietnamese during the long struggle," Phillips told me. "I just don't think he could have ever bought into the Communist Party propaganda line. I knew him as a patriotic nationalist and not a Communist and that is how I will always remember him."[33]

Lansdale viewed An as a potential recruit in the war against Communism, offering to sponsor him at the NCO School of Intelligence and Psychological Warfare. This would allow An to get promoted quickly though the ranks once he returned to Vietnam. An took Lansdale's proposal to his real bosses in Cu Chi, where his direct supervisor, Muoi Huong, told him to avoid this assignment because it was simply too risky. The Communists already had agents being planted in ARVN leadership who would eventually reach the rank of colonel, but no one was being groomed for his

type of mission. By studying journalism, An would be able to attend college in the United States. If he joined the military this would not be possible. "An was the only agent we sent to the U.S.," said Mai Chi Tho, who at the time was head of counter-intelligence of the Southern Regional Committee.[34] Tho and others did everything possible to make certain An was properly trained and protected for his mission.

When An told Lansdale that he preferred studying journalism, Lansdale immediately offered to sponsor An and contacted the Asia Foundation. Founded in 1954 and with an operating budget of approximately $8 million during this period, the foundation was a CIA proprietary undertaking cultural and educational activities on behalf of the United States government in ways not open to official U.S. agencies.[35] When a representative of the foundation visited Saigon in 1956 in order to explore establishing a program for journalists in Vietnam, Lansdale arranged for the military attaché in Saigon to take An for a meeting with the Asia Foundation representative, who referred An to Dr. Elon E. Hildreth, the chief of the education division of the U.S. Operations Mission to Vietnam and chief adviser to the Vietnamese government education department from 1956 to 1958.

Hildreth was always looking to sponsor bright and engaging Vietnamese to study in America. In An he found the perfect candidate. An spoke English, possessed a keen mind, and already had the endorsement of America's foremost anti-Communist counterinsurgency expert, Edward Lansdale. Hildreth was close friends with Orange Coast College president Dr. Basil Peterson.[36]

A week after Lansdale's arrival in Saigon, absentee emperor Bao Dai, then living in Paris, offered Ngo Dinh Diem the premiership of the State of Vietnam. "The salvation of Vietnam depends on it," Bao Dai told Diem. Recent scholarship shows that Diem and

An (front, right) with light infantry division commanders and CATO personnel, November 1955. PHAM XUAN AN PERSONAL COLLECTION

Dr. Elon E. Hildreth of the U.S. State Department later visited An at Orange Coast College and posed for a ride from his favorite cyclo driver. PHAM XUAN AN PERSONAL COLLECTION, PHOTO BY PETE CONATY

his brother Nhu did much maneuvering in the preceding year to place Diem in this precise position.[37] By the time Dien Bien Phu fell in May 1954, Diem had positioned himself as a nationalist with good connections in Washington. A Catholic from a prominent mandarin family, he had strong anti-Communist credentials and appealed to many anti-Communists in America, whose ranks included Senator Mike Mansfield, Francis Cardinal Spellman, Senator John F. Kennedy, and Supreme Court Justice William O. Douglas. "With the two ardent anti-Communist brothers John Foster Dulles at State and Allen Dulles at the CIA, Diem had powerful advocates inside the Eisenhower administration," Nguyen Thai told me.

"The hour of decision has arrived," Ngo Dinh Diem proclaimed upon landing at Tan Son Nhut Airport, three weeks after Lansdale's arrival. Diem faced a powerful coalition of enemies, who stood to lose everything in the unlikely event he was able to consolidate power. These included General Nguyen Van Hinh, a pro-French chief of staff of the Vietnamese army, who was already plotting Diem's downfall; the politico-religious sects of the Cao Dai and Hoa Hao; and the Binh Xuyen, a Mafia-like gangster organization that controlled Saigon's opium smuggling, gambling, and prostitution. To pay off millions of dollars in gambling debts, Bao Dai had sold leases to the Binh Xuyen on all gambling operations in Cho Lon, including the Grand Monde casino as well as Asia's largest brothel, known as the Hall of Mirrors. Bao Dai had also sold control of the national police to Binh Xuyen leader, Brigadier General Bay Vien.

Lansdale quickly developed a plan first to keep all of Diem's political opponents from ganging up to oust him as prime minister, then to defeat them one by one, either by military force or political maneuver. Lansdale began by channeling funds from the Saigon

Military Mission in a divide-and-conquer strategy before taking on the French.[38] He turned first to the Cao Dai sect, which claimed two million adherents and an army that had been funded by the French. By reaching out to a separate anti-French and anti-Communist Cao Dai force, headquartered in Black Mountain (Ba Den Mountain) and led by Trinh Minh The, Lansdale hoped to build a coalition between two anti-French, anti-Communist men—The and Diem. The two had been in touch with each other before Lansdale's trip to Ba Den Mountain and it was probably Diem's idea to send Lansdale to see The as a signal that he could deliver U.S. aid. Before proceeding, Lansdale sought Diem's approval for this controversial move and also support from General John "Iron Mike" O'Daniel, who was the head of MAAG. Diem approved the plan as did O'Daniel, who wanted the sect armies integrated into the Vietnam national army.

Traveling with members of his team to The's secret headquarters in Black Mountain, Lansdale brokered a deal whereby The agreed to support Diem in his battle for control against the French. In return, The's troops were integrated into the South Vietnamese army with The assuming the rank of general.[39] Still, for all of Lansdale's progress with the sects, Diem was making little headway stabilizing his fledgling government.[40] President Eisenhower was concerned enough about Diem's progress to send General J. Lawton "Lightning Joe" Collins, with the rank of ambassador, to Vietnam in order to find out what the hell was going on.

Collins and members of his mission arrived in Saigon on November 8, 1954, only to be "amazed and appalled" at the situation.[41] After five months in-country, Ambassador Collins returned to Washington for a series of high-level meetings that would determine the fate of Diem's fledgling government in the south. Secretary of State John Foster Dulles previewed the meetings by telling his brother, CIA director Allen Dulles, that "it looks like the

rug is coming out from under the fellow in Southeast Asia" and "the gangsters will have won."[42]

In a memorandum to Allen Dulles, Sherman Kent, CIA assistant director of the Board of National Estimates—and the person Pham Xuan An would model himself after as a strategic intelligence agent—summarized the thrust of Collins's remarks at a four-hour meeting in the State Department.[43] "Diem stinks" and "the situation in South Vietnam is entirely ascribable to Diem's failures. If chaos is to be averted, Diem must go." Under the heading "Diem stinks," Kent wrote that "there is no good that can be said of Diem as a chief of government and administrator. He has no sense of the task ahead, no vestige of administrative ability. He shuts his eyes to problems that confront him.... He cannot get along with people of ability and insists on having about him only like-minded men. Collins stated that...he is entirely despairing of any solution so long as Diem stays in office." Collins believed that civil war was inevitable.[44]

Meanwhile, An's probationary year with the party had just ended, and he was about to send his first big intelligence coup to the jungle. An learned from contacts in the French intelligence agency, Deuxième Bureau, as well as from his pro-French cousin, Giai, that Collins had become "close" with a female Vietnamese agent working undercover for French intelligence, who had been feeding Collins as much anti-Diem spin as possible. Collins had also boasted that he was going to Washington to finally get rid of Diem and identified Phan Huy Quat, a favorite of the French, as the next head of state.

Upon discovering all this from his French intelligence contacts, An went directly to Cu Chi, recognizing that advance notice of a change in government would be valuable information for Viet Minh propagandists. "The information I got on Collins was valu-

able because if Diem was going to be replaced, the Americans were threatening to leave and cut off all money. This would mean we would have an opportunity to unite the country very quickly," An explained to me. "I checked with my two sources and then reported it all to my superiors. It did not happen, but my information was correct."

On April 27, Dulles sent a cable to the embassy with instructions that the acting chief of the mission was to find another prime minister. Lansdale had learned about the Dulles cable of the impending shift in U.S. policy. Recognizing time was short, he counseled Diem to order a massive counterattack, but Diem needed hardly any prodding. Diem had been planning to strike for weeks and had already announced his plan to seize the Sûreté Headquarters from the Binh Xuyen. Diem also knew that his brothers had been carefully building up support within the Vietnamese army officer corps since the previous fall. In addition, Lou Conein had bought the loyalty of key officers, who promised to abandon Hinh, fearing that all U.S. aid would be terminated if Hinh was victorious. The Vietnamese National Army would be better off with Diem, who had the ear and money of Washington.

In fierce fighting lasting almost nine hours, the Binh Xuyen bandits were driven from Saigon.[45] During the battle against the Binh Xuyen, General Trinh Minh The was killed with a shot to the back of the head while riding in his jeep. An told me that The had been assassinated by order from President Diem's brother Ngo Dinh Nhu and identified the assassin as Cao Dai major Ta Thanh Long, who was quickly promoted to the rank of ARVN major and assigned to work on the Presidential Special Military Staff. An thought that The's popularity as a nationalist and fierce anti-Communist threatened the Diem family's hold on government because the non-Catholic population might rally to The. On May 1, in a rare bureaucratic pro-

Working for the
Americans after
being drafted into
French army.
PHAM XUAN
AN PERSONAL
COLLECTION

cedure, Secretary Dulles informed Ambassador Collins that his earlier cable was being recalled and that Diem's triumph over the Binh Xuyen was proof that the premier had consolidated his power and could survive, for the moment. "For us at this time to participate in a scheme to remove Diem would not only be domestically impractical but highly detrimental to our prestige in Asia."[46]

With his power base secured and the sects neutralized, Diem decided to take care of Bao Dai once and for all by organizing a nationwide referendum pitting himself against the former emperor. To no one's surprise, Diem won the plebiscite with a Ho Chi Minh–like majority of 98.2 percent, "a figure that would have made a Tammany Hall boss blush," wrote former foreign service officer Howard Simpson.[47] Three days later Diem, who had tallied thou-

sands more votes than there were registered voters, declared Bao Dai deposed and proclaimed himself president of the new Republic of Vietnam.

By the end of 1955 the impossible had happened: the position of Ngo Dinh Diem was greatly consolidated, thanks to the important covert help of Lansdale and his team, who succeeded in neutralizing the plots by Diem's enemies.

In May 1957 *Life* Magazine proclaimed Ngo Dinh Diem "The Tough Miracle Man of Asia."[48] Diem flew to the United States and gave an address before a Joint Session of Congress. In New York City, Mayor Robert F. Wagner called him "a man history may yet adjudge as one of the great figures of the twentieth century." The *Saturday Evening Post* called him the "mandarin in a sharkskin suit who's upsetting the Red timetable.*"

Five months after Diem's triumphant American tour, Pham Xuan An arrived in California on the *other* "Red timetable."

Chapter 3

CALIFORNIA DREAMING

> In my life, I consciously enjoyed 2 full years of peace when I was in California.

> —Pham Xuan An personal letter to
> Rosann and Rich Martin, December 13, 1969[1]

ON SATURDAY EVENING, OCTOBER 12, 1957, thirty-year-old Pham Xuan An arrived in California. He was fortunate to have made it because his visa had been mired in the bureaucratic depths of the Vietnamese immigration office.[2] In desperation, An called a cousin who worked for the youngest of the Ngo brothers, Ngo Dinh Can, the overlord of central Vietnam, to see if anything could be done to expedite things. An's file was referred to Dr. Tran Kim Tuyen with instructions to check with the Americans about An's character and loyalties. Lansdale's recommendation alone was sufficient for Tuyen to arrange immediate clearance of An's paperwork, making the trip to the United States possible. From this moment forward, the lives of Communist spy Pham Xuan An and one of Vietnam's most ardent anti-Communists, Dr. Tran Kim Tuyen, would be forever interwoven.

Tuyen was head of the Service d'Études Politiques et Sociales (Bureau of Political and Social Research), which was referred to by the James Bond-esque acronym SEPES. Operating in an annex building within the Presidential Palace and reporting directly to President Diem's brother Ngo Dinh Nhu, the office had close ties with the CIA and was staffed only with those most loyal to Nhu and Tuyen. This palace intelligence and security service was a secret police unit that had its tentacles in every part of South Vietnamese life.[3] From a prominent anti-Communist Catholic family in Phat Diem, a Catholic enclave in the north, Tuyen had been an early recruit of the Ngo brothers.[4] Nhu had come to regard Tuyen "as his fixer, a man with enough contacts in every corner of Vietnamese society to succeed with any project, large or small."[5]

If there was a silver lining to the visa problems causing An to delay his departure from Saigon, it was being home on September 24, 1957, the first day of the eighth month of the lunar calendar, the day his father died in An's arms at the age of fifty-seven. The loss weighed heavily on An because many family responsibilities would now fall on him as the eldest son, especially during the traditional Vietnamese three-year period of mourning. When his father died, An did not think it was going to be possible to attend college in the United States.[6]

At the first of several crossroads in An's life, his mission would take precedence over all else. Mai Chi Tho, the younger brother of Le Duc Tho, had been actively involved in planning An's mission. "At the time we were still in covert operations," Tho explained to me. "I had to raise the money in secret by using part of our intelligence fund monies and borrowing the rest."[7] I asked Tho why An was the one selected for this important mission: "He spoke English better than anyone else and possessed a God-given gift for his profession. One of the greatest strengths of a spy is to remain calm

and have many friends; to be consistent with everyone so that no attention is drawn. An was able to do that with everyone, and this is why I consider him to be one of the greatest spies in our country's history."

An's direct supervisor, Muoi Huong, was the one responsible for deciding whether An's mission would be postponed. Recognizing that there was simply no one else prepared for this special mission, Muoi Huong assured An that the party would take care of his family. "I knew then that I would have to leave for the United States, but I also asked permission to explain the reason to my mother because this was still our mourning time," said An. "His mother supported my husband completely, but she did not involve herself in his work," An's wife Thu Nhan told me. "She knew he worked for the revolution and that was enough." With his mother's acquiescence, An boarded a Pan Am four-prop aircraft for the flight to the United States on the evening of October 10, 1957, a few weeks after the start of classes at Orange Coast.

Orange Coast College was founded in 1948 on a deactivated World War II military base in Costa Mesa. Its opening day enrollment was five hundred students in September 1948. When An arrived nine years later, the school was still a small commuter college. School administrators assumed An was not going to enroll in the fall and his dorm room had been assigned to another student.[8]

The dormitory manager, Henry Ledger, happened to be outside to greet An when he arrived: "I've been waiting for a month—where the hell have you been?" quipped the burly Ledger. The dormitory itself was one of the remodeled barracks once constituting the former Santa Ana Army Air Base. With all the dorm rooms taken, Ledger converted the old linen storage closet into a single room for An, which An considered palatial. It did not take long for An to unpack his five suits and personal effects from the suitcase Mills Brandes

had bought for him. "Are you hungry?" asked Ledger. Not waiting for an answer, he opened up a can of beef stew—the first time An had eaten meat from a can. He thought it was terrible but on-the-job training for his mission to learn about American culture.

A veteran of World War II and roughly the same age as An's father, Ledger would immediately take An under his wing. Ledger enjoyed playing the guitar and dressing like a cowboy. Every Wednesday he and An watched boxing on television, and Sunday evening was spent watching bowling. Ledger had an old pickup truck with a camper shell, and he eventually taught An how to drive. "I loved him almost like a father," said An. "And he helped me when I had suffered a terrible loss of my father. He was a kind man who wanted me to like my new home, to be part of a new family. I was lonely when I first arrived, and he helped me feel like I was welcome in this new place."

An's first weekend at OCC featured the fall square dance. Ledger coerced the reluctant An to attend so that he could meet people. As An entered the dance hall, most eyes turned to the first Vietnamese to ever attend OCC and the only Vietnamese in Orange County at that time. He quickly picked up the nickname "Confucius" from his irreverent classmates, standing out that evening as much for the fact he was Asian as for the suit and tie he wore to the Western-themed dance.[9]

Hoping to spend the evening as a wallflower, An was totally perplexed when a female student asked him to dance. He literally froze in place, having never danced nor held a woman's hand in Vietnam. The young coed persisted, saying it was OK to hold hands while dancing. Later that evening she suggested that An enroll in dance class for his one credit of mandatory physical education. An became such a good dancer that eight months later, when summing up his first year at OCC for an article in the school

An wore traditional Vietnamese attire at Asilomar's YMCA-YWCA
1958 Student-Faculty Conference. An is circled in row 5.

An attended a reception for international students at OCC.

paper, the *Barnacle*, An wrote that social dance class "relieves a high degree of my shyness because of difference of culture."[10] In his OCC yearbook, the *Log*, Roberta Seibel wrote, "You are a very good dancer. Stay as nice as you are." When I spoke with Judy Coleman, An's date for the following year's homecoming dance, she told me, "He was a fabulous dancer and we danced all night. He was so charming."

"I come from Vietnam," An told his new acquaintants. Some students recalled that a few months earlier President Ngo Dinh Diem had visited the United States, but few really knew about this faraway place, especially since the old French maps at school identified An's native land as part of French Indochina. Matters became even more awkward on the first day of journalism class when Mr. Maurice Gerard, An's counselor, introduced An to his fellow aspiring journalists. Pete Conaty, who would serve in Vietnam as a technical/strategic intelligence officer stationed north of Hue and became An's close friend at OCC, casually commented, "Oh, you are from that place of the big fight, Dien Bien Phu." An snapped back, "Dien Bien Phu is part of Vietnam! The French map on the wall is outdated. We need to get a new one!"[11] More than four decades later, An recalled this moment in an e-mail to another student and special friend, Lee Meyer, "Now I guess you would realize how I felt when the name of my country was not on the map, it was a colony of France."[12] His friend Ross Johnson recalled that An "presented himself as a very strong anti-colonialist."[13]

A few years later, An and Pete would be located a few hundred miles from each other in Vietnam, both working in the intelligence field if for different sides. When I told this to An, he appeared genuinely disappointed. "I did not know that Pete Conaty was here. I am very sorry he did not come to Saigon and visit me. I told all of them if they were ever in Saigon to look me up. He should have done

that." When I asked An whether he would have felt awkward hosting an intelligence officer, he said, "Not at all. We were good friends on the *Barnacle*. I could have introduced him to my friends like Bob Shaplen and those at *Time*. We were all journalists."

One of the striking aspects of An's time in California is the degree to which he embraced all aspects of collegiate life, literally soaking in American culture. While many spies adopt a low profile, An chose to engage life as part of his cover. He regularly attended football games and beach parties and was known as a practical joker. He would frequently lie in wait for his dorm mate Ross Johnson to take a shower. "In the rickety buildings, where plumbing was questionable, An would flush the toilet and burst out laughing as Johnson was doused with a blast of ice cold water. 'And he thought that was hilarious,' Johnson said. 'I liked him. No one ever suspected his secret life. I thought I knew him well.'"[14]

Just before Thanksgiving 1957, the *Barnacle* featured An's arrival on campus with a story accompanied by a photo of An in front of an English dictionary with the caption: "*How Do You Say That in English?*" The article laid the groundwork for his cover: "A new foreign student arrived at Orange Coast College Oct. 12 and is now living in a dormitory on campus. Pham Xuan An, his name, a Vietnamese, an Asian from the Far East. He hopes to finish school in two years at OCC and return to Saigon, his home city and work for his country as a newsman … An is now continually learning new things about his life in the dorms and in this country. This way he can find what he wishes to carry back to his homeland."[15]

An quickly settled into studies and student life at Orange Coast. For the Persian student production of *The Lady and Omar Khayyam*, An played a Siamese dancer, doing the "dragon in defense position," which the *Barnacle* described as "a self-inflicted judo dance."[16] He

An loved sailing off
Newport as well as
attending beach
parties and luaus.
PHAM XUAN AN
PERSONAL COLLECTION

especially enjoyed participating in the traditional campus luaus with pit-roasted pig, hula ensembles, and sword dancing performed by his Samoan friend, Tualua Tofili. One yearbook inscription from Paula Jacoby reveals An as the consummate gentleman: "I have enjoyed knowing you. I hope you are here next year and don't return to your country or home. Thanks for keeping me warm with your sweater at the Luau. See you next year. (Take care.) Love, Paula Jacoby."

The best part of An's day was spent in the *Barnacle* newsroom. He developed close friendships with Rosann Rhodes, Rich Martin, Pete Conaty, Ross Johnson, and Lee Meyer. He actually introduced Rosann and Rich to each other, and they were soon engaged. In 1961 Rosann Martin wrote to An in Saigon, expressing disappointment

that An could not be at their wedding, but she wanted An to know "your picture is posted in our wedding book under the title 'how we met.'"[17]

When I spoke with Rosann in October 2006, she told me that An was always "so pleasant and had a wonderful sense of humor." She then stunned me by saying, "He asked me to marry him. I recall the moment very clearly. We were in journalism class, and he came up to me and in a very formal way said, 'Rosann, I've become very fond of you this year. I'd like to marry you, but my concern is that you won't be happy in my country because it is so different. People only ride bicycles, they wear pajamas outside, and ducks hang in the windows. I want you to think about it, please.' I was shocked—we'd never been on a date. I told him the next day that I could not marry him, and so the next year he became my matchmaker by introducing me to Rich."

In addition to Rosann, An developed a special relationship with Lee Meyer. A year ahead of An at OCC and with one year's experience on the *Barnacle*, Lee had been a reporter at Pasadena High School and attended Pasadena City College before transferring to OCC. She also worked at both the *Sierra Madre News* and *Garden Grove Daily News*. An was immediately captivated by what he described as her "light blonde hair, intelligent blue eyes behind a pair of thick glasses, perspicacious mind with sound judgment and penetrating perception."[18]

In January 1958 Lee assumed the editorship of the *Barnacle*. An was promoted from feature writer to second page editor, meaning that he and Lee would work closely for the entire spring semester of 1958. An inserted an important detail into the *Barnacle* article announcing his promotion: "An Pham, foreign student from Viet nam, will take over the duties of second page editor. An previously worked in the capacity of feature writer for the *Barnacle* and as a

member of a news censorship board in his native land."[19] There is more than a touch of irony here because in 1976 An scoffed at the idea that he should work in just such a capacity for the new regime.

Lee and An were virtually inseparable that year. Lee invited An home for Thanksgiving and Christmas. Every holiday season since then, the Meyers sent a gift to the American Heart Association in the name of Pham Xuan An. "I guess you could not imagine how much I was moved by your kindness to make me feel at home while away from my home," An wrote to Lee.

An fell in love with Lee. "She knew how I felt," An told me. "I loved her. I could not tell her, but I know she smelled it." The only evidence we have of Lee's feelings are e-mail exchanges between the two in the year 2001, two years before she passed away. "I thought of you so often and wondered if you were safe and how I would ever know how you were," wrote Lee. "I am so glad to hear that your sense of humor is still very wry in your e-mail. Do you remember a night when you were visiting with us and I drove you back to those very spartan dorms at OCC and we were in fog so thick that we couldn't see the road and you had to get out of the car and walk along so I could follow you? For some reason I have such a clear, not foggy, memory of that. I admired you so much for your adaptability and being able to live in the dorms which were designed for immature types, not grown men. It was a truly enriching experience just being in school with a cultivated and gentle soul like yourself. For us to be good friends was an amazing gift to me."[20]

An blossomed as a reporter under Lee's guidance, and with Lee at the helm, the *Barnacle* received a first-class distinction in the Associated Collegiate Press honor rating.[21] Lee encouraged An to write stories comparing Vietnam with the United States so that OCC students could learn about his country and Vietnamese cul-

ture. An's first story under Lee's editorship, "Finals—A Couple of Views—Exams Rough for Students in Far Lands," compared the stress of exams for students in Vietnam with the sleep deprivation associated with students cramming for exams at OCC.[22] "Every year, at the beautiful blossom of flaming trees in Saigon, capital city of Vietnam, the students there talk about examinations," An wrote in a somewhat awkward style that he would soon improve. Students in Saigon coped with the stress of exams by drinking lots of coffee, special tea, and what An described as special "awakening pills" that were well-known in "France and its colonies."

The next month An wrote in defense of the English X requirement at OCC.[23] Drawing from his prior military and administrative experience on TRIM and CATO, An saw the basic conversational English requirement, often derided as a class for "dummies," as a formidable tool of American leadership. "Especially new independent countries in Asia, Africa and Middle East," wrote An. He explained that Vietnamese "are eager to learn English, and try hard to master it" but have a difficult time learning the language. "Any private school of English there pays at least $3 an hour to any American who agrees to give an English conversation class to intermediate students." An shared a personal story: "Once I was selecting Vietnamese officers graduating from the Vietnamese American Association to be sent to the United States. Col. Jameson stepped in my office and showed me a $7500 check and said, 'An, look at this check and see how much we pay the teachers of your students, and tell me please how many officers meet the required working English knowledge you give me?'" In fact, very few spoke as well as An because their teachers did not have the proper training to teach effectively. The "parrot method" of learning English left the Vietnamese officers dissatisfied and frustrated.

The Vietnamese had little opportunity to read American text-

books or meet professional teachers as was the case in OCC's English X class, where conversation and context was emphasized. An was going to recommend that English X be adopted by the United States Information Service (USIS) and other teaching agencies in Vietnam as the way of teaching English to the Vietnamese "because it helps Americans in Vietnam to fight the above prejudice as well as raising the prestige of American English."

The next month An wrote on diet aids and the disturbing fascination young women have with remaining slim. "Young ladies in Saigon, Vietnam, have a great concern about fat. Traditional conception of a beautiful girl in Asia is one as graceful as a weeping willow. The ideal physique is conceived as an assembly of bones which are as fragile as apricot branches, and the flesh shaped in the fabulous crane profile because the profile of this animal is gracefully clear-cut. Not only do these Saigonese reduce their weights by skipping meals or going on diets, but they also resort to dangerous devises such as vinegar and chemical acid products. Some of them become so thin and weak that if they came to Orange Coast to study, they would be blown back to Saigon by the Santa Ana wind."[24] An concluded with a strong endorsement for a healthy and balanced diet and urged students to join the "Calories Counter Club" under the supervision of OCC nurse Martha Buss.[25]

Perhaps An's most interesting contribution to the *Barnacle* was his review of the 1958 movie *The Quiet American*.[26] In it, Audie Murphy plays the American liberal idealist who has come to Indochina in 1952 to promote a "third way" between French colonialism and the Communist insurgency. Edward Lansdale is generally regarded as representing the movie's main character, Alden Pyle. Lansdale was an adviser to the film, which departs radically from Graham Greene's book. The film is dedicated to Ngo Dinh Diem. An must

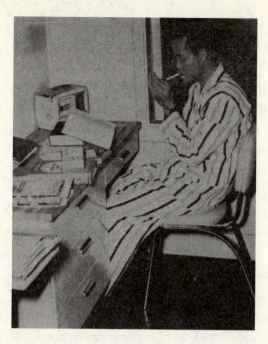

An considered his OCC dorm room luxurious compared to conditions back home. He loved listening to American music and news on the desktop radio.

JIM CARNETT, ORANGE COAST COLLEGE

have been walking a tightrope in some way here, writing about the film, thinking about his friend Lansdale, and probably worrying that something he wrote might be picked up as sympathetic to the Viet Cong cause.

The film blames the Communists for the Saigon bombings. "After the defeat of the French armed forces at Dien Bien Phu in July 1954," wrote An, "the existence and progress of the Free Republic of Viet-Nam under the leadership of current President Ngo Dinh Diem has proved that the conception of a 'Third Force' for which the 'Quiet America' died, should have been recognized earlier." An believed there could be no possible arrangement between Communists and the French, and "politically speaking, the 'Quiet American' may make the spectators misunderstand the meaning of United States foreign policy. A number of Vietnamese are imbued by Communist

propaganda and during the struggle for Indochina, the Americans tried to replace the French." An did not think the movie should be shown in Vietnam.[27]

The Quiet American was redone in 2002, starring Michael Caine and Brendan Fraser. Phillip Noyce, the Australian filmmaker, is much more faithful to Greene's novel, except for two major changes, one of which he identified as "the merging of two characters into one to create Fowler's assistant, Hinh (Tzi Ma)—inspired by famed double-agent General Pham Xuan An."[28] Hinh is depicted in the film as a deadly efficient assassin and nationalist spy masquerading as Caine's ever-invaluable assistant. The film premiered in Vietnam to rave reviews.

Perhaps An's most witty article of the year was about the dorm room of his good friend and *Barnacle* colleague Ross Johnson.[29] Ross's room was fashioned in tropical decor with a reed fence, palm leaves creating a thatched roof, and bamboo stalks on the walls. There were pictures on the walls of tigers and deer in the forest. In order to make the room even more authentic, Ross kept a small, downy chick. Tropical music played throughout the day. "I really feel homesick when I step in Ross' house," wrote An. Yet, there was one thing missing and that was a coed: "Ross, you have almost everything for your house, but you need someone particular to share this wonderful dream with you. I wish that Orange Coast regulations would be lenient for a week to let this particular one come and visit Ross' house."[30]

An was a good student, making the honor roll every semester and taking classes in history, political science, economics, psychology, and social science.[31] While at OCC, he was instrumental in establishing the new foreign student club that brought together students from Iran, the Philippines, China, Nicaragua, Japan, Belgium, France, Canada, and Poland.[32] He was one of nine students selected

to represent OCC at the World Affairs Seminar as part of World Affairs Day in Los Angeles. One of the topics debated that day was "Will communism win South-East Asia?"[33] He was one of six delegates from OCC's International Relations Club to attend the Long Beach Regional Organization of the International Relations Club on the theme "United States Investment in World Progress."[34] An also attended a journalism conference at the University of Redlands[35] and was part of the *Barnacle* delegation to the California National Publishers Convention in San Francisco.[36]

Somehow An also managed to get himself involved in campus student politics. He first turned down an offer to run for vice president on the ticket of the veteran's organization, comprised almost exclusively of Korean War veterans, who wanted an Asian anti-Communist on the ticket. He later cosigned, with five members of the *Barnacle* staff, including Pete Conaty and Ross Johnson, a letter to the entire associated student body titled, "New Blood Desired." This was an attempt to solicit a candidate to run against Fred Thomas for student body president. "We are interested in backing the right man for the job," the signers declared. The campaign was a success.[37]

OCC was a commuter college, and on weekends just about everyone went home or took off for anywhere other than campus. Bruce Nott lived briefly in the dorms and recalls that no one wanted An sitting around the dorms alone on the weekend. Bruce was one of the first to bring An home. His parents were immediately taken by An's charm, and for the next two years, Bruce's father would pick An up on a Saturday or Sunday, and they would go to the market and spend the rest of the day socializing at home. Bruce took An to Disneyland, and An visited Bruce's younger sister Barbara's school to speak about his home country. "He was a charming guy who loved to sit and talk and crack up laughing," recalled Nott. "He

wanted to know about everything, and he made us want to tell him everything about life in America."[38] In August 2005 I carried the following written message from An to Bruce: "I have missed you and your parents as well as Barbara, your sister. I am happy to learn that you are succeeding in your life. If we are lucky I'll see you and your family before going to see the Emperor of Hell."[39]

An loved to cook and enjoyed introducing his new friends to Vietnamese cuisine, so weekend evenings were often spent in someone's kitchen with Chef An. Bruce Nott recalls the pandemonium that would ensue when dorm residents saw An outside catching grasshoppers, because everyone knew he was about to bring a dozen or so inside and suggest cooking them up, as was done in Vietnam. "He was always bringing home bugs for people to eat, prefacing everything with a smile on his face, 'So who is hungry tonight?'"

Judy Coleman remembers An as a kind and warm person who fit right in on campus. They met in photography class, and An soon asked her to be his date for the 1958 homecoming dance. The guys in the dorms played a practical joke on An by telling him it was tradition to invite three or four girls to be your date for homecoming. Never one to buck tradition, An invited three different woman to the same dance. When his buddies told him it was a practical joke, he managed to extricate himself from everyone except Judy.

Ever the gentleman, An insisted on meeting Coleman's parents so that he could properly request permission to escort their daughter to the dance. Her father, Herbert Coleman, was then Alfred Hitchcock's first assistant director and associate producer and was completing the film *Vertigo*.[40] An visited their beautiful home to ask permission "the Vietnamese way," promising to have her home before midnight. Mr. Coleman assured him that because this was a special occasion, the curfew of midnight was unnecessary.[41] "No, I promise," said An. Judy remembers a grand evening filled with

laughs and dancing—and she was home before midnight. An did not see very much of Judy after the dance because she transferred to San Jose State University, but he became a frequent visitor to the Coleman home for barbecue and conversation with her parents. "My father really liked talking with An. He was just such an interesting and mature young man and so engaging. My dad and he spoke for hours," recalled Judy.

Not everything at OCC was fun and games. There was the night Henry Ledger tried taking his own life. After returning from a trip to the desert with his girlfriend, Ledger came to An's room and said, "Tonight we dine like kings because tomorrow we may die." An thought nothing of the remark, and together they feasted on a sumptuous chicken dinner, consuming more than either thought possible. It was not very late, but Ledger said he was going to sleep. While cleaning up, An noticed that the box of sleeping pills on Ledger's bureau was empty. In the past, Ledger had often offered An sleeping pills because An could hear Ledger snoring from his room next door. Now, based only on intuition, An thought Ledger had taken all those pills. His mind raced back to his words, "Tonight we dine like kings." An tried unsuccessfully to awaken Henry; then he called for an ambulance.

The next day An learned that his friend had been distressed over a breakup with his girlfriend and had indeed tried killing himself. Ledger survived the suicide attempt but was fired from his job. "I was shocked … a man in despair tries to take his own life and is fired. I did not understand," recalled An. An went to the administration to protest the firing but was told "I did not understand American culture; by trying to take his own life he was a bad example for students."

Ledger soon found work elsewhere as a janitor but did not tell An where he was living. Two weeks later An tracked him down at work. "An, I am angry with you; why didn't you let me die? You saved me

and now I suffer more," An recalled Ledger saying. One of Ledger's coworkers yelled at Ledger, "He saved your life—be grateful." The two men embraced and saw each other many times afterward.[42]

With his first year at OCC coming to an end, An drew a balance sheet of his gains and losses in a *Barnacle* story: "My working English was graded excellent at school in my country, but when I arrived at OCC I did not understand what my fellow students told one another. Now I enjoy what they say even though I do not catch all nuances, particularly their slang." His written English was much better because English X had improved his grammar and logic. English 1A was a very difficult class that "shook up my head and prevented me from sleeping many times. I continuously practice my English in journalism class. The *Barnacle* has the most freedom and is one of the best junior college papers in Southern California. It has taught me a great deal about journalism, my major subject.

"Besides these academic results, Orange Coast is the pilot place where I learned how to adjust myself to new culture, custom and way of living here. Here I have first chance to review what I heard and read about this new world in order to be more objective and to divert any kind of prejudice which unconsciously infiltrated the fold of my brain."

Yet An missed his country and family so much. "What I lost is not small. I miss my family, friends, relatives and countrymen as well as my native language and the small piece of land where I have been brought up. Fortunately, this loss is temporary. In addition, OCC faculty, staff, and students treat me so nice that sometimes I feel I am living among the Vietnamese."[43]

An was also very concerned about events back home. He had already received that letter from Mills Brandes and therefore knew that the government of Ngo Dinh Diem had initiated a massive crackdown against suspected Communist Viet Cong sympathizers

and agents. An wondered if any member of his family or friends had been caught up in one of these government sweeps and was now being tortured within the walls of Con Son prison. His greatest fear was that someone would give up his name as a Communist Party member. If that happened, he would never be able to return and his family could expect the worst from Diem's police. In January 1958 An's younger brother had been captured. "I was very sad," recalled An. "I had lost contact with the Communists, all my leaders were captured; my younger brother was captured, and after his release he wrote me a coded message."

His brother's letter was written in the ruse of a Tet New Year story. "Tet is coming and I don't have anything to talk to you about. Right now I know you like stories of the old days, and you like chatting about things of the sky and earth, so to make a contribution to happy days of Tet, I'll write you a story of the old days." What followed was the message in code: "Once upon a time, there was an old man who was really poor and endured many hardships. He raised two sons who liked to play in the jungle, but they also cut down trees and sold the wood in order to take care of their father. However, one day the two brothers went into the jungle and the younger one got caught by a monster while the elder escaped with the help of a dog and a parrot who showed him a way out of the jungle. The younger brother was now being held captive, likely to be eaten. The older brother was very sad. He missed his younger brother so much that he went back into the jungle with his dog and parrot. The parrot came back by itself."

An explained the coded message to me: "When I was about to go to America, I had a dog and a parrot. There was a guy who oversaw the intelligence unit I was in, and he had a little daughter. I told him to take the dog and the parrot home to his daughter because I was about to go to America." After reading his brother's story An

An with his 1949 Ford Mercury. "Henry Ledger checked it out and negotiated a good deal. It had low mileage," recalled An.

An's California driver's license; note his address at the OCC dorm.

thought to himself, "Oh shit, he got caught. I didn't know what to do. If I came back, then I will also get caught. But if I stay, then for how long?" An was uncertain enough about his future that he decided to study Spanish at OCC just in case there was a need to escape through South America or Cuba.

With these thoughts swirling in his head, An spent his first summer holiday driving up the coast to Monterey, where he visited friends from Vietnam at the Defense Language Institute Foreign Language Center, then called the Army Language School. The mission of the institute is to provide foreign language instruction in support of national security requirements.[44]

An had recently purchased a used 1949 dark blue Mercury for $250. Ross Johnson and Pete Conaty recalled that An followed precisely the manual instructions for starting a car by letting it idle and warm up for at least five minutes. "An would start the car and just sit there until he thought it was fully warmed up."

In the fall, An went back to work on the college paper. Lee Meyer had departed for USC, and the new editor was his dear friend Rosann Rhodes, who had been third-page editor under Lee and who was also employed by the Costa Mesa *Globe-Herald and Pilot*. Pete Conaty was promoted from sports editor to news editor, and Ross Johnson became the assistant feature editor. Rich Martin was sports editor, and An retained his second-page editor job.[45] This group would bond as friends and excel in journalism. Rhodes, Martin, and An attended an editors convention in Sacramento and were photographed with Governor Edmund G. Brown.

Aside from debate about whether or not men should be permitted to wear Bermuda shorts on campus, one of the hot-button issues of 1959 involved students cleaning up after themselves. For the first and only time in his association with the *Barnacle*, An sole-authored an editorial titled "Take That Trash."[46] An began his editorial

with the words of Napoleon before defeat, *"Après moi le deluge,"* explaining that "After me comes the deluge" had been the subject of a high-school-level final exam in Paris. "Many students flunked because they misunderstood the words of Napoleon," wrote An. They thought Napoleon selfish and not caring about what would happen to France after his death. "What Napoleon really meant was that he predicted the loss of the French empire after his death. He actually thought about the future of France and those who would come after him."[47]

OCC students were not thinking about who came after them at the cafeteria table. "The fact is that when they have their breakfast or lunch in the Student Center and snack bar, they leave an awful mess on the tables. They do not care who is going to eat there after them." An came to the defense of the three women who had been cleaning up this mess for the past fifteen months. "Some students take the attitude that they have created a job for these ladies, contributed to the solution of unemployment, made the economy grow up, and activated the flow of income by littering the tables. We think they are 'A' students of the school of rationalization and fallacy." An asked students to think about how they feel when they cannot find a clean place to sit and to compare that with the feeling of finding a nice clean table. Those coming after them deserved the same "privilege," and in order to achieve this An called on men to be "gallant" and clean up after dining with women and for women to be "considerate" and clean up after men. He concluded: "We have only four more weeks before the final. We don't wish to flunk this simple exam before facing the others which will be more difficult."

The final issue of the 1959 *Barnacle* contained a poignant farewell essay from An to his community. An had just received a gift from his friends at the *Barnacle*—a special coffee mug with a painted picture

With California governor Brown, Rosann Rhodes, and Rich Martin.
An was the matchmaker for Rosann and Rich.
PHAM XUAN AN PERSONAL COLLECTION

of An sitting at his desk typing a story, signed by the entire staff.
The mug was always prominently displayed on An's dining room
bureau, and when I visited the home in October 2006 to pay my
respects upon An's passing, the mug was the sole nonmilitary per-
sonal item on the family altar.

An's final article starts with a quotation from French writer
Anatole France: "'The most wishful departure leaves behind it
some melancholy. And I deeply share his feelings."[48] Saying good-
bye to his friends at OCC was so much harder for An than saying
hello. "Even though I am very anxious to go back to Viet-Nam to
see my motherland, the idea of leaving Orange Coast College, the
genesis of my studies in the United States has created a kind of
unexplainable 'melancholy' in my mind." An thanked the "debo-
nair" faculty for the help they had provided in his studies as well
as for caring about his health; he thanked the "warm ladies" who

worked the cafeteria and snack bar[49] and made his meals so appe-
tizing; he thanked the building and dorm staff for their kindness,
explaining that they were so cheerful "every day as I walk to the
mail box to check for letters from my dearest mother back home."
He thanked the "telephonists," who soothed him when there was
no letter from home. Most fondly, "my classmates and school-
mates have engraved my memory and filled my heart with their
friendliness." An was especially "sorrowful" about the news that
the old dormitories were being torn down the next year because
"the dormitories have replaced my mother's home. It is here that
I have learned how to apply 'The American Language' of H. L.
Menken, to enjoy the Hi-Fi, the Rock-n-roll, to do my homework
with the radio and the familiar heater noise, and to fill my lungs
with the air of humorous jokes of my dorm-mates . . . The hope of
seeing Orange Coast each year makes me dream of having wings
of migrating swallows which fly back to Orange Coast each spring
to build their nests under the roof of the Counseling Center. Here
is the place where I have received precious advice. Instead of say-
ing 'Good Bye,' I prefer to say 'Good Luck' and I hope to see
you all again and again." At the graduating honors banquet, An
received a special "service and leadership parchment" for his con-
tributions to OCC.

The Asia Foundation had arranged a scholarship for An, and he
was to begin an internship at the *Sacramento Bee* almost immediately
after graduating. The foundation wanted An to help develop a new
program in Saigon for training Vietnamese correspondents, and this
internship would provide him with both experience as well as cre-
dentials for that job. Before leaving for Sacramento he was given a
present by founding faculty member and school nurse Martha Buss.
It was a book, *Around the U.S.A. in 1,000 Pictures.*[50] Inside the front
cover she wrote: "Dear Pham: Hope you will always remember the

happy times at OCC. We have all learned to love and respect you. You are a good ambassador for your country. It should be proud of you. There are many pictures in this book of places you haven't seen and that is why I wanted you to enjoy this and come back to see the rest of the USA. It has been such a pleasure to know you." "I always kept that book," An told me, "hoping one day to come back and see the other places. So much to see and I had no time during my mission."

As he packed his car for the drive to Sacramento, An was notified that there was going to be a change in the place he was to be residing. This was the only time during the entire trip he encountered racism. The couple who had agreed to provide housing had not known he was "Mongolian," and he was no longer welcome in their home. The *Bee* and the Asia Foundation worked together and quickly found him new accommodations.

At the *Bee* he became friends with Eleanor McClatchy, daughter of publisher C. K. McClatchy. In July he was her special guest at the Sacramento airport to meet Soviet first deputy premier Frol R. Kozlov and his friendship delegation, who were traveling across the country in advance of Nikita Khrushchev's historic visit to the United States. The governor and a group of state officials and VIPs like McClatchy were invited to the airport to meet the Russian goodwill party.[51]

An's first assignment at the *Bee* was to cover the Sacramento County Fair. It is rather unusual for interns to get their own byline, but that is what happened in the June 20, 1959, *Sacramento Bee*, which carried An's first story, with an inset biographical sketch: "Pham Xuan An of Saigon, South Viet-Nam, is in Sacramento for a three month period of observation and study of the *Bee*. The on the job training for the student of journalism is sponsored by the Asia Foundation. Upon completion of the training and a tour of the east-

ern United States, he will return to Saigon to seek employment on a newspaper. His story on the county fair, an American institution, is printed below."[52]

The Sacramento County Fair of 1959 is the first county fair I have ever seen in the United States.

The high quality of the agricultural products, beef and dairy cattle, poultry, rabbits, swine, horses, and sheep does not surprise me because they are well known over all the world through books, magazines and movies.

The strong impression I have is that this livestock is raised by youngsters between 12 and 20 years of age. They certainly will be successful "future" farmers of America.

These healthy and good looking boys and girls who sit and lean against their cows or sheep remind me of the buffalo boys in Viet-Nam who graze their favorite companions of work after a long day of labor on rice fields.

The songs of big Rhode Island roosters, high temperatures and busy fairgoers are not all unfamiliar. In summer time back home we add to the scene the strutting of fighting cocks in the arena...

Entertainment is the best means to attract a crowd. As I have visited Disneyland, a ghost town, Santa Cruz, and Marineland, these entertainments are pretty familiar to me.

However, these famous places have not shown me the dynamic and talented youth of California as has the Sacramento County Fair.

A week later the *Bee* did an in-depth feature about An with the title "Vietnam Journalist Aims to Fight Red Propaganda."[53] "I used everything Lansdale taught me for this article. He was an excellent teacher," recalled An. The article is reprinted below.

Member of a family of four, Pham was employed by the psychological warfare department of Vietnam during the 1954 campaign against the Communist military attack which divided the country.

He explains the success of the campaign by the fact the Red leaders never preached open Communism at the time, but branded their movement as a nationalist fight against the French who still were ruling Indochina.

This fact made him decide, he said, that the best way to help his country would be to become a journalist so he could explain to the public the real goals and methods of Communism.

He said the Vietnamese government now maintains a tight censorship on all newspapers as a matter of necessity because otherwise the Reds would have a field day in spreading their ideas throughout the country.

There are nine daily newspapers in Saigon, the country's capital. Among them are six Vietnamese publications, one French, one English, and one Chinese.

All have a rather small circulation, he said, because few people can afford to buy them everyday. But, he added, it is common practice to rent or swap newspapers.

"Our people are very poor," he concluded, "but they are eager to learn, from the students to the rickshaw men."

He said he plans to join the staff of one of the Vietnamese dailies when he returns to Saigon.

The article turned An into something of a local celebrity. One woman called the *Bee* and offered to take him to Lake Tahoe. They stopped first at Travis Air Force Base where her son was stationed

for a quick hello, allowing An a look at his first USAF base (no strategic implications but just so ironic), and they then sped up Route 50 in her red sports car—going to Squaw Valley for a summer gondola ride.

An's assignments for the *Bee* included covering court cases, the rodeo, the fish hatchery, and Folsom Prison, where he ate with inmates and perused the prison library. An was fascinated by rice-growing techniques in Sacramento, the mechanized method was so different from Vietnam. He was in awe of the levee system in the Sacramento delta and marveled at the crop planes flying over fields and dropping seeds. When he left the *Bee*, Eleanor McClatchy presented him with her father's book, *Private Things*, with the inscription, "To Pham Xuan An, we were delighted to have had you with us at the *Bee* and hope you visit us again."

Next up for An was an internship at the United Nations, also arranged for him by the Asia Foundation. However, when An learned that the foundation expected him to fly from California to New York, he immediately drove from Sacramento to their San Francisco headquarters and convinced his sponsors to allow him to drive across the United States. He asked that the price of the plane ticket be given to him in cash to defray costs. After some wrangling over the dangers of driving alone across the United States, the foundation acquiesced to An's wishes, so long as he promised not to pick up any hitchhikers!

With Mrs. Buss's gift on the empty seat beside him, An began his journey across America. He explained to me that the trip would help his mission of learning all he could about the American people. He woke early and drove until dusk each day, but stopped at virtually all tourist points. Taking the midcountry route, he crossed Nevada, Utah, Wyoming, Nebraska, Iowa, Illinois, Indiana, Ohio (where

UNITED NATIONS
TEMPORARY PRESS PASS

FOR Pham An

OF Sacramento Bee

VALID FROM 14 Sept. 59 TO 30 Sept. 59

David J. Exley.

BMS.80C (6-59) AUTHORIZED SIGNATURE

An interned at the United Nations under the auspices
of the *Sacramento Bee*. PHAM XUAN AN PERSONAL
COLLECTION

he stayed with Mills Brandes's parents in Huron), Pennsylvania,
Maryland, New Jersey, New York, finally arriving in Buffalo, so
that he could attend a summer camp for Vietnamese students orga-
nized by Catholic priests from the International Voluntary Service
(IVS).[54] An even crossed the border into Canada in order to appre-
ciate the better view of the Niagara Falls.

When I asked An what he learned from the trip, he said how
impressed he was by "the fresh system, so unlike Vietnam....
everything was completely new to me. I had so much to absorb.
Most of all, the people were friendly and helpful, and I admired the
American independence of thought and speech. I learned a new way
of thinking in America, and I could never get it out of me, even
when they tried to do that after the war."

An then told me a story that he hoped would illustrate for me how
much his friendships with Americans meant to him. One day during
his time in California, he fell asleep on a bus ride from Monterey to
Costa Mesa and missed his stop. It was very late at night, and the bus

driver told An he could not turn back. An would have to wait for the next bus, which was not coming until the morning. A young woman overheard the conversation and felt sorry for An. She got off with him in order to call a family friend to drive An back to Costa Mesa. They first had to find a phone booth, and it took almost two hours for the family friend to arrive. The young lady waited the entire time with An. She was from Stanford, the daughter of a Colonel Thorton, recalled An. The family friend who came to pick An up was a Mr. Mendenhall, who lived in Laguna Beach. Mendenhall drove An back to the dorm, mentioning during the ride that he had a son in the air force. A few weeks later the Mendenhalls invited An to dinner at their home. An recalls that the family were big supporters of Richard Nixon, displaying an autographed photo of the vice-president on the wall of their living room. During dinner An learned that their son was stationed at military headquarters in Saigon. The Mendenhalls wanted An to meet their son when he returned to Saigon. "As a spy I considered exploiting this and could have, but chose not to and never said a word to my superiors about this. I remained silent because it would not be fair for me to take advantage of someone when their friend's daughter, a true angel, had saved me that evening. I was alone and cold, and who knows what could have happened to me, but she came to my rescue and protected me."

An drove from Buffalo to Arlington, Virginia, for a reunion with the Brandes family, staying at their home on South Joyce Street. Mills took An into Washington for a tour of the FBI building, Congress, and then Arlington National Cemetery. For downtime, An spent mornings watching television with Jud, especially quiz shows and westerns. An's favorites were *Dough Re Mi*, *Treasure Hunt*, *The Price Is Right*, *Concentration*, *Tic Tac Dough*,

Beat the Clock, Maverick, Wagon Train, Gunsmoke, and *Have Gun Will Travel.*[55]

An then drove to New York for his internship at the United Nations, arriving in time to see Soviet chairman Nikita Khrushchev address the U.N. General Assembly. He was immersed in his internship when he learned that Hanoi's Third Congress of the Fifteenth Plenum had issued Resolution 15, the start of guerrilla warfare in South Vietnam. "When I learned that the Communists were resuming war, I knew I must return home."[56]

The character of the war inside Vietnam was now in transition. That summer a terrorist attack at the South Vietnam Army Training Center in Bien Hoa on the fifth anniversary of President Diem coming to power in Vietnam resulted in the first American casualties of the war.[57] The attack was the most daring undertaken by Communists since 1957 when the United States Information Service (USIS) library building was bombed in Saigon.[58]

An sold his car in New York and flew back to California for meetings at the Asia Foundation in order to prepare for his return to Vietnam. The foundation made him an attractive offer: He could take a job with an excellent salary with the United States Information Agency in a program that would also allow him to get a PhD on a full scholarship, or he could teach Vietnamese at the language school in Monterey to the American advisers departing for Vietnam.

An went directly from the Asia Foundation offices to the Golden Gate Bridge overlook to contemplate his options. He carried with him a postcard from Lee Meyer, with a picture of Alcatraz on the front. Ever superstitious, An believed the card could be a harbinger of his future if he returned to Vietnam. Con Son Island was Alcatraz. He also wondered if the card might be a signal that he was

to stay in California and be close to Lee. He had received no instructions to return home.

At this important crossroads, An decided that he could best serve his country by returning to Vietnam. "I was worried about my family, my leaders, and my mission. I had given my word to the party. I was thirty-two years old already. I knew sooner or later I must return. I had people depending on me and my mission."

Chapter 4

THE EMERGENCE OF A DUAL LIFE

This document proves that the hard core VC have the professional ability to make detailed plans.... This should dispel the thinking of some who tend to regard the VC as an illiterate, backward rice-growing farmer.

—Covering memo to Viet Cong After Action
Report on Ap Bac battle, January 2, 1963[1]

ON RETURNING TO SAIGON IN LATE September 1959 after two years in the United States, An's greatest fear was getting off the plane and being taken away, never to be heard from again. An arranged for his entire family to greet him at the airport, figuring that if he was going to get arrested, it was best to have witnesses. "With my family at the airport, at least my mother would know if I disappeared," An told me. So many of his compatriots were already in prison. An had no idea if one of them had given up his name as a party member. Most unnerving was that his direct supervisor, Muoi Huong, had been arrested in 1958 and was still languishing in Chin Ham Prison. Muoi Huong was the founder of the Communist

strategic intelligence network in the south. He had recruited An into the network and sent him on his mission to the United States.

As family members milled about, An looked around for police, but no one stepped forward to make an arrest. An was so unsure of the situation that he remained at home for a month, fearing that if he ventured outside alone, he could be arrested. Spending most days looking out the window for signs of surveillance, An soon devised a simple yet carefully conceived plan to test the waters. He sent a message to Dr. Tran Kim Tuyen, the man who had helped him two years earlier with his visa problems and who was still closely aligned with Diem's brother Ngo Dinh Nhu: "I have returned from my journalism studies in the United States and need a job. Is anything available?" By An's calculation, if he was going to be arrested, Dr. Tuyen would never offer him a job since Tuyen was the person who kept the list of Viet Cong.

A tiny man weighing less than a hundred pounds, Tuyen "projected the quiet and shy air of the Confucian scholar," wrote William Colby.[2] Beneath the surface, however, Tuyen was a fierce anti-Communist and master schemer and coup plotter. Tuyen had studied but never practiced medicine, yet his power was so great everyone addressed him as "Bac Si," or Dr. Tuyen. He trusted only a few loyal anti-Communist friends within his organization.[3]

Dr. Tuyen saw much value in having the American college-educated An working for the Diem government. He assigned An to a staff position within the presidential office where he would have access to the files of the army, the National Assembly, and virtually every organization within South Vietnam. But Tuyen soon found a more important use for his new protégé, who had asked Tuyen for an assignment in which he could make use of his journalism skills. Tuyen sent An to meet Nguyen Thai, Director General of Vietnam Press, the regime's official press organ. Of the thousands

of news items provided every day by major international news agencies, Vietnam Press selected what was politically fit for translation into Vietnamese and published it as the official viewpoint of the Diem government. "Thus Vietnam Press acted as the censor of international news selected for local consumption," explained Thai. "Vietnam Press bulletins were used in all broadcasts by the government national radio network."

Like An, Thai had studied in the United States, which is where he first met Ngo Dinh Diem in June 1952 at a conference for Catholic students. Thai was president of the Association of Catholic Students in America and after their meeting, Diem frequently corresponded with him, offering his analysis of the political situation in Vietnam and assessing his own chances of coming to power. Thai later visited Diem at the Maryknoll Monastery in Lakewood, New Jersey, and arranged for Diem to give a visiting lecture at Cornell University's Southeast Asia program. When Diem returned to Saigon in June 1954, he cabled Thai at Michigan State University, asking him to return to Vietnam and assist him in building an independent south. Thai soon became the first publisher and editor of *The Times of Vietnam*, and in May 1957 Diem appointed him Director General of Vietnam Press.

In his position, Thai was privy to the secrets of the Diem government. "Almost every day, I was asked often by the President himself directly to watch for this special news item and to 'play it' this or that way because of some special policy reason. Information was power, and it had to be manipulated by those who monopolized it." One of the people seeking control of information was Dr. Tuyen. "It was not unusual for me to hear from Tuyen that such a politically important trial at the Saigon tribunal would result in this kind of sentence to be given by the judge or that on such date there would be such an incident (public demonstration or ransacking of an opposition

...paper or an election) and that it would be 'appropriate' for Vietnam Press to publish the news involved this way or that way, as required by the interests of the Diem regime," recalled Thai.[4]

Tuyen wanted An inside Vietnam Press so that he could keep tabs on Nguyen Thai, but Nguyen Thai also wanted An working for him: "He was the first Vietnam Press employee who had U.S. journalism training and who was fluent in English. Besides, I needed a reporter who could cover the president's office and this was a very sensitive assignment. I also found An to be very well informed and very well connected," recalled Thai. "It seemed that he knew everybody of importance in South Vietnam, yet he did not brag about it. His wit and sense of humor were also very likable. An was the darling of international journalists in Saigon, who all spoke very highly of him and were ready to vouch for An as a great South Vietnamese. He did not stay very long because he got much better job offers from foreign news agencies and newspapers. They all appreciated his encyclopedic knowledge of Vietnamese politics and the scope of his local contacts."

While working at Vietnam Press, An demonstrated the type of "professionalism" he insisted characterized his entire career. Dr. Tuyen had a scheme to use Vietnam Press as a cover for his own secret agents going overseas. He instructed Thai to teach the agents a few things about journalism before they were sent on espionage assignments to New Delhi, Djakarta, and Cairo. Thai vehemently objected, but Tuyen told him it was Nhu's order, so he had no choice. Thai decided that An would be the one to teach Tuyen's agents. Not only had he just returned from journalism school, but he was on better terms with Tuyen.

When An saw that Tuyen's men were not taking his classroom training seriously, he went directly to Tuyen: "Look, I refuse to teach them unless you order them to understand how important

One of An's many
press cards.
PHAM XUAN
AN PERSONAL
COLLECTION

having a cover is because they will be caught immediately unless
they learn this trade" is how An recalled his argument. "They need
to pay attention to detail, know how to file a story, interview, and
develop sources. If they do not learn this job, they will be caught
and you will be embarrassed." The agents returned to Vietnam
Press with orders from Tuyen to take their journalism training seri-
ously. Pham Xuan An, himself an undercover Communist spy, was
now preparing Dr. Tuyen's anti-Communist agents for their cover.
In Vietnam, nothing was ever as it seemed to be.

As Thai predicted, An did not stay too long at Vietnam Press,
moving to the British news agency Reuters as a stringer, work-
ing for Australian correspondent Peter Smark, whose offices had
been located inside Vietnam Press. "Peter Smark really understood
Vietnam. You need to read his articles," said An in a tone indicating

Thu Nhan between Reuters colleagues Nick Turner and Peter Smark. PHAM XUAN AN PERSONAL COLLECTION

there was more for us to discuss once I had done more reading. That evening I searched the Web for Smark's writings and came across an article titled *"Death and Vomit: The Real Meaning of War"*[5] written in 1990, but recalling his 1961 experiences in Vietnam. It became clear to me why An wanted me to know more about Smark: "We came to the hamlet near My Tho through fields green as limes. On the banks of the paddy-fields, palm trees nodded amiably. Under a fierce, noonday sun, three little girls chirped like crickets and giggled behind their hands at the heavy, awkward foreigners blundering into their world. Tossed like garbage on the clay were the bodies. I remember the number and will never forget, 82. The battle had been the previous day and the flies were already at work. I expected the blood, the grey horror of exposed entrails, the stench. But I hadn't prepared myself for the flies. I don't know why I hadn't thought about the flies. Or the rats. And so, at the age of 24, I discovered what war means ... As I sweated and vomited that day in

1961, a maelstrom of unconnected thoughts churned through my mind...," wrote Smark.

When I returned to An's home the next day, I showed An the article. "I spoke with him when he came back from My Tho. He knew what the war was doing to the country and was interested in the new counterinsurgency program. He was one of the first to see that it was going to become a big war. We became very close friends. He was at my wedding. I gave him some valuable tips," said An.

So, within a year of having returned from the United States, An had already aligned himself with Dr. Tuyen, worked in a staff capacity within the presidential office, befriended Nguyen Thai at Vietnam Press, and moved on to a job with Reuters. New Zealander Nick Turner, who replaced Smark as Reuters bureau chief in May 1962, later wrote: "Another advantage I had was my Vietnamese assistant, Pham Xuan An. We all relied heavily on our Vietnamese assistants, as translators and as interpreters of Vietnamese politics and the developing military struggle. My man was regarded as the best in Saigon, very well informed and shrewd. He was my intelligence officer. It later turned out he was also an intelligence officer for the Viet Cong, with the rank of colonel. Working for Reuters gave him a perfect cover to move around and pick up information."[6]

Indeed, An's work as a strategic intelligence agent was about to begin. He would use all of his connections with prominent anti-Communists as well as all the social skills he had acquired at OCC to gain access to documents and briefings that would provide the keys to countering the new American tactics in Vietnam.

VIETNAM HAD NO TRAINING academy for spies, and as odd as it seems, An attributed much of his preparation for espionage work to a book published in 1963, *Anatomy of Spying: The Spy and His*

Techniques from Ancient Rome to the U-2, given to him, said An, by the young Saigon correspondent David Halberstam so that An could improve his reporting skills.[7] An pulled his copy of the book from his library and showed me the key sections, beginning with Russian superspy Richard Sorge, an accredited correspondent for four newspapers while working under cover in Japan between 1933 and 1942. Sorge's cover gave him access to the German embassy, where he established valuable relationships with successive German ambassadors who became crucial sources for his information. "This is important," An told me. "But even more important is Sorge slipped up, was captured, and hanged by the Japanese. That was the fate I always feared for myself." On November 5, 1964, Richard Sorge was posthumously awarded the honorary title of Hero of the Soviet Union.

"My profession has two taboos," An told his Vietnamese biographer. "If you're captured, and you cannot escape you must consider yourself to be dead. The thing that must be protected is not your body. You have to consider that you are already dead, but you cannot disclose your sources. You do not confess; that is a given. Naturally you can admit the things that the enemy already knows, but it is vital that you must protect the people who supplied your information at all costs. The second thing is that whatever you have collected must be completely and totally concealed."[8]

An's copy of the book was heavily marked in the section on meetings with couriers. "For reasons of security, it is normally considered safer for contact to be made in a public place in the presence of a number of people. Two men meeting in an unfrequented place are more easily observed to meet, and if either of them has been compromised, the other is automatically so. In the crowded place—a bar, a theatre, a sports meeting, a main-line railway terminal—contact can be easily made without it being obvious to anyone. The

message can be passed either way by a variety of means without the two men speaking to one another."[9] Another section provides information on invisible ink and other masking techniques.

An chose to disguise his film rolls by placing them underneath egg rolls or *nem chua* (raw meat wrapped in banana leaves), but other agents adopted different methods. "We would buy a pair of sandals, peel the outer sole off, and then use a knife to cut a hole in the soft cushion padding in the sole of the sandal," recalled the son of agent Ba Quoc, another intelligence officer promoted to Hero. "The negatives would be cut into individual sections, concealed in the padding, and then we would glue the sandal back together ... a pair of sandals could hold one half of a roll of negatives. The other half roll would be cut, rolled up very small, and concealed inside a child's toy." Everything would then be placed inside a bag made of yellow oilpaper which was actually invisible ink reports and summaries of other documents that could not be photographed. "We used these pieces of paper to wrap packages or pasted them together to make a bag to carry things in ... so that everything, both the container and its contents, contained reports. My father would place the bag inside the storage compartment of his Vespa motorcycle and drive out to give it to a Saigon City courier."[10]

The constant danger for any agent was that a messenger would be captured with documents that would then be sent to the Combined Document Exploitation Center (CDEC), where an astute translator might trace the source. "Documents are not just secret reports; documents are the spy himself. If you lose the documents, you have also lost the spy."[11] Before October 1965, document analysis (referred to as "exploitation") was primarily handled by the South Vietnamese military. An recalled that there was one time when a contact inside that organization showed him a captured enemy document providing a summary of his own report on counterinsurgency and ARVN

strategy. "I went crazy and went to the jungle and told them to be careful how they summarized things, especially since this was something I wrote in 1961 and I knew it was mine; it was old but traceable."

An always referred to himself as a lone wolf agent because no one supervised his day-to-day activities. An was what is known within the U.S. intelligence community as a singleton operating within a denied area operation.[12] The situation was so dangerous that direct contact was not permitted; everything would be initiated by An. He did have a series of direct supervisors, beginning with Muoi Huong.[13] If there was something COSVN specifically needed, An would receive this request via coded message from Ba or she would try to catch An's attention when he dropped his children off at school.

"I was strategic intelligence, not political intelligence, where they work on things like organizing groups for coups and things like political espionage," An always insisted. "I was a student of Sherman Kent, and my job was to explain and analyze information." Kent had written one of the first books to systematically address the topic of intelligence analysis, *Strategic Intelligence for American World Policy*.[14] An learned about Kent from Lansdale as well as from his CIO colleagues when they returned from training sessions run by the CIA in which the core reading was Kent.

In the aftermath of Richard Nixon's historic visit to China in February 1972, an important shift occurred in An's modus operandi. "I had to change everything after the Nixon visit because there were too many Chinese agents operating in Vietnam. It was too dangerous for anything except reports, so I had to spend even more time reading and analyzing documents and then type long reports. Only one time in 1974 did I make an exception, but the Americans were gone by then. I told my superiors that I was an analyst, and if they wanted documents then the espionage people should do that; they

had plenty of ways to get documents but not from me anymore. There was just too much of a chance getting caught with the documents going home and then back."

An told me that *Anatomy of Spying* prepared him for a life of loneliness and demonstrated the importance of self-control and mental discipline: "The spy is a lonely man. The very nature of his activities makes it impossible for him to reveal himself, for in doing so he may indirectly reveal his intentions . . . he shall be in complete control of himself and able to subject his instincts and reactions to strict self-discipline."[15]

The book also instilled fear, a haunting sense that at any moment his mission would be over and his life snuffed out: "In war or in peace—though particularly in the former—he will be hedged about with enemies. Every man's hand is against him; a fleeting second of self-revelation will be sufficient to launch them into the attack against him. The spy knows this. From the beginning he has been aware of the vengeance with which his enemies will exact if they catch him. The danger to his life or, even if his life is spared (should his captors be among those who are prepared to resort to torture to wring information from him), the danger to his limbs by mutilations are risks which are constantly in the forefront of his thoughts."

"The lucky spy is the one not yet caught" is how An always described his situation. An had several close calls, but he remembered two in particular. The first was early in his career when he had just returned from the United States and was working for Dr. Tuyen. At the time, Big Minh was a lieutenant colonel in the ARVN 3rd Division and An recommended a WAC (Women's Army Corps) for a position in Tuyen's office. Unbeknownst to An, she was already working secretly for the Front in Big Minh's office, and now, on An's recommendation, she was in Tuyen's office. Military security asked Tuyen who recommended her for the job. When con-

fronted, An immediately answered, "How did I know she was VC? I'm not married, she was pretty and could type, so I offered her a job. I know nothing else." An stopped the story and turned to page thirty of *Anatomy of Spying*, "a prompt course of action or a ready remark, both almost spontaneous in commission, can often extricate him from danger." With satisfaction, An poured us more tea and said, "You see, nothing is too small to analyze and apply in my job. I hope you write it that way too."

An had another close call where quick thinking contained a potentially disastrous situation. After his children were asleep, and with his German shepherd and often his wife standing guard, An usually prepared his reports and film for rendezvous with Ba. One morning An overheard his daughter telling her brother that she awoke in the middle of the night and saw their father writing with a special ink and the letters disappeared. An was aghast. He had not heard her, his wife had been asleep, and the dog did not consider her an intruder, so it took no notice of her presence.

An worried that his daughter might go to school and tell her friends about this special ink. So he devised a plan to trick her. That evening, he awakened her with a light placed directly in front of her eyes. He then asked her to look at a page of writing done in regular ink. She, of course, could see nothing for a few minutes as her eyes adjusted, and then she could see the ink. "You see, that is what happened last night when you awoke in the middle of the night and saw me writing. You walked from the dark room into my light and only thought you saw no writing. Your eyes played a trick on you and since you were tired, you forgot all of that." She never said another word about the special ink. An's son An Pham later told me that he was a very light sleeper and often saw his father working late at night, but thought nothing of it.

An always emphasized the role of luck in the spying. He regularly

An's car being off loaded after he visited the 17th parallel. The car is on display with Tu Cang's pistols in a military museum in Hanoi. PHAM XUAN AN PERSONAL COLLECTION

consulted an astrologer and would not travel if advised of ill tidings. An even considered his automobile license "NBC 253" unlucky because the numbers totaled ten, very unlucky in Vietnamese numerology. "I remember when Madame Nhu outlawed gambling and we would sit on the corner, betting on car license plate numbers as they came around the corner. No one wanted to sit near my car because it was an unlucky number."

The role of luck is perhaps best illustrated in the case of Ba Quoc, identified in party documents as Major General Dang Tran Duc. Working for Intelligence Group H.67 under the direct guidance of COSVN, Ba Quoc operated for over twenty years inside South Vietnam, but unlike An's, his cover was eventually compromised. "His case shows you how lucky I was and how dangerous all of our lives were during this time," said An.

Ba Quoc was exposed purely by chance. He had already met his longtime courier, Bay Anh (who worked exclusively for Ba Quoc from 1966 to 1974), in a public market and passed on dozens of film canisters, but on this particular day, the documents were transferred from Bay Anh to a young female courier whose job was to bring them to Cu Chi. It was this courier's bad luck that police stopped the public bus to Cu Chi looking for someone else, but decided to detain everyone to make sure there were no other Viet Cong on the bus. The police found the documents in her satchel, and within days their investigation led them to Ba Quoc, who managed to escape into the jungle before the police arrived at his home. "It was chance only. This was the kind of thing I always feared," said An. "Maybe a courier is captured and one day I am exposed, and they come for me at *Time* or even worse, where there are no witnesses, and I would be tortured before being killed."

When working on stories for *Time*, An relied solely on materials other reporters had access to—captured enemy documents, wire service stories, and newspaper accounts, plus his well-placed sources. This meant that he held back on providing everything he knew when writing for *Time*. On the other hand, in his job as a strategic intelligence agent, An relied on the documents obtained from his many contacts in the Vietnamese CIO, ARVN, the National Assembly, and his contacts in the U.S., French, and Chinese intelligence communities. "I used the documents my CIO contacts gave me for my reports to the jungle," An explained to me. "The danger of slipping up and getting caught was great, and I needed to be vigilant in making sure that I did not use my real knowledge in the newspapers."

Working as a correspondent provided cross-training for his assignment in strategic intelligence because part of a good reporter's job is sorting fact from rumor. An saw many similarities between the two professions. "The only difference is who reads your final

report," he said. In *Anatomy of Spying* he had underlined "successful espionage is derived from the piecing together of tiny items of information which, taken by themselves, appear to be unimportant, but which, when placed with dozens of other snippets, build up the picture from which commanders plan." The book is also heavily underlined on the topic of selecting a cover: "Indeed, the cover work which the spy adopts is as important to him as his cover story. Ideally it will bring him into direct contact with the source of the information he is seeking; but if this is not possible, then it must provide him with time and opportunities for making indirect contacts." This demonstrates why An believed it was critical for Dr. Tuyen's spies to appreciate their cover: "If you view cover as just a fake profession, a profession at which one is not really proficient, a job that one does not truly perform, then you are dead, as if you had no cover."

An was not only skilled at analysis of the data; he was also skilled at synthesizing books like Roger Trinquier's *Modern Warfare: A French View of Counterinsurgency* (1961), a handbook for dealing with revolutionary warfare's tactics directed at overthrowing a regime.[16] He also regularly consulted the 1940 publication *Roots of Strategy: The 5 Greatest Military Classics of All Time*, edited by Brigadier General T. R. Phillips. This collection of the most influential military classics prior to the nineteenth century included *The Art of War* by Sun Tzu; *The Military Institutions of the Romans* by Vegetius; *My Reveries Upon the Art of War* by Marshal Maurice de Saxe; *The Instruction of Frederick the Great for His Generals*; and *The Military Maxims of Napoleon*.

Taking his crumbling copy from a shelf in his library, An drew my attention to the entries of Sun Tzu and Maurice de Saxe. Opening to the section from Sun Tzu, An asked me to read the following excerpt: "In making tactical dispositions, the highest pitch you can

An with a mustache. Frank McCulloch's picture is posted on the bulletin board on the left, with his likeness to the Venerable Thich Tri Quang posted above. PHAM XUAN AN PERSONAL COLLECTION, WITH PERMISSION OF LE MINH AND TED THAI

attain is to conceal them; conceal your dispositions and you will be safe from the prying of the subtlest of spies, from the machinations of the wisest brains. How victory may be produced for them out of the enemy's own tactics—that is what the multitude cannot comprehend. All men can see these tactics whereby I conquer, but what none can see is the strategy out of which victory is evolved....he who can modify his tactics in relation to his opponent and thereby succeed in winning, may be called a heaven-born captain."[17]

Prior to the large American buildup in the area surrounding Cu Chi, An would often go to the VC base to discuss his reports and receive new assignments. An adopted a strange modus operandi for these trips. He grew a mustache and allowed his hair to get a bit longer in an effort to disguise his identity and provide a cover for his absence. He told colleagues at *Time* that the "professor of sex-

ology" was leaving for a three-day holiday in Hue, where women fancied the "hippy-artist" look.

"The mustache was something I learned from the CIO, not to grow it but to be aware of CIO techniques for finding VC," An explained to me. "CIO agents always went to Cu Chi to interview local people, asking if they saw anyone new in the area. If I had been spotted, the description would not fit me, since the CIO guy would be writing down to look for someone with a mustache. No one knew my name out there, so it was only a description." What if someone in Saigon remembered he had grown a mustache, I asked. He laughed and said that by the time the CIO got that information to Saigon and asked about someone fitting the description, he would have long returned from Hue and no one would give it a thought, but if they did he would have said, "What are you talking about? I have no mustache. Look, do you see one? I was in Hue looking for pretty girls, not Cu Chi looking for VC. Then I would just tell them to go ask Ky—he had a mustache, maybe it was him in Cu Chi!" This was an alibi he never needed to use.

When I asked An what would happen if he was spotted in Cu Chi by a CIO agent, he answered, "Then I would be dead." When I later read William Prochnau's description of An, I realized just how effective this cover must have been. "An could cut red tape, roust out information, and talk poetry and philosophy as well as run a story to ground on deadline. Having a good Vietnamese aide was crucial, and An was the best, even when he disappeared for a few days, obvious to all that he had a secret love stashed somewhere."[18] What remains a mystery to me is how so many people seemed to have noticed An's periodic disappearances, yet he was never caught by any of the police or security forces that were constantly looking for people like An. Perhaps he was just extremely lucky, or maybe

An's cover story as a dog trainer, rare bird collector, or even as a lover was enough to keep people off his trail. Or maybe he had friends protecting him, perhaps other agents who had infiltrated the police or perhaps friends on the other side who valued him as well. We'll never know, and the more questions asked, the deeper the mystery.

THE INSURGENCY IN THE SOUTH increased in intensity. The number of small-unit guerrilla attacks on government posts and watchtowers averaged over a hundred a month in the last half of 1959.[19] Assassinations of government officials, police, and village notables had more than doubled. Kidnappings had reached an all-time high. In parts of the Mekong Delta and the Central Highlands there were numerous "spontaneous uprisings" in uncontested hamlets and villages. Riots and mass demonstrations organized by the Viet Cong had spread disorder and often provoked harsh government suppression.[20] A "Special National Intelligence Estimate" issued in August 1960 considered the upsurge to be tied "to indications of increasing dissatisfaction with the Diem government."[21]

The ARVN was ill-prepared to counter this upsurge in guerrilla activity. From 1954 to 1960, the two MAAG chiefs, General John W. "Iron Mike" O'Daniel and Lieutenant General Samuel T. "Hanging Sam" Williams, focused primarily on stopping a conventional invasion across the 17th parallel and never really considered that an internal insurgency could threaten South Vietnam's stability. South Vietnam's light mobile infantry groups had been reorganized into infantry divisions that were compatible in mission and design with U.S. defense plans. The ARVN was equipped with standard army equipment, and American advisers trained ARVN for conventional war, fearful of a scenario such as the invasion by the People's

Chatting with his friend Wendy Larsen on the top floor of Larsen's apartment building in Saigon. An gave Wendy and Jon a dove and a dog—Colombe and Bougie.
PHAM XUAN AN PERSONAL COLLECTION

Army of Vietnam that had defeated the French in 1954 and the 1950 North Korean invasion of South Korea.[22]

President Eisenhower ordered the development of a comprehensive counterinsurgency plan. In August 1960, Lieutenant General Lionel C. McGarr replaced General Williams as head of MAAG. McGarr had been commandant of the United States Army Command and General Staff College and commanding general of Fort Leavenworth, Kansas. He was one of the most highly decorated officers of the period, holding seven purple hearts. He viewed counterinsurgency as "a distinct species of warfare requiring devel-

opment of special doctrine and techniques."[23] His staff soon produced "Tactics and Techniques of Counter-Insurgent Operations (CIP)."[24]

This CIP reached Saigon in early 1961.[25] Almost immediately a copy of the report went to Dr. Tuyen, who gave it to An, requesting analysis of the document so that he could be fully informed on the new strategy. Army chief of staff General Tran Van Don also gave An the report, along with supporting documents such as Field Manual 100-5, *Operations*, which contained all of the relevant thoughts and actions of U.S. advisers as well as how MAAG envisioned ARVN should fight the new war. The manual was revised in February 1962, taking into account new technologies in warfare, such as airmobile operations and irregular warfare. In addition An received a copy of Field Manual 31-15, *Operations Against Irregular Forces*, published in May 1961, providing forty-seven pages of text and diagrams bearing on targeting and destroying the VC forces. An was also regularly in touch with those ARVN commanders returning from a special course on counterinsurgency strategies at Fort Bragg's U.S. Army Special Warfare Center.

Out in his side yard, An unlocked his file cabinets and removed a stack of these tattered documents. "Today they are all available at Texas Tech's Vietnam Center," said An, laughing. "When I am dead, my wife will throw it all away. We are the only ones who care." The director of the Vietnam Center, Jim Reckner, is a mutual friend and the man who introduced us years earlier. Jim and Khanh Le, another friend who works at the center, have been visitors to An's home, and I know they had suggested An consider transferring his papers to Texas Tech's Vietnam Archive so that the materials could be preserved for the future.

None of the documents An showed me that day or any day can be considered the crown jewel of intelligence or crucial military secrets,

but Vietnam Communists at the time had little understanding of the tactics that were being developed for a new type of "special war." The introduction of U.S. helicopters and ARVN mopping-up exercises were taking a heavy toll on Viet Cong forces. An's assignment was to analyze the new tactics so that Communist military planners could develop countertactics of their own. "They trusted me and gave me the documents, even Tuyen," said An. "So I read them all, spoke with American advisors and my friends who were returning from training, and I wrote reports, nothing else. It was easy once I had the documents ... All I did was read their documents, attend briefings, listen to what people were saying, provide my analysis and send the report to the jungle. I never knew what happened after that until years later."

Between 1961 and 1965, An sent forward just about every important document regarding military and civilian plans for operations in the south. "Ap Bac was about providing tactical information," Mai Chi Tho, the man who raised the money for An's studies in the United States, told me. "An was able to tell us about the new tactics developed by the Americans so that we could develop a tactical response. Other people developed that new plan to implement those tactics, and then others fought bravely at Ap Bac, but it was An who made it possible with his reports and documents." An would tell me something similar when showing me a copy of Saxe's 1732 treatise: "Strategic analysis also requires tactical ability." "My job during this period was to help understand the new American way of special warfare so they could devise new tactics. I provided the analysis; other people decided on the way and place to fight."

President-elect John Fitzgerald Kennedy believed that Edward Lansdale was one of the few Americans qualified to advise him on unconventional warfare and the American role in Indochina.[26] Lansdale had departed Saigon in 1957, the same year that An left for

California, taking a post in the Office of the Secretary of Defense as deputy assistant secretary for special operations.

During the 1961 presidential transition, Kennedy asked Lansdale to visit Vietnam for a complete assessment of the insurgency. The visit was full of high-level consultations and field visits, but An recalled that he and Lansdale had two meetings. Their first was the more casual. They chatted about An's two years in the United States. After raving about the scenic beauty of the California coast, Lansdale asked if there was anything he could pick up for An when he was next in California. An asked if Lansdale could stop along a certain stretch of 17-Mile Drive through Pacific Grove and Pebble Beach and bring back seal testicles that could be preserved in Black & White scotch. An told Lansdale that these made for the mightiest of all aphrodisiacs! Lansdale would later return empty-handed, explaining to An that he could not figure out how to immobilize the seal in order to carry out his mission.

Their next conversation was much more serious. Lansdale, having been made aware of An's work for Dr. Tuyen, was interested in An's assessments of the insurgency. An told Lansdale exactly what he had been telling Tuyen. "I had no reason to lie to Lansdale about this, especially since I knew he would speak with Tuyen. I needed to be consistent and objective in my analysis," said An. "I knew Lansdale a long time. He was my friend, and it was natural for us to speak about these things. I told him what I thought, and he shared with me his own assessments. He gave me valuable information. He was always teaching me and I always listened. He recommended that I read [Paul] Linebarger's book *Psychological Warfare*.[27] I learned so much from Lansdale about counterinsurgency, different ways of fighting the Communists and about Sherman Kent."

What Lansdale did not know was that everything An learned was being sent to Hanoi. "In 1962, Hai Trung sent us twenty-four rolls

of film of all plans related to the U.S. Special War strategy," recalled Muoi Nho, An's direct supervisor at the time. "They included the master plan of the war, the materials concerning the buildup of armed forces, the support of American troops, the strategic hamlet plan, the plan of reoccupying liberated zones and the plan of consolidating the puppet army with American military equipment."[28]

Muoi Nho personally developed the film; his hands trembled when he saw the entire text of the Staley and Taylor reports. "We could not have purchased such documents, even if we had offered to pay a billion dollars. The understanding of the enemy these documents gave us helped us to prepare pro-active plans to deal with the enemy strategy.... The enemy's total defeat in the battle of Ap Bac forced the U.S. to end its pursuit of its special war plan and seek a new strategy."[29]

When I asked Mai Chi Tho what he considered to be An's most valuable contribution, he surprised me by saying, "An sent us everything on the pacification program, the strategic hamlets, so that we could devise an 'anti' plan to defeat them." Yet An had not received a medal for these activities, I said. Tho smiled. "There are many more accomplishments that An made that could have earned medals, but I consider this to be the most important because of its strategic scale."

More than twenty years later, Lansdale found it hard to accept that An had been working for the other side. In 1982 Bob Shaplen wrote Lansdale about a Stanley Karnow article that identified An's apparent double life. Lansdale wrote back saying, "I don't know the Karnow talk about An and Thao. But I'd take anything he said about the Vietnamese with a grain of salt. I'd trust you to know better."[30]

In late January 1961 Lansdale returned to Washington for a meeting with Kennedy and his top advisors. Telling JFK that "the Communists regard 1961 as their year," Lansdale urged the admin-

istration to embrace Diem with what he called "friendly persuasion." Kennedy accepted most of Lansdale's recommendations by approving $28.4 million to expand the Vietnam army force level by twenty thousand and another $12.5 million to improve the civil guard. Kennedy approved the *Counterinsurgency Plan for Vietnam*, the same one that was in An's possession. In May, Vice President Lyndon Johnson spent three days in Vietnam, describing Diem as the Winston Churchill of Vietnam as well as invoking comparisons with George Washington, Woodrow Wilson, Andrew Jackson, and Franklin D. Roosevelt. When later asked by Stanley Karnow if he meant what he said, LBJ replied, "Shit, Diem's the only boy we got out there."[31]

The term *special warfare* came to embrace military and paramilitary measures and activities related to unconventional warfare, counterinsurgency, and psychological warfare. In Kennedy's own words, "To win in this struggle, our officers and men must understand and combine the political, economic, and civil actions with skilled military efforts in the execution of this mission." Counterinsurgency would provide ARVN with additional advisers, helicopters, and armored vehicles in order to improve field mobility in counterguerrilla operations, including the important role of training Vietnamese forces in new tactics.[32] Additional elements of counterinsurgency would include the strategic hamlet program, the utilization of chemicals and defoliation in guerrilla areas, and the establishment of Special Forces camps, whose role was limited to training South Vietnam rangers.

Believing that fresh ideas were needed on Vietnam, Kennedy dispatched an economic survey mission, headed by Dr. Eugene Staley of the Stanford Research Institute. Their report emphasized the inseparable impact of military and economic assistance on internal security in Vietnam, identifying the Viet Cong as "a ruthless, resourceful, and elusive" enemy requiring "the mobilization of the

entire economic, military, psychological, and social resources of the country and vigorous support from the United States."[33]

As soon as Staley returned from Saigon, President Kennedy announced that General Maxwell D. Taylor would visit Vietnam as the military representative of the president. Taylor was accompanied by Walt W. Rostow, chairman of the Policy Planning Council at the Department of State. The team arrived in Saigon on October 18 and spent one week focusing on the question of troop deployments to Vietnam. "Upon arrival Taylor and Rostow found the situation to be worse that they had expected."[34] Taylor believed it "was the darkest since the early days of 1954 it was no exaggeration to say that the entire country was suffering from a collapse of national morale."[35] Recent Viet Cong success in attacks and infiltration led Taylor and members of his mission to see the introduction of American troops as the only way to save Diem.

The final Taylor-Rostow report, offering a comprehensive plan to Americanize the war, was presented to Kennedy on November 3.[36] Describing a "double crisis in confidence" in both U.S. resolve and Diem's competence, Taylor pushed for a deeper U.S commitment by calling for the insertion of eight thousand troops on the ground, primarily engineers and logistic personnel, with combat elements into the Mekong Delta for base security. This eight-thousand-man contingent would operate under the guise of providing humanitarian relief for the massive flooding in the delta, but would really serve as a "visible symbol of the seriousness of American intentions."[37] Taylor believed that these troops might "be called on to engage in combat to protect themselves, their working parties, and the area in which they live." Taylor seemed unperturbed about "the risks of backing into a major Asian war," which were "present" but "not impressive."

From Hanoi's perspective, these highly visible visits were cause

for great concern. Here is how one 1965 Communist publication put it: "South Vietnam had become a proving ground for counter-guerilla tactics of the U.S. Army, an experimental war which resembled no previous undertaking of the United States."[38]

An revealed to me that General Giap was so concerned that he sent two delegations to Moscow to speak with Soviet Union military planners on ways to combat the American special warfare, but the Russians knew only conventional warfare. Giap then sent a delegation to visit with Chinese commanders who had fought against the Allied forces in Korea, but they too were of little help. "I was the one who did it. I helped them to understand the new American way of war, and that is why Giap was so happy. There had been two failed missions, and then I made the program," said An.

ON DECEMBER 28, 1962, the ARVN 7th Infantry Division, located in the Mekong Delta, received instructions to seize a PLAF (People's Liberation Armed Forces) radio transmitter operating near the village of Ap Bac, which was being protected by a small VC force of about 120 guerrillas. The senior American adviser for the army to the ARVN 7th was John Paul Vann, who had been in country for eight months and had yet to face the enemy. An army lieutenant colonel, Vann is one of the legendary figures of the Vietnam War. He was killed in a helicopter crash in Vietnam on June 9, 1972.[39]

Vann was itching for battle so that he could assess how much the ARVN commanders had absorbed of his teaching. On the other side, the Viet Cong commander was also prepared for a showdown against the American helicopters. The introduction of the first helicopter transportation company in December 1961 had caused many problems for the guerrillas, as did the fierce "mopping up" operations conducted by ARVN daylight sweeps into villages to look for

PLAF forces. "At the time we did not know how to fight the APCs and helicopters," Mai Chi Tho told me. "An was able to provide us with information that allowed us to develop on the tactical scale a way to fight the new war."

Now, armed with a new strategic plan, the PLAF forces were ready for the helicopters. For weeks beforehand, in order to calculate the most effective shooting range, they had been practicing in the nearby Plain of Reeds by attaching to bamboo poles cardboard models of Shawnee and Huey helicopters that emulated their flight characteristics.[40] "One of those rare events in a conflict of seemingly endless engagements no one of which appeared to have any intrinsic meaning, was about to occur—a decisive battle that would affect the course of the war," wrote Neil Sheehan. "Today the Viet Cong were going to stand and fight."[41]

Vann's intelligence was faulty; rather than a company of 120 men, he faced the 261st Viet Cong main force battalion of 320 supported by 30 village and hamlet guerrillas. But ARVN still had significant military superiority in both numbers and equipment. The 7th Infantry Division battalion consisted of 330 men supported by two battalions of civil guards and a company of thirteen M-113 armored personnel carriers, plus an infantry company backed by the M-113 ten-ton armored personnel carriers (APC) dubbed "green dragon" by the Viet Cong. Total strength was over 1,000.[42]

When the battle commenced, ARVN took quick casualties, and the commander called for reinforcements from nearby Tan Hiep. On the way were "ten Shawnees, with five of the new invulnerable Hueys flying shotguns."[43] As they approached Ap Bac, the trap was sprung and massive gunfire erupted from the tree line along the dike. Within minutes fourteen of the fifteen helicopters were hit, four were downed, including a Huey, and three Americans were dead. ARVN still had a chance to save the day because the VC were

surrounded and the only way out was east through the field. Vann called for the APCs, but Diem had issued a standing order that none could go into battle without Saigon's direct approval. He had also instructed all corps commanders and division commanders that they were to keep casualties low. Those who could not follow this simple instruction would not get promoted. A fifth helicopter went down during a rescue attempt. The ARVN commander refused to obey Vann's instructions to shut off the VC's ability to escape. Once the sun set, the VC were gone.

Vann saw the battle as proof that this army he had been sent to train was woefully inadequate. "It was a miserable damn performance. These people don't listen. They make the same goddamn mistakes over and over again in the same way."[44] The battle demonstrated that the soldiers who fought for ARVN were being sacrificed uselessly under the command of incompetent and sycophantic generals that Diem had placed in key commands. "Ap Bac revealed all that was wrong with ARVN leadership and promotion policies based on loyalty to Diem and not professional competence," An told me. General Huynh Van Cao, whom Diem had trusted as most loyal to his Ngo family and promoted quickly, proved both incompetent and cowardly. "Diem had generals who should have never received their assignments, but they were promoted because they kissed the hand of Nhu and Diem. Ap Bac was the place where the first roosters came home," said An with a smile at his bird analogy.

Vann's After Action Report was an indictment of commanders at all echelons for their failure to act decisively and inspire their troops. The U.S. senior adviser, Colonel Daniel B. Porter, called the After Action Report "possibly the best documented, most comprehensive, most valuable, and most revealing of any of the reports" previously submitted in the past year.[45]

It is impossible to underestimate the significance of Ap Bac for

the PLAF in the south and for An's reputation in Hanoi. Ap Bac became a rallying cry, and COSVN launched a movement throughout South Vietnam to "emulate Ap Bac." An April 17, 1963, CIA Special Intelligence Estimate concluded that "The Viet Cong have proved themselves a formidable enemy and an effective guerrilla force.... They have also demonstrated flexibility in modifying their tactics to counter new South Vietnamese operational concepts.... One important factor in their success is their effective intelligence system. Informants and sympathizers exist throughout the countryside, and the Viet Cong evidently have been able to maintain intelligence coverage of virtually every level in the South Vietnamese military and civil establishment."[46]

Perhaps the most revealing assessment to emerge from Ap Bac was the PLAF's own After Action Report known as "VC Document on Ap Bac Battle, 2 January 1963."[47] This captured document was translated into English and circulated in MACV headquarters by late April 1963. The Viet Cong considered their "counter-mopping operation on 2 January 63" as a "great victory of our Armed Forces and Countrymen ... The victory of Ap Bac counter mopping up operation proved that our armed forces have grown up in the domain of Tactic and Technique ... This victory also furnished us with a clear concept on the advantages of the enemy tactics."

An would receive the first of his four Exploit medals for his contributions to the victory at Ap Bac. Only two medals were awarded for this early battle in the war, one to the People's Liberation Armed Forces commander, Nguyen Bay, and the other to Reuters stringer Pham Xuan An for submitting reports that helped transform the nature of the war.

There is much irony in the fact that An's first Exploit medal, as well as his third for contributions to the 1968 Tet Offensive, were also watersheds in the media coverage of the war. Ap Bac was the

boiling point in the simmering hostility between reporters and the U.S. mission in Saigon, whose spin doctors claimed victory. "I don't understand how anyone can call the Ap Bac battle a defeat," said General Paul Harkins, commander of Military Assistance Command, Vietnam (MACV). "The Government forces had an objective (the transmitter), they took that objective, the VC left and their casualties were greater than those of the Government forces—what more do you want?" When Peter Arnett of the Associated Press asked a tough question at a post–Ap Bac press conference, Admiral Harry D. Felt shot back: "Get on the team."

"Prior to Ap Bac," wrote Sheehan, "the Kennedy administration had succeeded in preventing the American public from being more than vaguely conscious that the country was involved in a war in a place called Vietnam…. Ap Bac was putting Vietnam on the front pages and on the television evening news shows with a drama that no other event had yet achieved."[48] Reporters like Neil Sheehan and David Halberstam had been to Ap Bac and knew what had happened. "Ap Bac started the disintegration of the Diem regime," An said. "We knew that and soon everyone else would too."

An's boss, Nick Turner, was with Sheehan at the battlefield, seeing firsthand the debris of the downed U.S. helicopters and the bodies of ARVN soldiers. Halberstam was taken over the area in a small plane. "I will never forget the look on [An's] face when he burst into the office with the news of Ap Bac," recalled Nick Turner, "Emphasizing how important it was, even while first reports were just starting to come in."[49]

An was soon at Ap Bac too, taking the press helicopter on January 3. "I was there as a reporter, helping my colleagues understand what had happened and to see for myself," recalled An, whose cover allowed him to be considered part of the team. "Our closest friends were apt to be newspapermen like ourselves," wrote David

Halberstam in *The Making of the Quagmire*. "Pham Xuan An of Reuters, Nguyen Ngoc Rao of UPI, Vo Huynh of NBC, and Ha Thuc Can of CBS. They were remarkable men...they all had an intuitive sense of what a reporter's job was.... They were all proud men; they were the only free members of a closed society, and they were perhaps even more offended than we were when anyone tried to feed them phony stories."[50]

Ap Bac altered the way the reporters and the government would approach each other. It seemed that MACV could always demonstrate progress in the war, could always show that enemy strength was in decline, that more and more hamlets had been secured, the countryside pacified, but it looked different to the reporters who were there. AP reporter Malcolm Browne quickly discovered that getting the real story in Saigon required "methods uncomfortably close to those used by professional intelligence agents."[51] The battle for information pitted the press corps against the embassy, MACV, and the president's assertions of progress. It was tough going during the Kennedy years, but things got especially bad as the war became an American one. As new reporters headed to Vietnam, LBJ would tell them, "Don't be like those boys Halberstam and Sheehan. They're traitors to their country."[52]

The reporters became a special target of Mrs. Ngo Dinh Nhu, or Madame Nhu, Diem's sister-in-law, whose arrogance became the symbol of the Ngo regime. Known as the "Dragon Lady of South Vietnam" because of her strong anti-Buddhist, pro-Catholic ideology, Madame Nhu accused the Buddhists of being infiltrated by Viet Cong. When a Buddhist monk from Hue burned himself alive in protest, she remarked that it was the Buddhist leaders who "barbecued" the monk, and even then, had relied on foreign help as the gasoline used was imported. When other protests followed, she said, "Let them burn, and we will clap our hands."

The war against the Saigon reporters reached a crescendo in the summer of 1963 when *Time*'s chief correspondent, Charles Mohr, prepared a critical story on Madame Nhu. When it reached New York, it collided with Henry Luce's view of the world. The story was rewritten, incensing Mohr because his entire conclusion had been altered to now sound as if he agreed with the administration's position that there was no viable alternative to Diem.

A few weeks later, *Time* attacked the Saigon reporters by charging that the press corps on the scene was "helping to compound the very confusion that it should be untangling for its readers at home." *Time* accused reporters of pooling their convictions, information, misinformation, and grievances at the "Hotel Caravelle's eighth-floor bar." The result was that "the reporters have tended to reach unanimous agreement on almost everything they have seen. But such agreement is suspect because it is so obviously inbred. The newsmen have themselves become a part of South Viet Nam's confusion; they have covered a complex situation from only one angle, as if their own conclusions offered all the necessary illumination."[53]

Yet most of the pre–Ap Bac Saigon reporters had been supporters of administration goals in Vietnam. David Halberstam later changed his mind on the war, reflecting that "the truth, and it remains for me all these years still a painful truth, is that we in the media erred not in being too pessimistic, but in not being pessimistic enough... We never managed to get into our stories what the French Indochina war had done to Vietnam, how it had created in the North a modern dynamic society and how it had given us as allies a dying post-feudal order.... [our sins were] not that we were inadequately patriotic or that we undermined an otherwise high national purpose—but rather that we did not from the start make clear the impossibility of the struggle."[54]

The government became the least likely source from which reporters could get the real story on the war. This lack of reliable information allowed Pham Xuan An to thrive in his cover as a journalist because he could provide what the Saigon reporters needed while at the same time picking up information for his own strategic reports back to the jungle.

By now Diem's regime was inching toward bankruptcy, denying basic freedoms to the Buddhists and discounting everything except complete loyalty to the Ngos. In 1962 Dr. Tran Kim Tuyen, like Nguyen Thai and scores of others, could take no more of Madame Nhu's meddling in politics. In a long letter to Diem, Tuyen urged that Madame Nhu be removed from the spotlight. When the president's brother and Madame Nhu's husband, Ngo Dinh Nhu, learned of the letter, Tuyen's fate was sealed. He was exiled to Cairo under the rubric of consul general, but Nhu kept Tuyen's family under house arrest in Saigon. Before departing Saigon, Tuyen laid out an elaborate coup plan, sharing the details with An and others. Tuyen never made it to Cairo, deciding to monitor events from Hong Kong, waiting to return to a post-Diem Saigon.

Tuyen's other loyal assistant, Ba Quoc (the code name of Intelligence Major General Dang Tran Duc), passed a few lie detector tests and was soon transferred to the newly created CIO, where he picked up the nickname "Buddha Ta" because he seemed to be "as gentle as Buddha." Ba Quoc became the staff assistant to the director of the Domestic Intelligence Department. He had access to the most important documents in the South's intelligence network. Here was further evidence that the North Vietnamese Communist spy network had completely infiltrated virtually every layer of South Vietnam society, including the very intelligence agencies in South Vietnam that were responsible for eradicating the Viet Cong. Yet there seems to have been no counterpart agents to Pham Xuan An or Ba Quoc

operating in the North, which is probably why U.S. intelligence tried unsuccessfully at least twice to recruit An to work for the CIA.

Ba Quoc had no idea that An was working undercover: "I was acquainted with Hai Trung, but I knew only that he was a journalist working for the American who had a lot of influence and who had a very wide circle of contacts.... Because I knew that he was a person with considerable influence, I wanted to establish contact with him in order to elicit information from him. I reported my intentions to my superiors, but I received instructions forbidding contact with him." An was similarly unaware of Ba Quoc's role.[55]

Perhaps the most intriguing case of espionage involved Colonel Pham Ngoc Thao, whose mission was to destabilize the anti-Communist government of South Vietnam. Thao also became a renowned coup specialist, often collaborating with Dr. Tuyen and ARVN generals, doing whatever he could to discredit the South Vietnamese government. Shaplen described Thao as a "conspiratorial revolutionary figure straight out of a Malraux novel."[56]

Thao and An were friends, and although An was aware of Thao's mission, he never spoke a word of it to Thao, who was also close to Bob Shaplen and Dr. Tuyen. Thao operated as one of the most trusted aides to Diem and was generally hailed as one of the South's most successful anti-Communist crusaders. After seeing Thao's performance at Ben Tre province, a Communist stronghold, Shaplen wrote an article praising his skills at counterinsurgency.

Coming from an educated Southern Catholic family, Thao was introduced by his parents to Ngo Dinh Thuc, the older brother of Diem, who was then bishop of Vinh Long. Thao convinced Diem's eldest brother that he truly believed in the anti-Communist cause and wanted to support Diem in any way he could. Thao's mission had been approved at the highest level of the politburo. Thao was sent to study at the U.S. Command and Staff College in Kansas, and

he was promoted to the rank of colonel. He se
of the Regional Forces Group in Vinh Long pi
mander of the Regional Forces Group in Binh Duon.
later as the Ben Tre province chief.

Thao became one of the strongest advocates for agrovilles, sen
contained modern villages aimed at separating insurgents from the
rural population by moving peasants into large, well-defended vil-
lages that would allow the government to protect them. Thao knew
the program would alienate peasants, and that is why he became its
strongest proponent.[57] The peasants hated agrovilles for many rea-
sons, beginning with the fact that they were required to help build
them and then move from their homes. The program produced pro-
tests and alienation toward Diem. When it was disbanded, Thao
focused on strategic hamlets, convincing Diem to move quickly
rather than slowly, which would elevate hostility and alienate the
peasants. "Instead of testing and testing, they moved ahead in the
typical American way, with Thao's help," An said. "Thao had a
much different mission than me. I was strategic intelligence; he was
regime destabilization and coup plotting. His mission was much
more dangerous than mine."

I asked An why so many people admired Thao. "Bob Shaplen liked
him because he thought Thao's mentality was separate and different
from Hanoi. Thao was a dreamer, like many of us." Thao's close
childhood friend explained that "Thao was a man who, throughout
his life, fought single-mindedly for Vietnam's independence. He was
a nationalist, not an ideologue, one whose attitudes and goals were
shaped at a time when Vietnam was a politically suppressed and eco-
nomically exploited colony of France.... Looking back at his life, it
is hardly an exaggeration to say that he personally changed the bal-
ance of political power between the Saigon government and the NLF.
He helped weaken Diem and Nhu by assisting in the debacle of their

al pacification schemes, and he was a major figure in the whirl-
wind of plots that undermined and eventually destroyed them."[58]

Thao was killed on July 17, 1965. Nguyen Van Thieu is supposed
to have given the order for the execution that involved strangulating
the severely wounded Thao with leather thongs around the throat
and testicles. Thieu broke out champagne with his wife to celebrate
Thao's death.[59]

In one of our final conversations, I joked about what a poor
anti-Communist spy detector Dr. Tuyen turned out to be since
Ba Quoc, Thao and An got their start in his organization. This
was one of the few times in all our conversations that An's tone
changed. "There are things I cannot tell you, but I am not the only
one who saved Tuyen's life; Thao did too because Tuyen helped
free so many of our prisoners after he fell out of favor with Nhu
and Diem!" After the November 1, 1963 coup that removed Diem
from office, Tuyen flew to Saigon from Hong Kong, but was
immediately imprisoned as a suspected plotter. He spent over two
months in prison, isolated, tortured, and starved, left naked and
living with rats.[60]

It was Thao, the respected ARVN colonel, who used his influence
to get Tuyen released. "Dr. Tuyen was my friend," says An. "He
was Thao's friend too, and we saved his life because he helped our
people in prison. This should tell you something about our friend-
ship." At the time I recalled thinking that there were just too many
boxes within boxes in An's life.

AN RECEIVED HIS SECOND Exploit medal for his strategic assess-
ments of whether the United States would introduce ground
troops in 1964–65. Following the 1963 coup against Diem, some
in Hanoi thought the United States would seek some type of

UNITED STATES
MILITARY ASSISTANCE COMMAND, VIETNAM
1965 INFORMATION OFFICE
APO 143 SAN FRANCISCO, CALIFORNIA

NAME Pham Xuan An
ORGANIZATION New York Herald-Tribune
IS ACCREDITED TO COVER THE TRAINING, ADVISORY, AND SUPPORT ACTIVITIES OF U.S. FORCES IN VIETNAM

Warren C. Mahr
Lt. Col., Infantry
INFORMATION OFFICER, MACV

This card accredited An "to cover the training, advisory and support activities of U.S. forces in Vietnam."
PHAM XUAN AN PERSONAL COLLECTION

negotiated settlement or accommodation. On November 1, Diem and his brother were murdered in the back of an American-built personnel carrier. While the coup was planned and implemented by the South Vietnamese military, the CIA was deeply involved through An's friend Lou Conein.

"I was surprised by the coup," said An. "The Americans had put so much into Diem, but Lansdale was the only one who could restrain him. My superiors thought incorrectly that by getting rid of Diem, the United States was trying to rid themselves of Vietnam. I laughed and said, 'No way, they are coming and you better get ready for a big war.' I told them Diem also opposed American troops and that was another reason he was removed by the CIA. He became expendable because he was no longer on the American short leash."

The large-scale American commitment to Vietnam was made on July 28, 1965,[61] but An's reports began in 1964 during the presidency of Nguyen Khanh. An told me the same thing he told Bob Shaplen privately thirty years earlier, that when the CIA learned about

Khanh's secret overtures to the National Liberation Front (NLF), he was removed from power because the Johnson administration was already inching toward Americanizing the conflict.[62] "That is how I knew the Americans would never leave. I later learned that many in Hanoi thought differently, but I did not know then what they thought. I just gave them my honest analysis and learned later that I got a medal."

An said his primary source for the information on Khanh was the CIA's Lou Conein, although I suspect he also had other sources. "Lou Conein came back one day from a helicopter flight with Nguyen Khanh and started yelling at me, 'An, get your wife and family, pack up, and get out of here. All is lost. Your country is going to fall into the Communists' hands very soon. It is worse than I ever thought, Khanh is in bed with the NLF.'" An explained that during their flight Conein had decided to "test" Khanh by saying something to the effect that "this may be the right time to explore a coalition government and speak with the NLF."

Khanh took the bait and detailed his thoughts to Conein, who could scarcely contain his emotions. "I never saw Lou Conein that angry in his life, but he was also seriously worried about me and my family. He kept yelling, 'All is lost, all is lost,'" recalled An. "When he calmed down he told me he did not think Khanh would find much support for talking with the NLF. I knew then that the CIA would never allow Khanh to stay very long. The Americans would not allow this dialogue with NLF because the Vietnamese would not be allowed to reach accord between themselves, that was not in the U.S. interest."

The February 5, 1965, bombing of the U.S. Army barracks at Pleiku, killing eight Americans and wounding over one hundred, triggered a sequence of events that led to American combat forc-

es being placed on the ground in Vietnam. A day after the attack, Johnson made a prophetic public announcement. "We have no choice now but to clear the decks and make absolutely clear our continued determination to back South Vietnam in its fight to maintain its independence."

Presidential special assistant McGeorge Bundy was in Pleiku on the day of the attack. He cabled LBJ that "the situation in Vietnam is deteriorating and without a new U.S. action, defeat appears inevitable." On February 13 Johnson initiated Operation Rolling Thunder, the systematic and expanded bombing campaign against North Vietnamese targets.

As the pace of the air war quickened, the decision to introduce American combat forces simultaneously evolved. First, 3,500 marines stormed ashore to defend the key air base at Da Nang; by June 7 General William Westmoreland requested an additional forty-four battalions to prevent the defeat of the South. For the next six weeks the question of Americanizing the war was at center stage in Washington and being watched with great anticipation by Hanoi. "I was kept informed about the debate from my sources in the palace," said An. "I never doubted that the Americans would not walk away. They had invested too much money and prestige, so the only question I had was how much were they willing to invest? It was a lot and should have been enough to survive for a longer time, but the U.S. never cultivated a new generation of leaders in the South. This was their big mistake."

The sole voice of dissent within the Johnson administration came from Undersecretary of State George Ball, who tried to warn Johnson that he was beginning a new war pitting the United States against the Viet Cong. "Perhaps the large scale introduction of American forces with their concentrated fire power will force Hanoi

and the Viet Cong to the decision we are seeking. On the other hand, we may not be able to fight the war successfully enough—even with 500,000 Americans in South Vietnam we must have more evidence than we have now that our troops will not bog down in the jungles and rice paddies—while we slowly blow the country to pieces." In a memorandum Ball wrote that "politically, South Vietnam is a lost cause . . . Hanoi has a government and a purpose and a discipline. The government in Saigon is a travesty. In a very real sense, South Vietnam is a country with an army and no government. In my view, a deep commitment of United States forces in a land war in South Vietnam would be a catastrophic error. If ever there was an occasion for a tactical withdrawal, this is it."[63]

Ball's words fell on deaf ears. His last day in court was late July, a few days before Johnson announced that Westmoreland was getting what he needed. The president told Ball that the United States would lose credibility if it withdrew. "No sir," responded Ball. "The worse blow would be that the mightiest power on earth is unable to defeat a handful of guerillas." As An later explained it, "The United States is a beautiful country, with very nice people; they just don't remember history too well."[64]

WITHIN FIVE YEARS OF HIS return from the United States, Pham Xuan An had received two Exploit medals for his strategic reports and contributions to both Ap Bac and the Americanization of the war. He had also gained the well-earned reputation as perhaps the very best Vietnamese journalist working for the western press. Still, it would be over the next decade, from 1965 to 1975 that he would leave an indelible imprint of his work in espionage and as a journalist for *Time*.

Chapter 5

FROM *TIME* TO TET

> Farewell to the hero, the excellent intelligence officer who made great contributions to the cause of national liberation during the two resistance wars against the French and Americans. To me, Tu Cang, what many a memory I shared with you in the temporarily occupied capital of Saigon. Between life and death we were side by side, overcoming a host of difficulties.
>
> —Tu Cang inscription in An's memory book,
> September 2006

IN LATE 1967, FORTY-YEAR-OLD Major Tu Cang, the head of Pham Xuan An's Military Intelligence Cluster H.63 network, arrived in Saigon.[1] Months earlier, the Political Bureau of the Party Central Committee in Hanoi had endorsed a resolution calling for a new general offensive and uprising that would strike at "the nerve center of the Southern puppet government."[2] The main target would be Saigon! The resolution was carried by messenger down the Ho Chi Minh Trail and reached COSVN in November 1967. D-day was fixed for Tet Mau Than, New Year's Day of the lunar year of

the monkey, January 31, 1968. This left less than three months for intelligence gathering and strategic planning for the assault on the South's capital city.

Tran Van Tra, the commander of the People's Liberation Armed Forces of South Vietnam since 1963, was responsible for the tactical and strategic operations for the offensive. Tra was certain that if the plan succeeded, the South's government headed by President Nguyen Van Thieu would collapse. "The basic guiding method was to combine attacks by military units with mass urban uprisings, attacks from within the cities with those from outside, and military activities in rural areas with those in urban centers. The offensive was to be continuous, going from one victory to another, all the way to complete victory."[3]

Tra was relying heavily on his many Saigon-based intelligence networks. Tu Cang's assignment was to investigate the capabilities of the ARVN 1st Division, to report on security surrounding the navy headquarters in the Port of Saigon, to identify the best infiltration routes into the city, and those buildings or installations most vulnerable for attack. Tu Cang knew that he would need to spend as much time as possible with his top agent, Pham Xuan An.

An developed a cover story for Tu Cang. He was a friend from Hue, a teacher who oversaw a plantation at Dau Tieng and a fellow bird breeder and dog fancier.[4] This way they could be seen together at Givral and just about everywhere in Saigon without arousing suspicion. As a well-respected journalist now working for *Time*, An had easy access throughout Saigon and was brimming with ideas for possible attack sites and ways to avoid security systems.[5]

BY 1968 AN WAS generally regarded as the dean of Saigon's Vietnamese reporters. "He was one of the best-informed sources

in Saigon and scores of correspondents had relied on his wisdom," wrote Laura Palmer, who worked as a freelance reporter for *Time* and became a dear friend.[6] When David Lamb of the *Los Angeles Times* arrived in Saigon, he was told, "Go see An over at *Time*."[7] Henry Kamm of the *New York Times* knew An "as a generous, informative, and gently witty colleague, the only Vietnamese employed by the American press to be given by his employer, *Time* magazine, the status of a full-fledged correspondent, not a mere local assistant to his American colleagues sent out from New York to cover the war."[8]

Years before David Halberstam learned about An's espionage activities, he told Neil Sheehan that An was a major figure on the Saigon scene "because of the extent to which he influenced American journalists."[9] When I showed this archival transcript from Sheehan's papers to An, he smiled and said, "David Halberstam is correct, because I did influence journalists by helping them understand Vietnam. Many of them came here very young freelancers and always looking for a story. I did not want them to be misguided since there were many others who gave bad information. I was in a position to teach them because I could not let anyone ever suspect me. That is why I never engaged in disinformation, and only people with grudges make that charge. I had to be fair and objective or I would be dead. It is that simple."

The question of An serving as an agent of disinformation, that is, deliberately spreading false information in order to mislead his country's enemy has never been corroborated, despite several investigations and accusations.[10] It remains perhaps the most sensitive, if not most central question involving An's cover—did he bias coverage of the war to favor the Communists? The charge was initially made by Arnaud de Borchgrave in testimony before a Senate subcommittee chaired by former American prisoner of war Senator Jeremiah Denton. According to de Borchgrave, "He [An] was in

charge of relaying disinformation to the U.S. Embassy and to journalistic colleagues."[11]

Former colleagues who worked closely with An say that he never fed them disinformation. "To his credit," insisted Roy Rowan, former *Time* bureau chief, he never "misled our correspondents on the progress of the war."[12] *Time* later conducted an internal audit that found no evidence of skewed reporting by An. My extensive analysis of Robert Shaplen's detailed notes from conversations with An reveal nothing that could substantiate the charge that An was trying to push false information or even an interpretation that could be construed as pro–Viet Cong. "Journalism was a job that I took seriously," insisted An to his last day. "That is why no one ever suspected and why I have so many friends today. All I ever did was help my profession and my country, and the fair ones know that."[13]

An's closest professional relationship was with Bob Shaplen, who from 1962 to 1978 lived in Hong Kong as the *New Yorker*'s Far East correspondent, covering the Vietnam War and other countries in Asia. When in Saigon, he took up regular quarters in room 407 of the Continental Hotel. From his window and balcony he looked directly at the National Assembly; to his right and directly across the street was Givral. Anthropologist Gerald Hickey recalled, "When Bob Shaplen was in Saigon, An and I would go to his room at the Hotel Continental Palace, where a variety of people gathered. They included journalists, among them Jean-Claude Pomonti of *Le Monde*, George McArthur of the *Los Angeles Times*, Keyes Beech of the *Chicago Daily News*, and old Vietnamese hands such as Lou Conein. From time to time, Vietnamese officials, including General Tran Van Don, would appear."[14]

Lou Conein spent quite a bit of time with both An and Shaplen. He always insisted that An shaped Shaplen's writing. Conein remembered taking Shaplen to see the Venerable Buddhist monk Tri

An with his close friend Bob Shaplen.
PHAM XUAN AN PERSONAL COLLECTION

An and *Time* Bureau Chief Jon Larsen at a Chu Hoi camp. *Chu Hoi* is the Vietnamese phrase for open arms, meaning "welcome for those who are returning." DAVID BURNETT

Quang, but when Shaplen's interview appeared in the *New Yorker*, it bore no resemblance to what Conein heard Tri Quang tell him. When Conein challenged Shaplen about the accuracy of his story by saying, "Bob, he didn't say that," Shaplen responded, "But that's what he meant, Lou, that's what he was really saying." Conein concluded that this was because Shaplen would "scribble down a lot of notes on what Tri Quang said and then he'd go see Anh [*sic*] and Vuong in Givral. He'd show them the notes and they'd say, 'He said that, but this is what he really meant, this is what he was really saying.' Then Bob would write it that way."

Conein believed this type of influence also affected Shaplen's analysis of internal Vietnamese politics and their meaning. After reading his essays in the *New Yorker*, Conein would challenge Shaplen: "Bob, I've got sources and it didn't happen that way." According to Sheehan's notes, "Shaplen would tell Conein he was wrong, frequently citing what Anh [*sic*] and Vuong had said as authorities."[15]

Both Conein and Sheehan thought An made "a perfect agent for the VC because, among other factors, he knew everything Shaplen learned from the Embassy and the CIA station and what the Americans intended to do and how they assessed a situation, at least as this was relayed to Shaplen, and Anh [*sic*] had the perfect cover being Shaplen's principal assistant when Shaplen was in town and then in later years the Vietnamese reporter for *Time* magazine as well."[16]

An's value as a journalist is perhaps best demonstrated with a passage from Sheehan's *A Bright Shining Lie*. Sheehan recounted riding aboard a marine helicopter heading for a Viet Cong base in the Plain of Reeds. There was enemy activity below and the door gunners opened fire. Sheehan saw a dozen figures running through the reeds. They were dressed like the old Viet Minh guerrillas that

Sheehan recalled seeing photos of from the French war—green uniforms, dark sun helmets with a turtle shape, carrying weapons and small packs on their backs. But they were not Viet Minh, they were VC regulars from a main force battalion.

Nevertheless, an ARVN captain had gone into the village to question the locals about where the dozen guerrillas had disappeared to, over and over, using that term, *Viet Minh*. "Why is he calling the guerrillas the Viet Minh," Sheehan asked a Vietnamese reporter for one of the foreign news agencies who was with him. "I thought we were after the Viet Cong?" The anonymous source (later identified to me as An) explained "the Americans and the government people in Saigon call them the Viet Cong but out here everyone still calls them the Viet Minh." Sheehan asked why. "They look like the Viet Minh, they act like the Viet Minh, and that's what these people have always called them."[17]

An left Reuters in 1964 after a falling out with Nick Turner. "The eventual revelation of his undercover role surprised many of my colleagues and has been much written about, but it did not surprise me," wrote Turner. "I always had suspicions and told him so, but said it did not concern me so long as he did his job. However, I was cautious about sharing sensitive information with him, and he clearly resented this and eventually moved on to the *Time* bureau."[18]

When I later asked Turner for an elaboration of his views he wrote: "I never indicated to him that I believed he was a VC intelligence officer, let alone a senior one, and indeed I never suspected it. But his sympathies were clear enough and that is what I discussed with him, without making an issue of it. To me, it was quite natural—and not to be criticized—that a person of his kind of makeup and philosophical outlook might have VC sympathies, and I appreciated the opportunity his conversations gave me to understand some of the complexities of what might be broadly called Vietnamese

nationalism. My suspicion was that since his sympathies were fairly obvious, he was almost certainly feeding information to the VC, but probably at a low level, through some other agent or network. There were also other reasons I thought this was likely. But I repeat, I had no suspicion that he himself was actually an important part of their intelligence operation."[19]

An had a different version of their falling out, prefacing his story by saying, "Nick Turner never said a word to me about any suspicions that I was Viet Cong. I did not need him to share sensitive information with me because I had my own sources, better than his, I can assure you. I am very sorry to read what he now says because he knows that I protected him and Reuters from great embarrassment. I was his source for everything and he knows that. I am sorry to have to say this, but what he says is wrong."[20]

An explained to me that he quit Reuters the day he returned from covering the August 1964 coup in which Major General Khanh assumed the presidency of South Vietnam, ousting Major General Duong Van Minh. Turner needed to file the story, but events at the palace delayed An by several hours. "Where the hell have you been, An, I've been waiting for you," An recalled Turner yelling. "I've been covering the coup at the palace," An replied.

An said that as their argument got more heated, Turner ordered him to remove the small "singing" bird he kept on his desk. "I told him that if I remove the bird, I quit, and that is what I did right there. Actually, I got so mad I threw everything off my desk. I packed up my belongings and never returned to Reuters. Nick Turner lost a valuable source and he knows that."

"As regards An's departure from Reuters, the fact is that he was not just away for 'several hours' but two to three days and I knew he was not out of town," explained Turner. "When he strolled in rather casually I probably did say, 'Where the hell have you been, An?'

He replied that he had been working for Beverley Deepe on some big job. This prompted me to point out that he was paid a salary to work for Reuters, to which he replied that he wasn't paid enough. He was right. I had asked Reuters to increase his pay because good Vietnamese assistants to foreign correspondents were in hot demand, but this had been refused. I took some solace from the fact that visiting correspondents would beat a path to Reuters' door to pick his brains (to which I had no objection), and some of them remunerated him in various ways…. he did not appreciate this remonstration, and he did pack his things and left."[21]

An was not without work for very long. He first took a more or less permanent job with Beverly Deepe at the *New York Herald Tribune*. An had met Deepe in February 1962 when she arrived in Saigon as a twenty-five-year-old freelancer looking for stories. Photojournalist François Sully had just been expelled from Vietnam by the Diem government because of what they described as "pro-VC" views, and Deepe replaced him as a stringer for *Newsweek*. "I arrived in Vietnam in 1962, just five years after graduating from the University of Nebraska with majors in journalism and political science," wrote Deepe. "Even though I had dreamed of being a foreign correspondent, I was still surprised that I became one in such a short time and in such a faraway place that most Americans, including me, had never heard of. No U.S. textbooks had been written—in journalism, history, political science or military affairs—to teach anyone how to cover a war such as Vietnam."[22]

An often spoke to me about how proud he was of the ways he helped Deepe become a better reporter. Striking a deal, she would help him with English grammatical phrasing, and in return he would teach her how he "cooked" stories for Reuters. "I showed her how we use cables and other information, throw them all in, stir things up for an hour, and then out comes the story line of the day." Having

An with Francis FitzGerald, Beverly Deepe, and Seymour Freiden, 1966. PHAM XUAN AN PERSONAL COLLECTION

An with his colleagues in the *Time* bureau office.

PHAM XUAN AN PERSONAL COLLECTION WITH PERMISSION OF LE MINH AND TED THAI

been born under the sign Virgo, An felt he should be Deepe's protector as well. "She was so young, so brazen, and so adventurous, she took so many risks," said An. He cited as an example the Buddhist demonstrations at the U.S. Embassy. The Vietnamese riot control ordered everyone to disperse, but Deepe insisted on climbing the electrical fence in order to take pictures and see what was going on. An went to Colonel Bui, one of the original six light infantry commanders he knew from years earlier, who was in charge of the riot police that day, and "I asked for advance knowledge of the attack against the demonstrators so that I could get my boss out of there."

Deepe's blunt coverage of the war quickly got her banned from official briefings at the U.S. Embassy by direct order of Ambassador Maxwell Taylor. "They don't like me because I won't say what they want me to say. They accuse me of giving the Vietnamese line, when in fact what I do is listen to them and then go out and find out for myself."[23]

A January 8, 1965, article in *Time* focused on Deepe's exclusive interview with General Nguyen Khanh, concluding with the observation that Deepe "has developed resources and contacts that largely obviate the need for getting along with the embassy, or even with Saigon's somewhat clubby and introspective press corps. What she does not know she can usually get from her two Vietnamese assistants, both wise in the labyrinthine ways of the country's politics."[24] Those two assistants were An and Nguyen Hung Vuong, the same person Lou Conein had spoken of earlier. "She learned so much from me and Vuong," said An. "She was another one who was open to learning about Vietnam's history and people so that she could understand the war."[25]

Deepe is one of the few former close friends who felt betrayed by An's deception. She broke off all contact with An and his family, distressing them all since she had not only helped defray the medi-

cal costs associated with the birth of An's children, but also provided shelter for An's family at her home in Virginia after they fled Saigon in 1975. "She was a blood member of our family," said An. "The very first time I celebrated a birthday was at a party offered by Beverly Deepe and Charles Keever [her future husband] in 1968. I was so moved by their kindness." Over the course of my many visits with An, he always asked if I had any luck in reaching Deepe. I told him the truth: yes, I had reached her by e-mail at the University of Hawai'i's School of Communications, where she was on the faculty, but she would not speak about An. "I loved her so much, my children and my wife still love her. I still hope one day before I die we can reconcile, like our countries have done," An said with great sadness in his eyes.[26]

An was soon introduced by Bob Shaplen to Frank McCulloch of *Time*.[27] McCulloch, a former marine, covered just about every major battle in 1964–65, spending most of his time with the 9th Marine regiment. He later received a plaque naming him an honorary member. In early 1964 the *Time* and *Life* staff—like the war—was small. John Shaw was the resident Saigon stringer, and he and Frank worked out of Shaw's apartment on Cong Ly Street as well as McCulloch's hotel room in the Caravelle. The American military presence was about sixteen thousand. Soon Jim Wilde arrived, and they moved to room 6 in the Continental. In 1964 the Saigon bureau hired its first full-time Vietnamese employee, Nguyen Thuy Dang, as office manager. As the war grew, Frank told Dang to find a new office. They moved to 7 Han Thuyen, four blocks west of the Continental, a half block from the city's Catholic cathedral, the cable office, and post office. By the time McCulloch left, *Time-Life* had its own villa, five rooms in the Continental, including room 6, which was the *Life* office.[28]

McCulloch was immediately impressed by An. "He lived up to

every expectation I had. He had great knowledge of the changing landscape. I can say, in retrospect, that being a spy never warped his journalism." Still, working for *Time* provided distinct advantages. "I now see An's role was to listen, not plant stories," McCulloch told me. "Therefore, the bureau office provided a perfect listening post for his other job because the political and military data was discussed openly."[29] Robert Sam Anson wryly observed that "what better cover was there than for him to collect all this information while working for a news organization whose enthusiasm for the war made it MACV's and the Embassy's favorite repository for leaks. It was brilliant, and the most delicious irony was that all the while the empire of Henry Luce, the great Asian anti-Communist, had been paying his salary."[30]

Jon Larsen was *Time*'s bureau chief from late 1970 to 1971, having replaced Marsh Clark. He recalled for me that "An was our correspondent, our translator, our all purpose go-to guy. You could always get a good briefing from him. He was our information broker. He did not sit around the office; in fact, it was best to make an appointment, and he'd always show up, sit, and talk with you. I never did suspect. I knew him to be an ardent nationalist."[31]

As rudimentary as it sounds, An came to rely on Joseph and Stewart Alsop's 1958 book, *The Reporter's Trade*, written by two highly regarded Washington reporters renowned for their conservative anti-Communist views. An saw himself as the new type of defense reporter described in the book. He would often take the book from his library shelf and say to me, "Read this and then we can talk." One assigned page: "Defense reporting is altogether different from war reporting which has not greatly altered since the first war reporters took the field at Sebastopol and Bull Run. The defense reporter follows scientific publications instead of troops... he tries to report currently on the enormous changes in the national strate-

gic situation that are continuously taking place in this era of run-
away technology. This extreme fluidity of every nation's strategic
situation, even the situations of the giant powers, is an altogether
new thing in the world."[32]

An was especially enamored of the chapter "Some Trade
Secrets," which postulated that newspaper reporting was a craft or
trade in itself and required a sturdy constitution, "some feeling for
the English language," and a "knowledge of history." An told me
that he learned "the rule of the feet" from this book, meaning that
a good reporter needed to get out from behind the desk and see at
least four officials every day. "If you get out, and see what is going
on yourself and talk to a great many people who are responsibly
involved in what is going on, one can hardly help doing a good job
of reporting," wrote the Alsop brothers.[33]

An was hardly anonymous in his cover; indeed, he seems to have
incorporated the same modus operandi as he did at Orange Coast
College, which was to allow himself to be as visible as possible in
hopes that this would make him least likely to be suspected as a
spy. Bob Shaplen featured An in a 1972 *New Yorker* essay on the
subject of reporting from Vietnam. The biggest challenge facing
an American reporter in Vietnam was gaining access to the market-
places or coffee shops that constituted Saigon's informal rumor
mills. Shaplen had come to rely on his close friend Pham Xuan An:
"[He is] employed by an American news magazine and is probably
the hardest-working and most highly respected Vietnamese jour-
nalist in town...An, being a journalist who, though he works for
the Americans, is also trusted by the Vietnamese, makes a point of
visiting at least five of these (rumor) places each morning before
he heads to the Givral; and then after lunch, he goes to the official
American and Vietnamese briefings and back to Givral."

Shaplen then quoted An's own description of what qualities

made for an effective reporter in Saigon. "It takes a long time to build up your sources. You have to be frank and sincere, and you have to protect your sources," observed An. "You must also do them favors—tell them things they want to know, buy them lunches and dinners, give them Tet gifts. Saigon operates in this pattern of social circles. If you are not qualified for one particular circle, you won't be accepted in its restaurant. The people there will just ignore you. Journalists—the good ones—are the most useful informants, because they are in a position to hear things from so many different sources."[34]

To his last breath, An insisted that his job as a spy never influenced his professionalism as a journalist. "To work for *Time*, you had to be objective. Learning that helped me with my national obligation. The American press was different than any I'd known. A good reporter reports exactly what he sees and you get it right. You should not rationalize. So when I wrote for the Front, I'd ask myself, 'Am I being objective on this?' I learned a lot being a correspondent. And I learned a lot from America. It helped me open up my way of thinking."[35]

As if to demonstrate his loyalty to *Time*, An frequently claimed that he "saved" his magazine from jumping into several traps set up to embarrass correspondents. Former CIA agent Frank Snepp, who served two tours of duty in Vietnam as an analyst and counterintelligence officer, identified Shaplen as the target of disinformation campaigns initiated by the CIA with the sole purpose of showing (by creating) a Viet Cong bias in reporting.[36]

An told me that he got wind of a planted story about a renegade group of disenchanted Viet Cong who were attempting to overthrow the NLF. Some journalists took the bait and went to an area in Long Khanh to meet with a representative of the National Liberation Front, who told them about a coup attempt in Song Be province.

Jean-Claude Pomonti wrote a lengthy article that was published on the front page of *Le Monde* with the title "A Coup d'État in the Jungle."[37] The story was picked up by many other news agencies. The only problem was that it was all a CIA disinformation plan to discredit journalists. An told me that Pomonti was embarrassed and his professional reputation tarnished.

Time bureau chief Stanley Cloud had wanted to send someone to cover the story, but An urged him not to do so, knowing it was false. He asked Cloud how could there be a coup in the jungle that no one else knew about it? When the Pomonti story was published, Cloud called An into his office, shouting, "Why, why, why did we not run this story; why did you not cover this?" An could only tell him, "Look, my sources tell me it was a fake and there was no coup. Trust me, I guarantee my source."[38] When I spoke with Cloud and McCulloch about this, they said that there were several times when An urged each of them to avoid a false lead, whether it had been a planted one or just based on bad information.[39]

An felt badly that he could not stop his friend Jean-Claude Pomonti from going into the jungle, and a few months later helped Pomonti make contact with real spokesmen from the NLF by instructing him how to find a liberated area.[40] According to Pomonti, after the signing of the Paris Agreement, many reporters wanted to visit the VC "liberated zones" and write articles about the "other side." One afternoon An came to see him in his room at the Hotel Continental. They chatted, and when leaving, An casually mentioned that if Pomonti wanted to discover a VC zone, he could take the road to the city of My Tho (about sixty kilometers south of Saigon), then before arriving at My Tho, take the road to the My Thuan ferry, then before coming to the ferry stop at a hamlet called My Qui. An then said, "People say that there one can pass [to the VC zone]." The next day, Pomonti said his group was able

to reach the "VC liberated zone," where he was greeted with banners saying, WELCOME TO THE INTERNATIONAL PRESS. Pomonti spent two days in the "liberated zones" and attended a theatrical performance.

"I had to help him the second time to make up for saying nothing the first time," An explained. "I could save *Time* from embarrassment, but if I told Pomonti and no one went to the fake story, my cover would be gone."

An told his Vietnamese biographer, Nguyen Thi Ngoc Hai: "People usually have only one profession, but I had two: following the revolution and working as a journalist. These two professions were both extremely opposite and extremely similar to one another. Intelligence work involves collecting information, analyzing it, and keeping it secret, protecting it like a mother cat protects her kittens. Journalists, on the other hand, collect information, analyze it, and then broadcast it to the entire world."[41]

ALL OF THESE SKILLS and talents would manifest themselves in An's almost schizophrenic life during the Tet Offensive. "We took a motorized sampan up and down the Saigon River to investigate the location of gasoline and also security posts," said Tu Cang. An later described this as "rather dangerous, and dangerous to a degree that was not truly necessary."[42] They also drove around Saigon in An's green Renault, identifying the easiest targets for attack, with An advising ways to avoid security systems. During their time together, Tu Cang informed An that he had received a medal for Ap Bac. "I can never wear the medal until the play ends," An replied. "I will only be happy to wear it at that time of liberation."[43]

Tran Van Tra would eventually settle on five main targets—the Presidential Palace, Tan Son Nhut Airport, the Directorate General

of National Police, the Office of Special Forces of the Capital, and the Saigon Office of the General Staff. A second group of targets included Radio Saigon, post offices, the U.S. Embassy, the Saigon Navy Command, as well as ports, warehouses, power stations, and other logistical installations and government offices. Most of these had been endorsed by Tu Cang, who would participate in the attack on the Presidential Palace.

An knew that he would be expected to cover the "surprise" attack for *Time* and assist correspondents in understanding what was going on. "This was a very difficult time for me," recalled An. "I already knew so much and was worried about my family's safety, should the popular uprising succeed. I even made arrangements for my family to stay at the home of Marcus Huss if necessary." Huss was the principal American liaison to the Vietnamese government in regard to pacification.[44] "I also knew that I needed to be available to my colleagues, who would need to know what was going on, but I was also expected to write a report for the jungle on the operation."[45]

During the early morning hours of January 31, approximately eighty thousand North Vietnamese regulars and guerrillas attacked over a hundred cities throughout South Vietnam. Tet involved enemy attacks on thirty-five of forty-four provincial capitals, thirty-six district towns, and many villages and hamlets. For weeks prior to the offensive, enemy forces had been filtering into Saigon in civilian clothes in preparation for a well-planned campaign of terror. The goal was to demonstrate that not only could the countryside not be pacified, but now South Vietnam's cities, including Saigon, were not secure. William Tuohy, who received the 1968 Pulitzer for his reporting from Vietnam, provided a firsthand description of the fighting: "A truckload of U.S. military policemen had been gunned down just outside Tan Son Nhut airport and all hell was breaking loose around town. A group of Vietcong were holding off

the national police force in a building only a grenade's throw from Independence Palace."[46] Inside Saigon, attack units occupied the radio station for several hours, the U.S. Embassy, part of the palace, and gates 4 and 5 of the Office of the General Staff of the Army.

The front page of the February 1 *New York Times* showed a picture of the U.S. Embassy in Saigon under assault. Guerrillas had blasted their way into the embassy and held part of the grounds for nearly six hours. All nineteen guerrillas were killed, as were four MPs, a marine guard, and a South Vietnamese embassy employee. The attack on the heavily fortified Presidential Palace was led by Tu Cang. "The Viet Cong took refuge in an unfinished apartment building across the street and held out for more than fifteen hours in a running gun battle until nearly all of the small unit was killed," wrote former *Washington Post* diplomatic correspondent Don Oberdorfer.[47]

Tu Cang was a renowned marksman. "He could shoot K-54 pistols with both hands, firing one shot a second and never missing the target," said An. He always kept one bullet in his pocket, a bullet that he reserved for himself if necessary.[48] When the attacks on the Presidential Palace were repulsed, Tu Cang found himself holed up in a house across from the palace: "From my hiding place I could see that in a house directly across from the house that our commandos were defending there was a group of American and puppet officers shouting and directing their soldiers to attack the house. I thought to myself that only if something were done to disrupt the enemy's deployment of his troops would our commandos be able to escape. However, I also knew that firing a gun is something that an intelligence agent has to weigh extremely carefully, because if an intelligence agent is exposed it is very likely that an entire espionage net that has taken years to develop will suddenly be rendered ineffective. After carefully analyzing the situation, I pulled out my gun, aimed it at two American officers, fired two quick shots, and then immedi-

ately pulled back into my hiding place."[49] Tu Cang takes credit for killing the two American officers.

On February 1, Walter Cronkite did a one-minute segment on the gun battle at the Presidential Palace. The pistols used by Tu Cang during Tet are today on display next to An's Renault in Hanoi's Army Museum in recognition of the two men's accomplishments during this period.[50]

While Communist forces had been given the general order "Move forward to achieve final victory," the Viet Cong suffered major casualties at Tet, for which Tran Van Tra would be held accountable. "Our shortcomings and weaknesses were that we were not able to destroy a significant number of enemy forces and their top leaders," wrote Tra. "The operations were not effective enough to lend leverage to the people's uprising.... However, our attacks sent shudders through the enemy's vital points, and destabilized its military, political, and economic foundations throughout South Vietnam."[51] Over half of the VC committed force was lost and perhaps a quarter of their whole regular force; it would take years to recover. Don Oberdorfer explained, "The Viet Cong lost of a generation of resistance fighters, and after Tet increasing numbers of North Vietnamese had to be sent South to fill the ranks. The war became increasingly a conventional battle and less an insurgency."[52]

Nevertheless, Tet became the decisive battle of the war because of its effect on American politics and public attitudes on the war.[53] The offensive set in motion a remarkable sequence of events, including discussion as to whether tactical nuclear weapons should be used at Khe Sanh, where a fierce diversionary battle still waged. General Westmoreland now requested an additional 206,000 troops to meet his needs, bringing the U.S. commitment to almost three-quarters of a million, yet Saigon itself was not secure from attack. The rate of the war and the capacity to sustain it were controlled not

by America's superior technology, but by the enemy. There was no breaking point, no crossover point in the enemy's will to continue the struggle indefinitely. On the evening of February 27, CBS anchor Walter Cronkite told the nation that the war was destined to end in stalemate. "We have been too often disappointed by the optimism of American leaders, both in Vietnam and Washington, to have faith any longer in the silver linings they find in the darkest clouds.... For it seems now more certain than ever that the bloody experience of Vietnam is to end in stalemate. To say that we are mired in stalemate seems the only realistic, yet unsatisfactory, conclusion."

In the aftermath of Tet, An had much work to do in his job as a reporter. He took Bob Shaplen all around Saigon, providing a detailed account of how the Viet Cong had been able to infiltrate so many into the city without detection. Shaplen's March 2, 1968, *New Yorker* essay is essentially a distillation of An's insights.[54] If there was anyone who could shed light on Shaplen's questions about VC infiltration, it was the man who had just helped coordinate the plan.

Shaplen wrote about a twelve-man commando squad that had attacked the naval headquarters along the Saigon River, the same one that Tu Cang and An had checked out just days earlier. Describing that attack as "one of the boldest that had been conceived," Shaplen reported that the attack had been designed to capture the headquarters building, deploy three machine guns on the roof in order to neutralize other naval vessels in the river, and then "capture these ships and use them as ferries to bring two Vietcong battalions into the city from the far shore. If the plan had succeeded, it could have affected the entire situation in Saigon quite significantly."[55]

When the attack started, the VC commandos killed three navy guards and blew a hole in the side of the headquarters building, but all twelve commandos were eventually killed or captured. "Yes, that one was part of our assignment," recalled Tu Cang. "We checked

out the river, made reports on the different type of vessels and our impression of their defenses."

Most of the work in planning the attacks on the palace and the navy installation was the work of the C.10 Battalion.[56] When I asked An about how he and Tu Cang were able to traverse the river without drawing suspicion, he said, "Everyone knew me, and it was daylight, and if anyone thought about it they would think I was writing a story. But many agents were making reports at this time, not just me. This was very dangerous for us at the time."

An and Tu Cang both placed great emphasis on An's post-Tet analyses. "After the first stage of the general offensive, I sent a report from the city to senior leaders, saying that the situation was rather unfavorable. However, when Hai Trung took me around, I changed my opinion."[57] An attended virtually all military briefings on Saigon security, order of battle, and the American response to the attacks. "I was the only one who wrote that we won a psychological victory, that we lost and we won. I needed to explain why. My report was pessimistic in that I explained that government troops had not gone over to the other side and that we had lost so many men. I also reported that regiment commanders performed well, but while we had lost tactically, we won politically. When Tu Cang heard all this, he also changed his opinion and put this in his reports as well."

An's thinking was influenced by his friend ARVN General Tran Van Don, among others. "I could tell that morale was low, and questions were coming up about whether the United States would now leave South Vietnam. It was funny because I remember so clearly that Tran Van Don was now worried after Tet that the Americans would soon leave because of public opinion in the U.S. He came to me, and I had to reassure him with the same information I sent to jungle, 'Don't worry, you have won a big military victory in this offensive, so many were killed, and there was no general uprising.

The Americans are not going anywhere. I guarantee they will stay for years and years.' I told my superiors the same thing, but added the psychological element that I believed American public opinion would help us in the long term."

As my interview with Tu Cang drew to a close, he told me, "An really contributed to the big changes that came as a result of the offensive. Soon, Westmoreland was replaced, Johnson retired, and the United States started peace talks—everything was changing in our favor. An contributed to the unraveling of the whole American war plan. His reports were a key to Johnson going to Paris to seek a peace."[58]

The second wave of planned attacks associated with the general offensive started on May 4, 1968, with attacks on 119 southern bases, towns, and cities. Special attack units and artillery power attacked the Presidential Palace, the residence of the American ambassador, as well as the U.S. Embassy compound. "The government had a difficult time rooting out the Vietcong in May," wrote William Tuohy. "The Vietcong hoisted a flag over the Y-Bridge, so-called because it split into two sections halfway over the canal marking the southern boundary of Cholon."[59] This so-called Second Tet was also characterized by successful infiltration into the Cho Lon area, where on the first day of the fighting four journalists from Reuters and *Time* were killed by the Viet Cong.[60] An's friend, *Time* correspondent John Cantwell, lost his life along with Michael Birch of Australian Associated Press, Ronald Laramy of Reuters, and Bruce Pigott, assistant bureau chief of Reuters in Saigon.

The group had been riding in a jeep when they noticed a column of smoke rising above Cho Lon. Heading for the smoke, they soon found themselves moving through a stream of people fleeing the Viet Cong. The reporters kept going, ignoring warnings until they arrived at an empty intersection where they were

confronted by armed Viet Cong units. Cantwell, who was driv-
ing, tried to put the jeep in reverse, but it was too late. When the
VC commander approached the jeep, Birch cried out, *"Bao Chi,"*
using the Vietnamese word for newsman. *"Bao Chi,"* replied the
VC derisively and pumped three rounds from his .45 into the
correspondent.[61]

When I asked An about these deaths, the killings of Americans by
Tu Cang, the deaths of Americans and South Vietnamese during the
Tet attacks, as well as the boastful claims made by his intelligence
unit, H.63, for having killed so many Americans, he insisted that he
never knowingly hurt anyone. When I said to An that even if this
was true, people had died, he said these were "casualties of war."
When I pushed him even more, he chose to dismiss my questions
as misguided, saying more than once that "these were my friends, I
would not hurt them, but terrible things happened to many innocent
people in the war. I was defending *my country*."

It was then that An told me to ask Rufus Phillips about the day
they had visited the site of the massacre of so many innocent people
in Westmoreland's supposed "rings of steel" Hop Tac program,
designed by the general in 1964 as part of MACV's pacification
efforts.[62] "It was designed to expand security and government con-
trol and service—pacification—gradually outward from Saigon
into six provinces that form a kind of horse collar about the city,"
Westmoreland wrote in his memoir, *A Soldier Reports*. "As larger
enemy forces were pushed farther and farther from the city, satura-
tion patrolling and ambushes would further enhance security until
the task could be turned over to militia and an expanded police
force. As areas were secured, civilian agencies would be moved in to
institute government control and service, providing everybody with
ID cards, police protection, and such amenities as schools, wells,
dispensaries, and medical care. The idea was to provide a standard

of living perceptibly higher than the Viet Cong could provide. It was, in effect, a 'spreading oil spot' concept."[63]

An was fortunate that Westmoreland had created a Hop Tac Council that would assist in the overall coordination of military and civilian agencies. Many organizations were represented, including An's contacts in the Ministry of Interior, National Police, and the South Vietnamese Central Intelligence Organization. He was able to keep Hanoi posted on all pacification efforts, which is likely the reason Mai Chi Tho identified this as An's greatest contribution.

An took Phillips to the outskirts of Cho Lon where the previous night a VC ambush had killed an entire unit of self-defense forces. "When we got there the survivors were still holed up in this little fort," Phillips recalled. The attack occurred within Hop Tac's Rings of Steel, demonstrating that there was no such thing as security in this area. It was a no-man's-zone. The next day Brigadier General Fritz Freund joined An and Phillips for a return visit, which confirmed a deplorable lack of military coordination. An told me that this area was later used by the VC as a general staging area for Tet in 1968 and that he had made the recommendation.[64] "There were many more places I could have taken Rufus, but this one was so sad because of the innocent people who were also killed. I showed it to him because he needed to see that innocent people were being killed on both sides and that there was no such thing as security in these programs."

I tried returning to my point. An helped Tu Cang plan the attack on the palace and Tu Cang, the head of H.63 Hero Unit, had taken credit for killing Americans that day. Did An feel any responsibility?

"No, not the way you mean," he answered. "I showed Tu Cang the places that were most vulnerable to attack. That was my assignment. I had no weapon, and everyone knew I could not shoot anyone."

I never got any farther on this with An, who I knew felt stung by former *Time* colleague Zalin Grant's 2005 letter to the *New Yorker*, which charged, "while spying for the North Vietnamese, An transformed *Time*'s correspondents into an inadvertent network of spies for Hanoi. *Time* had high-level sources who often provided classified information on the condition that it would be kept secret and used only as background. The content of these confidential briefings was circulated internally in the weekly '*Time* memo,' which was considered so sensitive that copies were numbered and returned after a reading by the editors. The memo contained much useless gossip, but also solid-gold insider reports from the White House, the State Department, and the Pentagon. The memo was also circulated to *Time* bureaus around the world, which were also to take equal precautions; An, as a *Time* reporter, had access to it. I often saw him taking notes from the Saigon bureau chief's confidential reports. These would have included briefings by generals William Westmoreland and Creighton Abrams and ambassadors Henry Cabot Lodge and Ellsworth Bunker, which often covered operations and strategy scheduled for weeks in the future. Then An would suddenly disappear without a word, presumably to brief his comrades in the tunnels of Cu Chi. I have always questioned the American journalists who insist on romanticizing An. It was one thing to have been against the Vietnam War—many of us were—but quite another to express unconditional admiration for a man who spent a large part of his life pretending to be a journalist while helping to kill Americans."[65]

Frank McCulloch was so upset at these accusations that he sent off his own response to the *New Yorker*. The letter was not published, but McCulloch gave me a copy: "My past and continuing respect for An has nothing to do with his work for the communists and everything to do with his integrity, intelligence and fierce love of his own country...certainly I had no reason to suspect him and didn't know

until after the war ended of his communist role. I forgave it then and forgive it now for two reasons: First, An's reporting never reflected anything resembling the communist line—and I dearly wish those old files could be inspected to verify that. Second, if the situation had been reversed and more than a half million Vietnamese military were flooding into an area about the size of California, which is about the size of Vietnam, and we didn't believe in their reasons for being there, how would we have reacted? It was his country, not ours—a mistake that always costs us dearly. I didn't and don't, subscribe to An's ideology, but I refuse to budge from my conviction he had every right to hold it."

With respect to the "mysterious" *Time* memo, "that was the weekly Washington letter produced by that bureau for the information, guidance and amusement of *Time*'s editors. I don't remember numbering the copies we got in Saigon, but if we did, it was only because we didn't have enough copies to go around. About 90 percent of the 'letter' eventually wound up in print in the magazine, so if there was valuable detail for the communists there, all they had to do was subscribe. To be completely candid about it, we were cautious about its distribution only because we didn't want *Newsweek* to see it."[66]

Following the Tet Offensive, An told me he was approached by the CIA to run a cow plantation and dairy farm in Tay Ninh, between zones B and C, a known area for VC infiltration. An would be set up as a gentleman farmer, his only real responsibility to raise cows and watch the workers and report. An was very worried about this offer because he would have to leave *Time* and become a double agent, something he had no interest in doing. He was told to "get back to us" on the offer, meaning he had a way out. "I decided not to ask my superiors if I should accept because I had no interest in working as a double agent."

Thinking that perhaps the problem was being a plantation owner,

the same CIA contact suggested that An operate a cannery in the Nha Trang and Vung Tau area, again with the goal of surveillance on possible VC activities. An's sole job would be to observe activity among the fishermen arriving to sell their fish, because the CIA was trying to identify boats that were being used to infiltrate arms into the South. An quickly turned this offer down too.

Another curious offer came from the CIO, just after the signing of the Paris Accords in 1973. Knowing that the Provisional Revolutionary Government (PRG) delegation was staying at a nearby hotel, the CIO hatched a plan to bug Givral with electronic listening devices, certain they could obtain valuable information from their conversations concerning plans for a "coalition government." Givral was privately owned, so the CIO wanted An's wife to buy Givral with CIO funds. An wanted no part of this, but the bugging of Givral proceeded, and part of the shop was renovated into an ice cream and milk café to disguise the real purpose of the renovations, which was to install the equipment. "It was an easy way to get caught. No one can protect you but yourself," An said.[67]

Most colleagues assumed at one time or another that An must have been working in some capacity for the CIA. Richard Pyle, *Associated Press* bureau chief in Saigon from 1970 to 1973, recalled that every day, from his regular table at the Givral, "An dispensed tidbits of Saigon's convoluted politics and presidential-palace machinations to a rapt audience of disciples—the Vietnamese reporters who worked for the foreign press and networks. These reporters then returned to their offices with the latest inside information from their 'sources.' It was no mystery where the information was coming from, and a standing press corps joke was that anyone with An's connections must be CIA."[68]

It was logical for the CIA to attempt to recruit An. It was well

known that pro-government labor unions were full of Communists and the unions were becoming holding tanks for infiltrators. A CIA contact asked An if he would be willing to work under the guise of doing stories on the union, keep his eyes open on suspected VC activity. In return, the CIA would feed An some super scoops, thereby raising his stature at the magazine. An told me he had declined the offer, pointing out that he already had good sources, knowing privately that this work was too dangerous for his cover.

An went back a long way with his CIA contacts, beginning with Lansdale, Conein, and Phillips. In the aftermath of the unsuccessful 1960 coup against Diem, station chief William Colby recommended that Dr. Tuyen create a Vietnamese Central Intelligence Office. Tuyen called into his planning circle only those he knew could be relied on, and of course An was one of those.[69] "Everyone in the CIO considered me one of their own," says An. "They were my best source for information during the war." This group worked hand in hand with the CIA in creating the South Vietnamese counterpart.

When the war ended, An faced questions about whether he in fact had worked as a double agent. "I was lucky because if I had worked for the CIA I would have had big problems with the security people. I was watched very carefully because I was the only one for twenty-three years who did not get caught and they wanted to know how that happened. They could not check on my connections because I worked for myself. I was a special case because no one gave me orders. I had no handlers. I sent in my reports, and they never said a word until the war was over on anything except Ap Bac. Then after the war they asked me to write up everything I did in a report for the decorations I was going to receive. I did that but then they wanted more. They wanted to know about all my connections, they wanted me to report names, of all my friends, everyone

I had worked with all those years. I refused. I had too many friends who trusted me. I would never reveal a source either. Then they thought I had a protector, maybe in the Chiang Kai-shek network like my friend Francis Cau, head of intelligence in Southeast Asia, who often came to my home. His job was to root out Communists in Cho Lon, and he often shared his information with me and wanted me to work for him too."

TWO OF THE MOST instructive cases for demonstrating An's apparent objectivity to his dual professions and which dispel the charge of disinformation can be seen in Lam Son 719 and the 1972 Easter Offensive.

On February 8, 1971, twenty thousand South Vietnamese troops crossed into the Laotian panhandle to interdict the Ho Chi Minh Trail in an operation code-named "Lam Son 719" in commemoration of Emperor Le Loi who had been born in the village of Lam Son and who had defeated a fifteenth-century Chinese invasion.[70] The immediate target was the small Laotian town of Tchepone, some twenty-five miles from the border with Vietnam. The town was adjacent to Route 9, and virtually all of the roads of the Ho Chi Minh Trail led through this area.

That An forwarded his analysis predicting the Laos action was unremarkable. "Everyone knew about Laos well in advance, except those in charge," An told me. "My primary military contacts included an ARVN colonel, paratroopers, and special forces. I remember the day I met the colonel, who had been gone from Saigon for a few days. He was tan, and I knew he had been somewhere else, so I said, 'Have you been fishing in southern Laos?' He smiled and I knew the answer right then. I was worried because I knew what was awaiting all of them. I told him to be careful and look at the maps for

An walking to Givral,
1973.

Doug Pike took this photo of Blanche Cao, Myrna Pike and a
friend, having lunch with Thu Duc 15 kilometers from Saigon.

Communist activity. I could not jeopardize the other side's plans, but I wanted my friends to be careful."

One of my regrets was not asking An to elaborate on this struggle or tension between knowing that friends were walking into a terrible trap that he and others had contributed to, yet being unable to do anything except say, "Be careful." I wondered if he had sleepless nights or felt the moral ambiguity in his life.

Planning for Lam Son 719 began in November 1970; by January 1971 there was an observable increase in military activity in preparation for some type of action. An picked up information from one of his sources in ARVN about planning for an impending cross-border attack that was to begin before the rainy season set in, thus disrupting utilization of the Ho Chi Minh Trail for a much longer period of time. Richard Pyle and Horst Faas of AP later wrote that "northern spies were everywhere in the south, from the hootch maids cleaning up after the GIs, to the ranks of ARVN, to the Saigon press corps—and, as would later be reported, even inside the Danang headquarters of Eye Corps where Operation Lam Son 719 was being planned."[71]

When An was ready to send his report forward, he walked along a prearranged street while Nguyen Thi Ba carried a tray of costume jewelry that she dropped on cue. An stopped to help her pick up the jewelry and passed her the report. Eventually the report reached COSVN and defense preparations were made for Lam Son 719.

An's private assessments on Lam Son to Shaplen were right on the mark. "An—the Laos invasion was planned way back...the communists knew of it maybe six months ago." Citing "three probing operations, with the last one on Dec. 8th, lost 200, so really telegraphed."[72] An was telling Shaplen the truth about Communist intelligence knowing in advance. In their own post–Lam Son assessment, ARVN General Cao Van Vien and Lieutenant General Dong

Van Khuyen wrote that "the enemy was not surprised by Lam Son 719 and was fully prepared to meet our forces head-on."[73]

The North Vietnamese lost over twenty thousand troops, but ARVN, in their first big opportunity to go into action without American advisers and troops, lost over half of its force and the United States lost 108 helicopters with another 618 damaged. An provided another remarkable post–Lam Son analysis for Shaplen, beginning with ARVN tactics and failure to open up Route 9. "They ended by using half French and half U.S. tactics, but assimilate French more. Moved by road slowly at outset. They should have used the Abrams pile in tactic. So they fell between stools." An was especially critical of intelligence: "G-2 not good, detected tanks only an hour or so before they close." Shaplen inserted a note to himself that "An keeps saying we'll survive—because CP [Communist Party] doesn't dare take it all." Lam Son was an all-ARVN mission with no U.S. advisers along to observe the South Vietnamese. An apparently could not resist telling Shaplen another truth: "As long as US advisors were along, it was hard to lie. Now it's too easy."[74]

An was equally objective in explaining the 1972 spring Communist offensive, which began a few months following Lam Son on Easter Sunday, March 30, 1972. This was the largest attack launched by North Vietnam during the entirety of the Vietnam War. Lasting six months, the offensive was designed as a conventional military attack by the armed forces of North Vietnam to inflict a crippling blow against ARVN forces. General Giap hoped to use massive waves of troops to capture and hold territory, including major South Vietnamese cities such as Hue and Da Nang. This would enable the NVA to potentially attack Saigon itself.

An provided Shaplen with an accurate assessment of Communist strategy. "No US troops now is of course vital change. In 1965 they had to prepare to fight 200,000 men and they figured on this, but not

now....May and August, 1968 were designed to force us to talk and halt bombing, even tho for diplomatic reasons they had to lose a lot of people. Forced us to de-escalate. Strategic gain, tactical loss, but worthwhile...Fatherland Front was culmination of the reevaluation. Communist Party learned very fast. US bought time for GVN but lack of leadership prevented GVN from taking advantage of time bought. Political leadership is therefore still the key, no leaders."[75]

Nixon believed that the North Vietnamese had committed itself to a "make-or-break" campaign for 1972. On April 1 Nixon ordered the bombing of North Vietnam within twenty-five miles of the DMZ. By April 14 he ordered air strikes up to the 20th parallel. The Paris peace talks were suspended. "Those bastards are going to be bombed like they've never been bombed before," Nixon told his National Security Council. What followed was the most successful use of air power during the war and one of the largest aerial bombardments in world history, Operation Linebacker I. Targeting roads, bridges, rail lines, troop bases, and supply depots, the attack utilized precision-guided laser bombs for the first time in modern aerial warfare. Led by fighter-bombers rather than B-52s, it also provided effective close-air support to South Vietnamese ground troops. The end result was fifty thousand dead NVA, and the estimated destruction of 225 tanks and heavy guns.

The Easter Offensive in the short term was clearly a military defeat for the North Vietnamese. By spreading its troops across three disparate fronts and attacking in massive waves, the North Vietnamese were spread too thin and proved unable to pour enough firepower on any one point to win major territory. Because of the sweeping scale of the conventional attack, many North Vietnamese units were annihilated (some battalions were reduced to fifty men), which made them combat-ineffective for almost two years. But the more crucial local bases of North Vietnamese supply in South

Vietnam survived. Hanoi's casualties from its conventional offensive were staggering, losing over half of the two hundred thousand troops committed to the fighting. The reality of the disappointing results of their spring offensive forced Hanoi to the decision to seek a negotiated settlement. They had misjudged Nixon, and now it appeared that Nixon was destined to win reelection in November.

An did not try to spin this with Shaplen. "They did underestimate government resistance and US help. Communist Party has been hurt but not to point of being paralyzed. Despite their heavy losses of last two months, they are not shaken in that determination. This campaign will thus be followed by others ... Communist Party has all come back now, same old units of 1966 on up, all back in. Meanwhile we—the US—haven't returned and can't ... learned at Lam Son—saw new 'objective opportunity' of launching new offensive now.[76] ARVN was being Vietnamized. Coincided with US elections, which they couldn't altogether predict. They had to take risk of attacking now ... Nixon is tough and won't negotiate. We have blown this up too much again as an invasion, to call for world opinion against it, but in reality all we do is scare our own people and get Nixon on edge."[77]

An had already received three Exploit medals when he spoke with Shaplen about Lam Son and the Easter Offensive. His reputation as a journalist was unquestioned. "I first met Pham Xuan An in 1972, when I arrived in Vietnam as a 24-year-old war correspondent for *Time*," recalled David DeVoss. "By then, An was a legend, a jovial boulevardier nicknamed 'General Givral' after the Tu Do Street coffee shop he frequented. Despite the prevailing climate of suspicion, everybody trusted An."[78] His cover was impregnable and for over a decade, An's H.63 intelligence network had protected him and his documents. One final mission remained—the defeat of the southern nation.

THE BLURRING OF ROLES: APRIL 1975

I'll look them square in the eye and say—all right, what do you want to do with me? I'm a southern land-owner's son.[1]

—Pham Xuan An to Robert Shaplen, April 1975

AT TEN THIRTY ON THE MORNING OF February 5, 1975, the twenty-fifth day of the twelfth lunar month, an Antonov AN-24 aircraft took off from Hanoi's Gia Lam military airfield bound for Dong Hoi, a small fishing port located approximately three hundred miles south. On board was four-star general Van Tien Dung, who had lived in the shadow of North Vietnam's other four-star general, the more heralded commander-in-chief Vo Nguyen Giap. Dung had been the army's chief of staff since 1953, and at the age of fifty-six was now the youngest full member of the politburo.[2]

Extraordinary levels of secrecy and deception had gone into Dung's departure. The driver of the Russian-built Volga automobile that took him to work was instructed to continue making the two routine trips a day between army headquarters and Dung's home.

Soldiers were instructed to continue their daily volleyball games in front of Dung's home. Hanoi's newspapers reported on Dung's supposed activities around the city for weeks after his departure.[3] Dung even prepared personally signed postdated Tet holiday gifts for mailing when he was away. He also signed in advance telegrams of congratulation for the armed forces anniversaries of the Soviet Union and the German Democratic Republic in February and of Mongolia in March 1975, so that they could be sent on the appropriate days. Aliases were created for coded messages between Generals Dung and Giap: Dung would be known as "Tuan," Giap as "Chien."[4]

In Dong Hoi, Dung was greeted by Major General Dong Si Nguyen and a group of cars from the 559th Division command. Dung was then taken to the Ben Hai River, where he boarded a motorized boat; by late afternoon on this especially cool day, they had arrived at the headquarters of the 559th force, west of Gio Linh.

Dung was focused on the politburo instructions for his new command, Campaign 275, to liberate the South. Intelligence agents in Saigon had reported the complete details of a meeting held less than two months earlier at Independence Palace between President Thieu and the commanders of his armed forces and military regions.[5] Unbeknownst to anyone in the room, Dung had an agent at this meeting about Communist war aims for 1975. Within two weeks a complete account of that strategy session had reached Dung, who now knew the strategic thinking of Thieu and his commanders in response to what they thought were Dung's own war plans. Thieu believed that because of significant casualties inflicted against the Communists in both 1968 and 1972, North Vietnamese forces had the ability to attack only small isolated towns. While anticipating an attack in the Mekong and Central Highlands, the decision was made not to reinforce the Western Highlands. "I had good sources at that

meeting, and they told me about Thieu's assessment," An explained. "I received detailed accounts from at least two people and immediately wrote my report."

An's work during this period, most especially his contributions just prior to Campaign 275, would earn him a final Exploit medal. "I didn't know what he had done before. But during the period I was the head of the intelligence network, Hai Trung managed to obtain all U.S. documents of strategic importance every year," said Ba Minh, his immediate supervisor during this final phase of the war.[6]

In October 1974 the Central Military Party Committee met with the politburo in Hanoi to discuss whether or not the war was at its final stage. The key question according to General Dung was "did the Americans have the ability to send troops back into the South when our large attacks led to the danger of the Saigon army's collapse?"[7] Members of the joint meeting discussed Watergate, the resignation of Richard Nixon, and congressional funding cuts. The conference endorsed a general staff plan that called for a "large-scale, widespread 1975 offensive" in the Central Highlands.

By early December, the politburo called all leading party members and battlefield commanders in the South to Hanoi to assess the strategic plan for the 1975 offensive. One of those making the journey north was General Tran Van Tra, who had last traveled the Ho Chi Minh Trail in 1959, moving north to south along the original trail, known as Route 559. That trip took him four months; this time it would take ten days. Climbing into the front passenger seat of the Russian-built GAZ69 on November 13, 1974, Tra looked in the back to see COSVN chairman Pham Hung, the highest ranking Communist in the South. The car turned onto Route 13 in Loc Ninh district, home of the B-2 regional military headquarters that now served as the capital of the Provisional Revolutionary Government. Less than a hundred kilometers from Saigon, it turned north on

Route 13, traveling in broad daylight with little fear of attack from the depleted ARVN reserves, who were under orders to conserve ammunition and fuel. Within an hour they crossed the border into Cambodia, turning northwest along the banks of the Mekong near Kratie, where they boarded motorized sampans. When they reached southern Laos, they transferred back to automobiles and continued along the Ho Chi Minh Trail. At Dong Ha, they turned north for the final leg of their journey to Hanoi.

The meeting would last twenty-two days, from December 18, 1974, to January 8, 1975, and provided Tra with an opportunity for redemption. He had paid a heavy price for his 1968 plan to achieve a general uprising at Tet. His record blemished, Tra had lost his chance to join the politburo. "Now, as a member of the Communist Party Central Committee and lieutenant general in command of communist military forces in the lowlands–Mekong delta region, he again made plans for the conquest of the South."[8]

The conferees were deeply divided on Tra's strategy and time-table. Several members of the politburo remained concerned about how the Americans would react to a renewed offensive. They had underestimated Nixon badly in April and December 1972; memories of the Linebacker attacks were at the forefront. Bui Tin, the man who later accepted the surrender of the South on April 30, 1975, described the December 1972 bombings as being "like living through a typhoon with trees crashing down and lightning transforming night into day."[9] But now Nixon was gone. Watergate had unraveled his presidency and with it the numerous private assurances made to South Vietnam's president Nguyen Van Thieu that America would not abandon its ally when faced with the type of attack currently being planned. "Watergate probably stopped another bombing—to really destroy the north,"[10] An told Shaplen, who considered this to be such an important point, he wrote "PT PT" after An's remark.

The Linebacker attacks also served as a message to President Thieu—the Communists would face this same unrelenting punishment for any violations of the Paris Accords. Thieu, who viewed the accords as a suicide pact, needed to stop his obstructionism and agree to sign on. He had been told that one way or another, Kissinger intended to sign an agreement in January 1973. Thieu's choice was to accept and stand with Nixon's promise to send back the B-52s at the first sign of Communist violations or face the enemy alone.

Buttressed with private assurances from Nixon that South Vietnam would never be abandoned, Thieu relented in his opposition. The Americans would be leaving Vietnam. The essential elements of the Paris agreement signed January 27, 1973, included the cessation of hostilities and the withdrawal of American troops. The United States would halt all air and naval actions against North Vietnam and dismantle or deactivate all mines in North Vietnam's waters. Within sixty days after the signing of the agreement, all United States forces, as well as all forces of foreign nations allied with the United States, would withdraw from Vietnam. The United States was prohibited from reintroducing war materials or supplies into Vietnam and was required to dismantle all military bases in South Vietnam. The armed forces of both parties were permitted to remain in place, but the cease-fire prohibited the introduction of troops, military advisers, and military personnel, including technical military personnel, armaments, munitions, and war materiel into South Vietnam. The two parties were permitted to make periodic replacement of materiel that had been destroyed, damaged, or used up on a one-for-one basis under international supervision and control.

The United States and North Vietnam pledged to respect the principles of self-determination for the South Vietnamese people, including free and democratic elections under international supervi-

sion. To this end, a Council for National Reconciliation and Concord was created, and the United States was prohibited from intervening in the internal affairs of South Vietnam.

North Vietnam heralded the Paris agreement as a great victory. Hanoi radio, in domestic and foreign broadcasts, confined itself for several days to reading and rereading the Paris text and protocols. From the premier's office in Hanoi came the declaration that the national flag of the Democratic Republic of Vietnam (DRV) should be flown throughout the country for eight days, from the moment the cease-fire went into effect on January 28 through February 4. For three days and nights Hanoi's streets were filled with crowds of people celebrating that in sixty days there would be no foreign troops in Vietnam and that all U.S. military bases in the South would be dismantled.

In South Vietnam there was no joy or celebration. President Thieu and his countrymen knew that the diplomatic battle had been won by Le Duc Tho. Henry Kissinger had negotiated an agreement representing nothing more than a protocol for American disengagement. It was apparent to many, including assistant John Negroponte, that Kissinger acted like he had a "death wish for South Vietnam."[11]

Still, at the time of the agreement, Hanoi had no plans for an imminent attack on the South. The North needed time to restore its stockpiles and regenerate manpower levels. Internal party documents show that in 1973 the North was thinking about relaunching large-scale attacks after 1976, but political events within the United States altered these plans.[12]

An's analytical objectivity and the quality of his South Vietnamese government sources is illustrated in his analysis of the 1973 Paris Accords. An's contacts within the Thieu government, the National Assembly, and ARVN were so good that what he told Shaplen often sounded as if he were present at the meetings of October–

December 1972. In the weeks before the agreement was signed, An told Shaplen, "Thieu will get pledge from Nixon on B-52s to fight a new Tet.... in case of major Communist Party offensive they'll need B-52s.... Thieu wants economic support, political guarantee and B-52s. Aid for three years spelled out."[13] From the twenty-fourth to the twenty-sixth of January 1973, the days immediately preceding the signing, Shaplen wrote that "An feeling that we won't cut aid—can't do that in face of world opinion on reconstruction. But we might cut Thieu's throat."

An provided a sophisticated analysis of the pre-1973 political situation. "An says no conflict between North Vietnam and PRG on continuing war. There are simply two possibilities. First, to reach agreement. Second. War drags on thru 1973. The sooner there is an agreement the better. PRG documents of January he's read all say that. Stress victory. US has agreed to go...then puppets fall.... what they demanded back in 1966 is what they now have—right to participate in government.... So now the NLF has what it wanted. So maybe they will push it for sixty days—or the push for Thieu overthrow."

An also provided Shaplen with his thoughts on the post-Paris Communist strategy: "They will now try to make friends with US—diplomatic offensive—and then get rid of Thieu. Attack him on all three sides, political, economic and diplomatic. May take several years. Not unless provoked by ARVN. So line for now is to stick to agreement. They now have legal status and won't willingly or over-eagerly violate that. So-again-press on countryside and take time winning people over thru reconciliation and concord. Cities will fall in their laps later—meanwhile get people to countryside—in rainy season—and keep them there."

An told Shaplen that from the Communist perspective, "carry out agreement altogether is what they want, there is no doubt about it.... GVN is purposely lagging. They want status quo still or

elections on their terms which Communist party won't buy. Their attitude is that North Vietnam and US confronted them with a fait accompli, a brutal peace, so they will try to keep status quo as long as they can and strengthen their position.... But there are also too many internal problems here, and this is another reason we can't negotiate. Economic, political and military problems, corruption, social problems and socially—must straighten that out before we can deal with the other side."

Perhaps the most distressing aspect of the Accords from Thieu's perspective was the cease-fire in place, allowing the North's army to remain in the South. In October Kissinger returned from Phnom Penh and went directly to see Thieu, who was in a tense and highly emotional state. "Now that you recognize the presence of North Vietnamese troops here, the South Vietnamese people will assume that we have been sold out by the United States and that North Vietnam has won the war," Thieu said to Kissinger.

How could he be asked to accept the presence of 200,000 to 300,000 North Vietnamese troops—"if we accept the document as it stands, we will commit suicide." Pointing to a map on the wall, Thieu said, "What does it matter to the United States to lose a small country like South Vietnam? We're scarcely more than a dot on the map of the world to you. If you want to give up the struggle, we will fight on alone until our resources are gone, and then we will die...for us, the choice is between life and death. For us to put our signatures to an accord, which is tantamount to surrender would be accepting a death sentence, because life without liberty is death. No it's worse than death!"[14]

Making matters worse, Kissinger left the Cambodian leader Lon Nol with the false impression that an agreement had been reached and that Thieu had endorsed the Accords. An ebullient Lon Nol offered a champagne toast: "Peace is at last coming. We are going

to drink to it and to compliment Dr. Kissinger on his mission." An's contacts were again the best in town; he told Shaplen: "An says Thieu did send letter. Also told HK—if we die now or six months later, no difference. Also says Haig didn't get along that much better...Thieu will resist the accord, mobilize, and insist Hanoi deals with him...HK lied to Lon Nol."[15]

An communicated all of this dissension between Kissinger and Thieu to Hanoi, and he later told me that this is why *Newsweek*'s Arnaud de Borchgrave was invited to Hanoi for an exclusive interview with Premier Pham Van Dong. De Borchgrave had not even requested the meeting, but Hanoi saw a chance to embarrass Kissinger in the eyes of the South Vietnamese. The October 23 *Newsweek* interview quoted Dong as saying that an accord had already been reached, with the signing scheduled for Paris on October 31. Hanoi also released the full text of a draft agreement that was still being negotiated between Kissinger and Le Duc Tho. Dong referred to a "coalition of transition" and said that events had simply overtaken Thieu. The interview with Pham Van Dong was intended to present a fait accompli in the eyes of public opinion, especially American public opinion; to demonstrate the bad faith of Nixon and Kissinger in seeking peace; and to show to the Soviet Union and China that Hanoi was genuinely trying to come to an agreement with the United States and deserved to receive continued aid from them. "That was An's greatest achievement, in my opinion," recalled Ambassador Nguyen Xuan Phong, who served from 1965 to 1975 as a cabinet minister in the Republic of Vietnam government in South Vietnam.

Kissinger was forced to return to Washington, where on October 26 he held a press conference on the status of the Vietnam negotiations. "Ladies and gentlemen, we have now heard from both Vietnams, and it is obvious that a war that has been raging for ten

years is drawing to a conclusion, and that this is a traumatic experience for all of the participants. The president thought that it might be helpful if I came out here and spoke to you about what we have been doing, where we stand, and to put the various allegations and charges into perspective ... we believe that *peace is at hand*."

An insisted that he derived as much personal satisfaction from getting the story right for *Time* as in embarrassing Kissinger for Hanoi. *Time*'s bureau chief, Stanley Cloud, agreed. An went to Cloud to say that he had picked up tips from several sources that there was a breakthrough, but that peace was not going to be at hand. An guaranteed his source, although he actually had three sources—his contacts in French intelligence, the CIO, and the Communists. I later discussed this with Stanley Cloud, who confirmed that in the long run, An's story was indeed the correct one and Cloud even called Kissinger for a confirmation.[16] "An kept telling me 'there is no peace plan, things are still very vague, nothing is settled,' " recalled Cloud. "I'm quite proud of what he did for *Time* on this story and many others." An insisted that one of the reasons Arnaud de Borchgrave raised the charge that he was an agent of disinformation centered on what happened in October 1972. "We scooped him with the better story and he knows it," An told me several times.

The resignation of Nixon on August 9, 1974, stunned President Thieu and altered the equation on the guarantees made by the former president. The one person who had assured him was gone, although on August 10 the new president, Gerald R. Ford, wrote that "the existing commitments this nation has made in the past are still valid and will be fully honored in my administration." But the tide was changing in American politics. In the November 1974 congressional elections, the Democrats gained forty-three seats in the House and three in the Senate, leaving them with huge majorities of 291–144 in

the House and 61–39 in the Senate. Americans were ready to turn away from Vietnam, to bury the entire sordid history.

All of these factors help explain why Tran Van Tra and his fellow southern commanders were in Hanoi and why General Dung would soon be heading south. As Tra made his case, news came about a major Communist victory at Phuoc Long province, some seventy miles from Saigon. That battle plan had been devised by Tra as a test of American resolve. Even though some members of the politburo disagreed with Tra's plan, North Vietnam's leader Le Duan personally approved the attacks, warning his top commander in the South to "go ahead and attack.... [But] you must be sure of victory."[17]

Relatively isolated Phuoc Long was easy pickings for the NVA 301st Corps, which included the war-tested 7th NVA Division, a tank battalion of Soviet-supplied T-54 tanks, an artillery regiment, an antiaircraft artillery regiment, local sapper and infantry units, and the newly formed 3rd NVA Division. The attack commenced on December 13, 1974. Phuoc Long City fell almost immediately, prompting an emergency meeting in Saigon between Thieu and his generals. The immediate question was whether or not to reinforce Phuoc Long.[18]

"The news that we had completely taken Phuoc Long City arrived while we were in session," wrote Dung. "Everyone jubilantly stood up and shook hands with one another to celebrate the victory...It signified something about the fighting capabilities of our army and the weakness of the enemy army. A new page of history had been turned."

By January 7 the entire province was in Communist control. The South Vietnamese troops and rangers had performed well, but they faced overwhelming numerical disadvantages. Only 850 of the 5,400 South Vietnamese troops survived the carefully planned

Communist attacks. Three thousand civilians from a population of 30,000 escaped capture; the hamlet and province officials were summarily executed.[19] In the words of Colonel Harry Summers, "the little-known battle for Phuoc Long was one of the most decisive battles of the war, for it marked the U.S. abandonment of its erstwhile ally . . . In the face of this flagrant violation of the Paris Accords—and it was deliberately designed to be flagrant so as to clearly test U.S. resolve—President Gerald Ford pusillanimously limited his response to diplomatic notes. North Vietnam had received the green light for the conquest of South Vietnam."[20]

An told me that the aftermath of Phuoc Long was the only time his superiors doubted his assessment of the situation. Hanoi's intelligence reports indicated that the aircraft carrier USS *Enterprise* and its accompanying task force had moved from the Philippines closer to Vietnam and the marine division on Okinawa had been placed on alert. There was activity at Subic Bay, perhaps a signal the Americans would return. "I said they will not fight, they are making action, but it is empty, hollow. I told them the Americans would never return, but they still were not sure. They tested again at Ban Me Thuot to see if the Americans would intervene, and then they knew I was right. I sent them reports on what Thieu's generals were thinking. Then I went up there and spoke with a province chief who could only say that Thieu refused to defend the province. He was disheartened and knew the end was coming, that the Americans were gone. I knew then they were finished. Thieu thought it was OK to lose one province to see America's reaction, but I understood the American temperament was tired of the war. The B-52s were not coming back."

It was around this time that Australian journalist Denis Warner ran into An in the foyer of the Continental Hotel. Warner had just

returned from a tour of central Vietnam, where he'd seen firsthand the effect of America's slashed military assistance program. ARVN troops were short on ammunition, fuel, and pay. Morale had collapsed. Artillery units were severely restricted in the use of ammunition, and to save on fuel, helicopters were limited to medical evacuation only.

"How did you find the situation in the Centre?" An asked Warner.

"I told him that I thought that central Vietnam, despite the five divisions of South Vietnamese forces stationed there, would be a pushover if the North attacked."

Eighteen years later the two men reminisced about that conversation. "I'd just sent a courier to COSVN with a message that said I thought it was too early to launch the major offensive and that it should be delayed until later in the year," said An. And then I met you."[21]

When I asked An what he did after the meeting, he told me, "I always thought Warner was working with Australian intelligence, so I trusted his report and sent a new one almost immediately with his assessment. I later thanked him because it turned out he gave me valuable information."

An received the Order of Battle report for Phuoc Long province dated November 30, 1974. Vietnamese history books compare An's contributions during this period to master spy Richard Sorge's famous report that "Japan will not open up an eastern front," which allowed the Soviet Union to transfer its military forces westward to stop the German advance during World War II.[22]

An also secured the secret "Strategic Studies" report documenting that the ARVN was running low on supplies and morale and that it was unlikely that the American B-52s would return. The author

of the report, General Nguyen Xuan Trien, director of strategic studies for the army, identified Ban Me Thuot as the most vulnerable point in the defense system of South Vietnam.

An was very critical of President Nguyen Van Thieu, the best evidence of which is found in Shaplen's notes where An compares the effects of President Thieu's leadership with opium-addicted circus monkeys. "An: Thieu, we made him so, and if we let him go, he'll sink. Lots of Chinese and Saigonese raise monkeys, feed them opium, good food, do tricks, put on fancy hats. Circus. But when owner turns his back for three minutes, the monkey will revert to his basic nature, eat excrement, like Thieu. So if we are delaying our support for five minutes, ARVN gets swallowed up. We have created a monkey climate here."[23] An explained to Shaplen that the leadership crisis in Saigon was a direct result of the United States doing nothing to develop a new generation of leaders in Vietnam. "Blood and dollars have been spent here but what have we done to Vietnamese and Saigon? Most Americans are in contact with the monkeys and we will soon withdraw anyway. We know only the monkeys. When we came we made use of Viets trained by French, mandarin crowd, and we made the new generals. Dollars, etc. and the monkeys didn't know how to use them. No Viet doctrine, no US doctrine either. We build school buildings, but no teachers. Build roads and new canals, but Viets don't know how to use them. So the Americans can't put their brains in our hats and that's been proved. No real leadership training." An predicted that when the United States left, Vietnam would be "a dry corpse."[24]

With the fall of Phuoc Long, General Dung and his colleagues watched for an American response, but none came. Tran Van Tra recalled Pham Van Dong saying, "The United States has withdrawn its troops in accordance with the Paris agreement, which it regards as a victory after suffering many defeats with no way out. Now, there

is no way that they could intervene again by sending in troops. They may provide air and naval support, but that cannot decide victory or defeat." Then he laughingly said, "I'm kidding, but also telling the truth, when I say that the Americans would not come back even if you offered them candy."[25]

The concluding resolution of the Hanoi conference stated, "Never have we had military and political conditions so perfect or a strategic advantage so great as we have now; complete the national democratic revolution in the South and move on to the peaceful reunification of our Fatherland..."[26]

GENERAL DUNG WAS IN transit to Ban Me Thuot on the eve of Tet 1975, the Year of the Cat. Stopping at the headquarters of the 470th Construction Division stationed at Ia Drang, Dung enjoyed a traditional Tet breakfast with his soldiers of glutinous rice cakes and meat pies.[27] The final leg of his journey brought Dung to a misty, forested valley west of Ban Me Thuot, where he established head-quarters for the forthcoming campaign. "We were in a green jungle next to a forest of *khooc* trees, whose dry fallen leaves covered the ground like a golden carpet." The target would be the capital city of Darlac province, Ban Me Thuot, "the most picturesque of the highlands towns, where Rhade tribesmen in brightly embroidered garments walked the streets and where Emperor Bao Dai's now-crumbling hunting lodge still stood as a reminder of more peaceful days when he and other luminaries came to hunt boar, deer, and tigers in the surrounding hills."[28]

The next weeks were spent coordinating and finalizing battle plans. In recent years, Dung had become the prime force in transforming the North Vietnamese army into a modern military machine.[29] After the signing of the Paris Accords, Dung had been responsible for

rebuilding the North's military force and expanding the extensive network of roads along the Ho Chi Minh Trail. "The products of his efforts were a northern militia of 200,000 men to protect the home front and an expeditionary force of twenty-two divisions backed by hundreds of Soviet and Chinese tanks, long-range artillery, large-caliber anti-aircraft guns, and a variety of missiles. Perhaps even more crucial than its sheer firepower and numerical strength was the force's mobility; it could strike anywhere in South Vietnam within a matter of weeks, perhaps even days."[30]

On the evening of February 25, 1975, Dung signed the map delineating assignments, forces, and routes for the attack on Ban Me Thuot. For the next few days, Dung and his commanders readied their forces for battle. On March 9 "Tuan" sent a coded message to "Chien" in Hanoi: "On March 10 we will attack Ban Me Thuot."[31]

Forty-eight hours later Ban Me Thuot was in enemy control. This time, President Thieu could not afford inaction so he ordered the recapture of the province, issuing instructions that all forces should be redeployed to assist in the reoccupation of Ban Me Thuot. This plan was undertaken without consulting the American ambassador or anyone else. Thieu was undertaking a dangerous move by redeploying his troops in the middle of contact with the enemy. When the local populations saw troops moving from their cities, they mistakenly thought troops were running away rather than being redeployed. Mass panic ensued with a tidal wave of people fleeing toward the coast.[32]

On March 11, 1975, Tuan sent another coded message to Comrade Chien: "We are in complete control of Ban Me Thuot.... We are proceeding to wipe out all the surrounding targets." The next day Chien responded with instructions from the politburo: "Le Duan, Le Duc Tho, and Vo Nguyen Giap agreed that we must rapidly

wipe out the remaining enemy units in Ban Me Thuot" and move toward Pleiku. The complete disintegration of ARVN as a fighting force was under way.

North Vietnam was openly invading South Vietnam with its regular army divisions. Gerald Ford had spent a lifetime in Congress and understood that this Congress was not likely to fund his supplemental budget request to give South Vietnam the equipment it needed to stave off the offensive. Ford dispatched army chief of staff General Fred Weyand to South Vietnam to assess the situation and make recommendations for future action. Weyand visited Vietnam from March 27 to April 4, 1975, meaning that he was present for the fall of Da Nang on March 30.

Returning immediately to the United States for a meeting with President Ford in Palm Springs on April 5, Weyand agreed that the United States owed it to South Vietnam to do everything possible that would allow them to replenish their resources in the face of the current offensive. "We went to Vietnam in the first place to assist the South Vietnamese people—not to defeat the North Vietnamese. We reached out our hand to the South Vietnamese people, and they took it. Now they need that helping hand more than ever." Weyand recommended an additional $722 million in assistance for minimal defense in order to meet the current invasion. "Additional U.S. aid is within both the spirit and intent of the Paris Agreement, which remains the practical framework for a peaceful settlement in Vietnam." His conclusion was that "the current military situation is critical, and the probability of the survival of South Vietnam as a truncated nation in the southern provinces is marginal at best."[33]

In a final plea for assistance, President Thieu penned a personal letter to a man he had never met, President Gerald Ford. "Hanoi's intention to use the Paris agreement for a military take over of South Vietnam was well-known to us at the very time of negotiating

the Paris Agreement...Firm pledges were then given to us that the United States will retaliate swiftly and vigorously to any violation of the agreement...we consider those pledges the most important guarantees of the Paris Agreement; those pledges have now become the most crucial ones to our survival."

The final assault on Saigon was about to begin. On the afternoon of April 7, a motorcycle arrived at General Dung's headquarters carrying Le Duc Tho, the same man who had presided at Pham Xuan An's induction into the Communist Party twenty years earlier. Tho was carrying a satchel containing the final attack order, titled "Forward to Final Victory," which confirmed Dung as the overall commander with Tran Van Tra and Le Duc Anh as the deputy commanders. In his parting words, Le Duc Tho told his commanders that "even if they [the United States] risked intervention they could not possibly turn the situation around. They could only suffer a heavier defeat. We are certain to win." The politburo named their new plan The Ho Chi Minh Campaign.

The attack on Xuan Loc, the key ARVN stronghold along Route 1, commenced April 9.[34] Xuan Loc would be an epic battle of the war in which the 18th ARVN Division fought heroically against tremendous odds and demonstrated why they were the finest of all ARVN divisions. Nevertheless, after two weeks of heavy fighting and having killed over five thousand enemy soldiers along with destroying thirty-seven NVA tanks, the 18th Division was ordered to evacuate, and Xuan Loc fell to the North Vietnamese on April 22.[35] The next day President Ford told an audience at Tulane University, "America can regain its sense of pride that existed before Vietnam. But it cannot be achieved by refighting a war that is finished as far as America is concerned."

An provided Shaplen with a detailed analysis of the situation.[36]

"An most afraid of undisciplined soldiers and bandits. He says May for Saigon," wrote Shaplen.[37]

The end came sooner than most thought possible. An was shocked that the nearly one-million-man ARVN, the fourth largest army in the world, could crumble so quickly between March and April 1975. "An says that he never thought it would be so easy," Shaplen wrote in his notebook for late April 1975. "Thieu will continue to blame everyone except himself and will bring house down with him. Après moi le déluge complex," said An.[38] "No longer any justification for our lives. Fact we are still alive doesn't mean anything," Vuong told Shaplen.

President Thieu now announced his resignation, telling his closest advisors that the military situation was hopeless and that his continued presence in office could conceivably be a block to a peaceful resolution. On April 25, at 9:20 p.m., he was aboard a C-118, tail number 231, from Tan Son Nhut for Taipei. Rumors swirled that Thieu had also transported over sixteen tons of South Vietnam's gold reserves out of the country. Vice-President Tran Van Huong assumed the presidency.

THE MONTH OF APRIL had been full of anxiety for An as he worried about the safety of his family and friends. He knew time was running short. "I never gave any thought to me going to the United States, but I did not know if I should send my wife and children. I received no message from Hanoi, no instructions, and I was under pressure from *Time* to decide. All my friends wanted to help, not just *Time*, so many kind people. Malcolm Browne offered to put me on the *New York Times* list even though I worked for a competitor; a representative from Reuters came to Givral and offered me and

my family passage out. Jim Robinson, who used to work for NBC, offered to take me and my family on the plane he had chartered. Then on April 22 Bob Shaplen told me I had to decide now, for the safety of my wife and children. I said OK, give me one day to think it over."

An could never abandon his mother in Saigon, but worried that he might receive instructions from the party to evacuate with the Americans. That would mean continuing his mission in America, which made no sense to him personally. To cover all bases, he tried reaching his younger brother in Can Tho, a few hours south of Saigon, to see if he could get to Saigon as a contingency plan to take care of their mother. But he was not confident he could get to Saigon before An would have to depart, if ordered to do so by Hanoi.

The day following Thieu's departure, An's wife and four children left Saigon on a CBS News flight along with thirty-nine other *Time* employees. "We were each given one small Pan Am bag to pack some clothes and that was it," recalled An Pham, the eldest of the four children. "We were not scared because my mother protected us so well. I never thought that this was going to be the last time I saw my father. For some reason, probably because we were kids and also because of the way my parents always protected and insulated us."

An told his colleagues he was unable to leave his mother. "In life, you have only one mother and father, and we Vietnamese can never leave them like that; it is our responsibility to take care of them for their life. My father died in my arms in my home, and I would never leave my mother and she would never leave Vietnam."[39] After things settled down, An told those close to him that he would find a way to join his family. He was just so grateful that they were going to be safe and that *Time* was taking care of everything. Shaplen wrote Lansdale on May 10 that "among those who stayed back, at his insis-

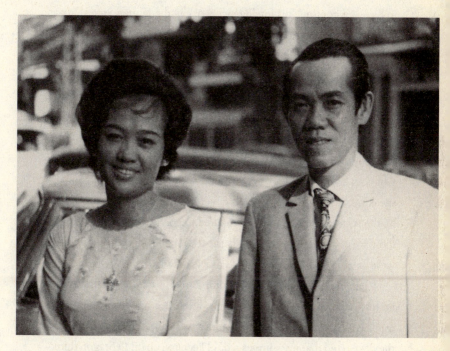

This is one of the family's favorite pictures of An and Thu
Nhan. PHAM XUAN AN PERSONAL COLLECTION

tence in the face of all the pleas, mine included, was Pham Xuan An, our old friend of *Time* ... I hope he'll be ok."[40]

What An did not know at the time was that serious consideration was being given within the politburo's Military Central Party Commission to have An continue his intelligence work in the United States. It was General Dung himself who finally decided that An should remain in Vietnam. "If he continued his work, he would certainly gather valuable intelligence information for the country. However, sooner or later he would be discovered in a foreign land, and the loss would have been great."[41] The man who had recruited An as a spy, Muoi Huong, regretted this decision. "An's ability would have been brought into full play if he had continued his espionage abroad."[42] I asked Mai Chi Tho about this idea of continuing An's mission: "Professionally speaking, it was a good idea. His cover was still intact, he was trusted by the Americans, and he was prepared to go, he was ready to go. But there was a paradox: he was ready professionally, but other conditions were at work too. He had done so much already."

When I spoke with An about continuing his mission in the United States, he emphasized that he considered it a far-fetched idea. "I don't really know what they would have wanted me to do. Maybe they expected that my sources would keep me up on Pentagon thinking, but that was unlikely since many of my contacts were in reeducation or refugees in America with no access to anything. Or maybe I could report on the organization of the newsroom in Los Angeles or San Francisco," said An, followed by his usual wry smile.

Rumors were circulating throughout Saigon that when the Northern army arrived, there would be a bloodbath. "The tension was caused not by the certainty that Saigon was going to fall, but an uncertainty about how that fall would come about," wrote William Tuohy. "Would there be heavy shelling and later door to door fighting? Would there be a bloodbath with the communists getting even

with anyone identified with the United States or the South Vietnamese regime? Would the South Vietnamese themselves, in rage and frustration, turn on the Americans who were deserting them and lash out at any 'round-eye' they encountered?"[43] An was fearful of staying at home, not knowing where artillery shells might land, but he was privy to the fact that the Communists had designated three safe havens: the French Embassy, the Grall Hospital, and the French-owned Continental Hotel. An's pockets were already filled with the keys of the departing journalists, so he decided it would best to stay with his mother in Bob Shaplen's room 407 at the Continental.

In these final days of South Vietnam, many friends were coming to An for advice, others with offers to help. American Jolynne D'Ornano and her husband, Pierre, a French businessman of Corsican birth, who owned the popular street-corner Basque restaurant, Aterbea, that was known for the best soufflé in Vietnam, came to help. Jolynne had arrived in Vietnam in 1965 to work at the Vietnam Press. She had been a student of Diem's good friend Wesley Fishel at Michigan State University, who advised her to look up An when she arrived. Fishel had met An much earlier when they were introduced by a mutual friend, Edward Lansdale.[44]

Jolynne fell in love with the country and Vietnamese people. After meeting Pierre in 1967, she made Saigon her home, later moving from her apartment by the river into the Eden building above Givral, where over time her neighbors included Jack Reynolds, George McArthur, Lou Conein, François Sully, and a host of Indian money changers. Jolynne and An developed an extraordinary friendship, characterized by regular discussions at Givral about dogs, tick collars, flea medications, worm medicines, politics, history, current events, and astrology. Jolynne owned a large black Doberman by the name of Roscoe, which she brought to Givral daily for her talks with An, who was always in the company of his German shepherd.[45]

"Very few people would interrupt us with those large dogs sitting at the table," recalled An. "So we had wonderful conversations."

After working at Vietnam Press, Jolynne taught English literature classes at the University of Saigon. She recalled for me the day one of her students was locked up in Con Son prison. The student was suspected of being Viet Cong and was terribly sick with tuberculosis, desperately needing medicine. Jolynne related the story to An over coffee at Givral. An told her to get the medicine and be back at Givral by 3:00 p.m. A man would come for it. "I will always remember An for his compassion and caring," she told me. "Somehow the student received the medicine; it was An's doing."

Jolynne offered An and his mother her apartment on the river as a place to hide from the invading army. When An told her that this was not safe, she and Pierre made arrangements for An to go into the French military attaché's residence behind their home, but An chose not to accept the offer. As a parting gift before she left, Jolynne gave An her *Merck Veterinary Manual*. Thirty years later An pulled it from his shelf and asked me to photograph him holding the book as a gift for his dear friend. He continued to make regular use of the manual in treating his animals.

An had good reasons to fear for his life. His close friend Vuong had once worked for the CIA and had already made arrangements to leave, knowing the consequences awaiting those who had collaborated with the Americans for so long. Vuong told An that he must leave since he was the best-known South Vietnamese reporter working for the Americans. Years earlier Vuong had tried unsuccessfully to recruit An to work for the CIA, and guilt by association was going to be all the Communists needed to lock An up for a very long time. "I did not know the Communists and they did not know me," An explained. "What was I going to do when one of the cadre pointed a rifle at me? I could not say, 'Welcome, I have been waiting

twenty years, my mission is now over.' All I wanted to do was be like Tarzan, go off with my Jane and my animals and be left alone. I was so tired. I could not tell them of my mission because they would have laughed and maybe shot me right there as a crazy man, born in a psychiatric hospital in Bien Hoa. I would have to play along and hope my story reached Saigon soon. Besides, I knew that when security asked about my wife and family and I said I sent them to the U.S., they would never believe I was on the same side. They would kill me just to grill my dogs for dinner."[46]

"For me, my home is Saigon," An told Shaplen in late April, joking that the "bird and grasshopper people" had promised to take care of him. He then said, "I have lived long enough." In parentheses Shaplen later wrote, "Did he mean it? Anyway, he stayed, cud be in trouble."[47] I asked An Pham about the reference to grasshopper people. "He was referring to vendors of birds and grasshoppers. If you buy something at the same place all the time, you would develop good bonds with over time. And my dad was always generous with these vendors; they became friends."

The North Vietnamese attack on Saigon was only days away. "Very fast tactics," An told Shaplen. "This is 1968 and 1972 combo." Dr. Tuyen told Shaplen he thought "200,000 to 300,000 killed at minimum. Some will go to concentration camps." Vuong added, "thinks no immediate killing tho later yes."

One of those leaving was correspondent Laura Palmer. "I could barely speak when it came time to say goodbye to him on the steps of the Continental Hotel. I walked away with a group of journalists towards our evacuation pickup point. I could not look back."[48] David Greenway remembered that "in the chaos of the republic's last day, An was the last Vietnamese friend I saw before I boarded a helicopter at the US Embassy, to rise over the rain-soaked streets with the fires from exploding ammunition dumps burning in the dis-

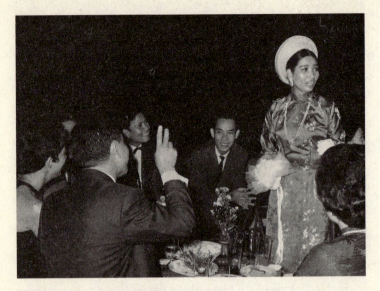

An attended Dick and Germaine's wedding.

tance."[49] *Time*'s bureau chief, Roy Rowan, still recalls the last words An said to him as they walked together out of the Continental Hotel, "Don't worry. You'll be all right."[50]

Time-Life photographer Dick Swanson had just returned to Saigon from his home in Bethesda, Maryland. He had first arrived in 1966 and married Germaine Loc in 1969. An attended their wedding. Loc had been working at the Japanese Embassy when Nick Turner met her at a 1962 press conference and offered to double her salary if she came to work at Reuters. "I remember my first day walking into Reuters, and there was An sitting at his desk by the window that had a view of the whole Catinat. His very large German shepherd was sitting beside him. The dog growled as soon as he saw me, but An said, 'Be good,' and the dog listened. An was very friendly, saying, 'I'm not here a lot, so you can use my desk whenever you want.' When we worked together, whenever I needed

information, he always helped me. Foreign journalists followed him everywhere because he was always willing to share his information," said Germaine Loc Swanson.

Before working in journalism, Loc was an ARVN nurse, with over twenty parachute jumps into combat. She was one of the few women working as a Vietnamese stringer for *Life*, NBC, ABC, CBS, *Look*, and Reuters. Loc was known as a fierce anti-Communist, yet to this day remains a dear friend of the entire An family, whose children call her "aunty." In December 1970 she left Vietnam with her husband for life in the United States, but now as they watched events unfold in Saigon, Dick Swanson knew he had to return and get his wife's twelve family members out of the country.[51]

Swanson had been without sleep for nearly two days when he met An at the *Time* bureau. "I ask him in the elliptical way of the Vietnamese: 'Will my family and I be safe if we stay behind?' His answer is, 'Probably.'" Swanson smiled. "It's like when I ask Germaine if we have ice, back home, in Bethesda. 'Yes,' she says. I go to the refrigerator and the ice-cube trays are filled with water. Germaine says, 'We have ice, it's not frozen yet.'"

Swanson then asked the question he had been wanting to ask his friend for years. "An, the war's over. Tomorrow, the next day, the day after that. Whenever. We've known each other for nine years now. You can tell me. Are you with them, the other side?"

"I'm a Vietnamese. I'm not concerned about the Communists. I want to stay here," replied An.

"Are you going to have problems with the Communists?" Swanson asked.

"At times like this, danger comes from several different directions," An replied.

"Okay, it's good to know that if I get stuck in Saigon one of my best friends is a Communist," said Swanson.

An smiled.[52]

An later told me that "I knew that if Dick did not get out on April 30, they would kick him out very soon after that. So for him, there was going to be no problem going home to the U.S., but the same was not going to be true for Germaine's family."

The American embassy had informed all bureau chiefs that when it was time to evacuate Saigon, Armed Forces Radio would issue a special weather report, "The temperature is 105 and rising!" The evacuation would be in full swing when Armed Forces Radio broadcast Bing Crosby singing Irving Berlin's *White Christmas*. On the morning of April 29, 1975, reporters and all remaining U.S. personnel living in Saigon awoke to the recording being broadcast over Saigon's Armed Forces Radio station. "This is it," confirmed the U.S. Embassy. "Everybody out!"[53]

Dr. Tran Kim Tuyen had missed several chances to leave. His wife, Jackie, and children were already in Singapore, having gone earlier under the auspices of the British Embassy. Tuyen had spent the last twelve years either in prison or under house arrest.[54] He was still in Saigon because several of his supporters and friends had been jailed in early April under trumped-up charges of coup plotting and general opposition to the Thieu government. Tuyen refused to leave Vietnam without securing their release.

Tuyen was high on the CIA's evacuation list. His agency contact, William Kohlmann, assured him the CIA would not let him down. Dr. Tuyen saw Kohlmann at least twice during the last week, including when he came to see Tuyen at An's home.[55] But Kohlmann had problems of his own getting out. Stricken with polio twenty-five years earlier, he walked slowly with the assistance of braces and could not use his right arm.[56] He would need extra time and assistance boarding a helicopter; by the time Tuyen was ready to depart on the twenty-ninth of April, Kohlmann was gone.

From his home, Tuyen first tried calling his contacts at the British, U.S., and French embassies as well as fellow journalists, but all the phone lines had been cut. Tuyen found a small coffee shop on Cong Ly Street with a phone that still worked. He tried calling the U.S. Embassy, but the lines were jammed. Tuyen finally got through to Bob Shaplen at the Continental, who explained that he was on his way to the embassy and promised to do all he could to get Tuyen on the list of foreign journalists who were departing later that morning. Shaplen told Tuyen to go home, pack one suitcase with whatever personal belongs he could carry, and be back at the Continental by 11:00 a.m.

By the time Tuyen returned, the reporters were being ordered to board a bus in front of the hotel that would take them to Tan Son Nhut for their helicopter evacuation.

"It is hopeless," said Shaplen, who had been unable to get Tuyen onto the list. He tried calling the embassy again, but after ten minutes the reporters on the bus were becoming impatient. It was time to go. There was little else Shaplen could do than reach into his pocket and hand his friend all the money he had, plus another spare key to his hotel room, telling him, "Stay with An!" One of the final entries in Shaplen's notes is "I left the Continental at about 10:15. Waited. Tony [Tuyen] and Nghiem in room just before I left. Told them to stay there with An and gave Tony the 22 Gia Long information (he finally went there, hopefully not too late.)"[57]

Tuyen went to the *Time* office and asked An if he was leaving. "No. *Time* got my wife and children out. But I cannot leave now. My mother is very old and ill and she needs me. Of course you must go."[58] An's other close friend, Cao Giao, whose wife had introduced An to Thu Nhan, tried reassuring An and Vuong, telling them that the new regime would look favorably on Vietnamese nationalists. "Why do you have to leave? There is nothing to be afraid of."[59] An knew better: "No, impossible. You must try to leave!"

An posed for this picture at home with his dog, birds, and fish, each symbolizing a part of how he conducted his own life. He told me that birds symbolized the concept of freedom. Fish did not speak and served as a reminder that one should often remain silent. The dog symbolized loyalty to friends and country.

PHAM XUAN AN PERSONAL COLLECTION

An and Tuyen decided to take a chance by returning to the embassy. Getting into An's green Renault, they drove there, but the crowds were so large that there was no way to get close to the gate. They drove back to *Time* in order to run through An's contact list in a desperate attempt to reach someone who could help, but the phone lines were either busy or dead. Out of frustration, Tuyen suggested they drive back to the embassy again, but the situation was even worse than before and they retreated to the Continental. "In case you can't leave, don't go back to your house anymore," An told Tuyen. "You can come temporarily to live in my house."

By now it was after 5:00 p.m. The two men sat forlornly at *Time*, not knowing what else to do. "I thought of my wife and children in Singapore," said Tuyen. "I might not see them again."

Then out of the blue, An's desk phone rang. "You see, this was another lucky day; this time for Tuyen," An told me. *Christian Science Monitor* correspondent Dan Southerland was calling An to see how he was holding up and to check on the evacuation. An cut Dan off before he could say another word. "Dan, we need your help! I have no time for anything else. Quick, see if you can reach the embassy and tell them Dr. Tuyen is here with me and they need to get him out. Call the ambassador." Before hanging up, Tuyen asked to speak with Southerland. In French, Southerland promised Dr. Tuyen to do whatever he could, telling An and Tuyen to stay off the line until he called back.

An and Tuyen sat in silence for thirty minutes until the phone rang. Southerland had reached the embassy and spoken with CIA station chief Tom Polgar. It was going to be impossible for them to send a car to pick up Tuyen, but it was imperative to get Tuyen back to the embassy. Polgar would be waiting and had already confirmed that Tuyen was on the marines' security list by the gate. "Tell him to take one piece of luggage," Polgar said to Southerland.[60]

If Tuyen was unable to get to the embassy, Polgar said he should go to 22 Gia Long Street, an apartment building that had been used by the United States Agency for International Development, the same place that Shaplen had told Tuyen to go hours earlier. The top floor of that building had been used by the CIA's deputy station chief, and it was now being used to support helicopter evacuations. Tuyen's name would be added to that list as well.[61] "If you can't come here, go there quickly. Very soon, the last helicopter will be there. Tran Van Don is there, with twenty or thirty other people."[62]

Tran Van Don had been vice premier and minister of defense in the last Thieu cabinet and, ironically, a longtime secret source for An. After handing over power to Big Minh on April 29, Don was also having difficulties getting out of the country. He first called Ted Overton in the embassy's CIA office, who told him to get to the embassy right away. Don's wife was already in France, but his son, a skilled pediatrician, was home waiting for his father. Don went home and before heading to the embassy with his son, took a few minutes to go into his library with an empty valise, taking only the draft of his memoir and some money.[63]

By the time Don reached the embassy, he confronted the same chaotic scene as Tuyen and An; he called Overton who said to drive to the office building that the embassy rented, but when they got there it was so crowded, the helicopters could not land. Overton then sent Don to Polgar's house, but that too was mobbed. Overton next suggested getting back to the embassy and try using the side gate. By now, however, the popular Tran Van Don had been spotted by other South Vietnamese seeking to find a way out. A line of cars and people on foot followed him to the embassy, but he could not get in.

In a final desperate call to Overton, Don was told the only chance

was 22 Gia Long. Don also got lucky when he reached the building, seeing the CIA's Nung guards, who immediately recognized Don and let him in. The Nung were extremely loyal to Americans and served in U.S. civilian agency programs, U.S. Special Forces units, and security units guarding the U.S. Embassy and other sensitive installations. Don was on the roof by the time Tuyen, with Pham Xuan An behind the wheel, arrived at the building. They would not be as fortunate as Tran Van Don. The guards were rolling down the gate and locking up.

An jerked the car to a stop, jumped out shouting, "By order of the ambassador, this man must get in."[64] The guards said no one else was to enter; the last helicopter was about to depart. On the rooftop, CIA employee O. B. Harnage was making his final pickup of the day. He had been landing a silver Huey on the elevator shaft and shuttling fifteen people at a time to Tan Son Nhut, where larger helicopters took them to ships in the South China Sea. He would later receive a CIA medal for his heroism that day.

The situation seemed hopeless, but as the gate was being closed, An instinctively reached under the gate with his left hand and used his right to push the diminutive Dr. Tuyen under the gate. No more than eighteen inches separated the gate from the ground. There was no time to say good-bye or thank you. "Run," An said as tears ran down his face. Tuyen was also crying and could say nothing except "I can never forget."[65]

The elevators were dead, forcing Tuyen to run up the eight flights to the rooftop. Tuyen was so out of breath he could not speak. The last few people were boarding the helicopter. An exhausted Tuyen did not think he would make it until he saw the hand of Tran Van Don reach out of the open door. "Remember I am tiny, and couldn't reach easily. So Don gave me a lift," said Tuyen.[66]

"I was sad on April the thirtieth," An told Henry Kamm. "I said

good-bye to Tuyen. Most of my friends left, and I knew those who didn't would be in trouble."[67] Tuyen had similar thoughts. "A strange feeling. So sad. After so many deaths, so many families destroyed so many Americans dead . . ."

Tuyen could not avoid thinking about the irony of he (the opposition) and Don (defense minister) sitting next to each other as they left Vietnam. "Now government and opposition in same helicopter." They said nothing during the short journey. "We didn't talk. Everyone thinking. Sad," recalled Tuyen.

The greater irony was that here were two of An's most reliable sources and friends sitting opposite each other on one of the last helicopters to leave Saigon. They were worried sick about their friend, not yet knowing the truth about An.

Meanwhile, the American embassy was in complete chaos. From the embassy rooftop, marine major James Kean described the scene as similar to the movie *On the Beach*. CH-46 Sea Knight helicopters and larger CH-53 Sea Stallions had been ferrying evacuees from the embassy rooftop to the U.S. fleet offshore. Finally, at 7:51 a.m. Saigon time, a CH-46 using call sign Swift 22 transmitted a final message, "All the Americans are out, repeat out."

At 12:10 p.m. the first tanks of the People's Liberation Armed Forces broke through the gates of the Presidential Palace. Within minutes the PRG flag was raised. The final president of South Vietnam, Duong Van Minh, An's old friend "Big Minh," was waiting to preside over the last breath of the Saigon government. "The old administration has totally collapsed," Colonel Bui Tin told Big Minh. "You cannot hand over what you do not have. You must surrender immediately." To ease tensions between Vietnamese, Bui Tin asked Big Minh if he still played tennis and how was his splendid orchid collection, reputed to have over six hundred species. Bui Tin asked him why his hair was so long, since he had promised to wear it

short for as long as Thieu remained president. Big Minh laughed at this, saying that it was no wonder the North had won the war, their intelligence kept them so well informed.

Big Minh was one of South Vietnam's most well-liked leaders. Back in October 1971, An had convinced Minh not to run as the leader of a neutralist faction against Nguyen Van Thieu. "Big Minh came to me for my advice. He was my friend and he knew I would give him an objective analysis. I told him Thieu needed him to run to make it look like a close election. If Minh ran, he would be serving the role of *red carpet* for the Americans, because he was needed to make it look like a democracy, but after he lost the Americans would walk over him like a red carpet. They needed Thieu to win the election. He was their man." An told me that Minh tried arguing, but An told him, "Look, you will lose, although if you do win, I will get good scoops all the time." An told Shaplen the same thing: "Minh will run, but will give up at the last minute to save his prestige. Then he returns to his orchids … the elections aren't genuine anyway, so what difference does it make?"[68]

On October 3, 1971, eighty-seven percent of the eligible seven million voters went to the polls and in a one-man election, Thieu received ninety-four percent of the vote. Just what the Communists had hoped for in undermining the South's credibility.

Big Minh was then driven to a radio station near the palace to broadcast a message that all armed forces of the Republic of Vietnam should lay down their arms and surrender unconditionally. "I declare that the Saigon government, from central to local level, has been completely dissolved." South Vietnam ceased to exist.

THREE DECADES LATER Dan Southerland recalled that day in April 1975: "An rushed Tuyen to the designated address—and to free-

dom. I can only say with certainty that on the last day of the war he helped to save the life of a man who strongly opposed the goals that An secretly worked toward most of his life. I will always remember An for that."[69]

Dr. Tuyen would never forget what An did for him. When reports surfaced about An's espionage, Tuyen easily forgave An, expressing his gratitude in a secret message carried into Ho Chi Minh City by Henry Kamm. "He thanked me and told me he understood," said An. "I wrote back telling him that I did not want to see his children orphaned, and we had known his wife for such a long time. I also knew how much he loved his wife and they loved each other. He was a friend, and we were Vietnamese, and he had helped many on both sides."

Tuyen later told friends that he trusted two people more than any others: An and Pham Ngoc Thao. When he learned that both had long been working as Communist agents, Tuyen said that in retrospect he could see Thao, but it was impossible to believe that An had worked for the Communists; he never gave even the slightest clue. "Dr. Tuyen, that was an act of the heart," An told me. "His wife was expecting a baby. He could have left anytime earlier, but he stayed to get his men out, and then it was too late. The CIA could not help him. Bob Shaplen could not help him. It was up to me."

In the immediate aftermath of the evacuation, Peter Shaplen, desperate for information about his father's whereabouts, heard from the Pentagon's Naval Command Center and the State Department's Public Affairs Office that his father was "somewhere in the South China Sea." In a touching letter mailed to his father's apartment in Hong Kong, Peter asked: "Where is George McArthur? Where is the Ambassador's secretary, Eva Kim? Where the hell are all those dogs from Saigon? What happened to their homes and their property? Did any get out? What happened to the $17 million in Saigon

gold? Did it get out? Where is Vuong? Where is Philippe Francini [*sic*]? Where is Vinh and his family? Did they get out en masse? Did Francini [*sic*]stay to be with the hotel? Did An get the Time, Inc. charter? What about his family? Where is Keyes Beech? Where is Dennis [*sic*] Warner? Where is Dan Southerland?"[70]

An did indeed get the Time, Inc. charter. For a brief period he would be *Time*'s only reporter in Vietnam.

One of Bob Shaplen's most revealing notations is an entry on his last day with An in Saigon. "An—mass of people want peace more than ever, do not want to strengthen government; the masses don't want war, want reconciliation."[71] An had always dreamed of a united, reconciled Vietnam.

Chapter 7

IN HIS FATHER'S SHADOW

> My father's exciting and rewarding career in journalism greatly impresses me. I plan to study journalism with emphasis in Economics, International Trade, Marketing and Developing Countries.
>
> —Pham Xuan Hoang An, résumé, 1990

AN'S FAMILY FLEW FIRST TO GUAM, where they remained one week, waiting to see if An would be joining them. An was able to stay in contact with Thu Nhan by using *Time*'s bureau telex, and he ultimately told her to accept *Time*'s offer to relocate to the United States. The family flew to Fort Pendleton, California, for processing, but there was no time to reflect on the fact that they were just fifty-three miles from the campus of Orange Coast College in Costa Mesa. With *Time* already having agreed to serve as sponsor, the family was processed quickly, receiving their Social Security cards and documents. They were driven to Los Angeles, spending one week in a motel with *Time*'s other Vietnamese staff. "I did not feel

comfortable in Los Angeles," recalled Thu Nhan. "It was too large for me, and I asked *Time* if we could go to Virginia."

David DeVoss of *Time* accompanied them on the flight and then to the Arlington, Virginia, apartment of Beverly Deepe, where the family would stay for three months until Thu Nhan found a house to rent. *Time* covered all costs associated with their relocation and provided Thu Nhan with An's $700 monthly salary. The children, ages twelve, eleven, ten, and eight, all attended the Patrick Henry Elementary School. Each morning Thu Nhan, who already spoke basic English, took the bus to school with her children and stayed in class to assist them since they spoke no English. Thu Nhan also enrolled in advanced English classes, and the family began adjusting to a new life in America. With so many displaced South Vietnamese moving into the Washington, D.C., and Virginia metropolitan area, there was never a shortage of friends for emotional support and reassurance in the absence of her husband.

"She was always sick worrying about her husband," recalled Germaine Loc Swanson. "She did not know what was going to happen to him." Thu Nhan was well aware that she might never again see her husband. She had grown accustomed to these feelings over the past thirteen years, but now she was on the other side of the world. On the one hand, An might be killed by the liberation forces for his assumed collaboration with the CIA; there was also the frightening prospect that with the war over, her husband's secret life as a spy might become known while she and the children were living in America. Their very safety would then be jeopardized within the vitriolic anti-Communist refugee community. She also did not know whether Hanoi would order An to continue his espionage work in America. The future was unclear.

"My mom never let any of us know how worried she was," recalled An Pham. "This made it so easy for us to adjust. We made

new friends very easily. I remember the day we arrived at Ms. Deepe's apartment. I looked out the window and kids were playing. They waved and I waved back. They went to the same school as me, and we became friends. I learned to speak English. I even had a girlfriend. I still remember her name is Robin, and her father was a Vietnam veteran. When it was time for me to return, she and I both cried."

Back in Saigon, An was also sad and scared. After a few days at the Continental Hotel, he and his mother returned home, but An still feared what he described to me as the "two a.m. knock on my door, when I could be taken away and never heard from again. This was the same feeling I had when I returned to Saigon in 1959. It was very dangerous for me at this time because I was only known as a Saigon reporter who worked for the Americans." An did not think it was fair for his country to be united but his family separated.

An was instructed to register with the local authorities, where he listed his employer as *Time* magazine and his occupation as journalist. A few months earlier—in a letter to Edward Lansdale and his wife, Pat—Bob Shaplen explained that "most of our old friends are pretty despondent, Vuong, An etc.... the morale of the Americans left, like Jake and Mark Huss, is low. They're all hanging on as long as they can, for what else can they do? As for the Viets, like Vuong and An, they're stiff upper-lipping it, but are not happy because the stigma of being with us has hurt them professionally."[1]

The Australian reporter Neil Davis and the Italian correspondent Tiziano Terzani were two of the few reporters remaining in Saigon. They would often drop by *Time* to check in with An and seek his views on the transition.[2] Davis was also staying in close contact with Shaplen, providing updates on the situation and conveying messages from An. Davis's reports left little doubt that post-liberation Saigon was a dangerous place. "I was accosted by *bo doi* [North

An in front of City Hall prior to the North Vietnamese entry into Saigon, 1975.

Vietnamese soldiers] who suddenly appeared from behind bushes or trees where they had been hiding and who demanded to see my credentials"—everyone, foreigners as well as Vietnamese, had to register officially with the new authorities at the outset—"or by more dangerous trigger-happy young men who are part of the new self-defense corps and who represent just about the same sort of menace the government's old self-defense troops did. The registration process, in Saigon at least, appears just about completed, and it was one of the few firm demonstrations of authority to date, with every category of Vietnamese from former soldiers, government workers, employees of the Americans to what was rather oddly described as 'secret agents' told to report to such and such a place and make his or her identity and address known."[3]

By early May a triumphant General Vo Nguyen Giap had flown from Hanoi to Saigon, arriving at Independence Palace for a meeting with General Tran Van Tra, the NLF's commanding general who had just been appointed military governor of Ho Chi Minh City. Years earlier Giap and Tra had relied on An's intelligence reports; now, just weeks after liberation, the master spy who had contributed so much to Hanoi's victory was a few blocks away, worrying about his own safety under the new regime.

An was now quite literally *Time*'s man in Ho Chi Minh City, staying in touch with former colleagues and contributing to coverage in post–April 30 editions. "All American correspondents evacuated because of emergency," An telexed New York. "The office of *Time* is now manned by Pham Xuan An."[4] *Time*'s publicity department published a picture of An standing on a deserted street, smoking a cigarette and looking pugnacious.

Each morning An went to the *Time* office, where the "liberation forces" had placed a censor, which boiled down to censoring An. "I was all alone, except for my censor," An told me. "He was not a

difficult guy to work for, but he was a difficult censor. After a few weeks, nothing went out."

One benefit An did have was access to *Time*'s telex equipment, which allowed him to send messages to Thu Nhan via *Time* headquarters in New York. "I was able to get messages through that indicated I was ok, for the moment. But I could not really say anything else because many people would read it," said An.

An's last dispatch appeared in the May 12 issue of *Time*, titled, "The Last Grim Goodbye." Here is an excerpt from the report:

The last images of the war: U.S. Marines with rifle butts pounding the fingers of Vietnamese who tried to claw their way into the embassy compound to escape from their homeland. An apocalyptic carnival air—some looters wildly driving abandoned embassy cars around the city until they ran out of gas; others ransacking Saigon's Newport PX, that transplanted dream of American suburbia, with one woman bearing off two cases of maraschino cherries on her head and another a case of Wrigley's Spearmint gum. Out in the South China Sea, millions of dollars worth of helicopters profligately tossed overboard from U.S. rescue ships, discarded like pop-top beer cans to make room for later-arriving choppers.

In the end, the Viet Cong and North Vietnamese poured into Saigon, raised the flag of the Provisional Revolutionary Government and took into custody South Vietnamese President Duong Van Minh and Premier Vu Van Mao. For many Americans, it was like a death that had long been expected, but was shocking when it finally happened.

So the century's longest war was over, in an efficient but ignominious evacuation. It was nightmarish enough, but it could have been worse; only a few South Vietnamese soldiers fired at the

departing Americans, and none were on target. At least the U.S. was spared the last awful spectacle of its people fighting a pitched battle with its late friends and allies. In fact, the Americans managed to bring about 120,000 South Vietnamese refugees out with them.

Perhaps appropriately, the American goodbye to Viet Nam was the one operation in all the years of the war that was utterly without illusion....

The new rulers announced that they would "firmly adhere to a policy of independence, peace, neutrality and non-alignment."

For those South Vietnamese who worked and collaborated with the Americans, life would soon become brutish and harsh. Some, like General Pham Van Phu, the commanding officer of Army Corps II, who had ordered the retreat from the highlands, chose poison over surrender to the Communists.[5] For most former high-level officials who remained, there was little to do except wait for the new regime's instructions. This was an especially awkward time for An personally, with so many friends surely headed into darkness. "My mission was technically over, my country was reunited, and the Americans were gone, but I could not tell anyone the truth. I could not feel happy because I was very lonely and scared. My wife and family were in America. I did not know if I would see them again. I also had many friends who could not leave, and I did not know what would happen to them either. There was so much unknown."

One of those awaiting his fate was An's friend Nguyen Xuan Phong, who had served in cabinet-level functions in the Saigon government, most recently as minister-of-state in charge of negotiations in Paris. He returned to Saigon on April 25 in order to be with his elderly mother and father. Like An, he could not abandon his parents. Declining Ambassador Graham Martin's offer for evacu-

ation, there was little for Phong to do but wait. He dutifully registered with the authorities, not knowing if he faced death, life in prison, or something less. "I had thought that between five and ten years in prison would be bearable, but twenty years was not to be unexpected."[6]

Tran Van Tra had decreed that all officials of the old regime who were above the level of service chief and all armed service officers above the rank of second lieutenant were to report for mandatory thirty-day reeducation from May to June. All other civilian and military officers were instructed to begin seven days of reeducation at their local areas of residence. Day by day An's friends disappeared for their reeducation. At the end of his thirty days Phong and countless others were told that they were not going home, despite the decree by Tra. This was because by now officials from Hanoi had arrived in the south and countermanded Tra's order, over Tra's objections. "We were made to understand that we were at fault for having committed offenses and crimes against the fatherland," Phong recalled. "The phrase 'traitors to the fatherland' was not used, but we were made to understand clearly that we were guilty for lending a hand to the American neo-imperialist aggressor, which had resulted in death and destruction to the Vietnamese people and nation. We weren't told whether we would be tried in a court, or on what other basis we might be judged, or what the duration of the penalty would be, or how the period of our detention would be assessed, individually or collectively."[7]

Nguyen Xuan Phong's journey into the unknown began at Thu Duc prison in June 1975, where he shared a cell with twenty others. After a few weeks, prisoners were instructed to gather in the courtyard, where they were chained two-by-two and taken to the airport in army trucks. They were flown to Gia Lam airport, near

Hanoi, and then transported to Camp A15, dubbed the Hanoi Hilton Annex because of its location fifty kilometers from Hanoi and the former prison for many American POWs. Phong and his 1,200 fellow inmates would remain in this place until someone said go home. For Phong, that day came in December 1979; for so many others the day would come ten or even fifteen years later. "No explanation was given, just that I was among a dozen or so who would soon be free. Criteria for the releases were indecipherable."[8]

Cao Giao, the "leading tenor" of Radio Catinat, faced a more difficult fate. In the days after liberation he attended the thirty-day reeducation and was allowed to return home. He was not arrested until June 1978, accused of being a CIA agent. Placed in solitary confinement and interrogated daily, Cao Giao endured nine months of daily interrogation and then four months in solitary confinement, his cell door never opening. After this confinement, he was transferred to Chi Hoa prison, where seventy-two political prisoners were placed in one cell. Three and half years later, in 1982, he was released, with no explanation.[9] For the entire time Cao Giao was in prison, An regularly visited his family to report confidentially on Cao Giao's health and bring food and medicine to the family. "I tried my best to take care of his family while he was in prison. Every day that I could, I visited his wife," said An. After his release, whenever asked about An, Cao Giao would say that An had been a "a deceived and disenchanted idealist." He forgave An because "we are Vietnamese."[10]

A far better fate awaited Pham Xuan An when a few weeks following liberation, someone from the regime's new security force came to him and said, "You're OK."

"That is all he said," recalled An. "So I knew it was safe now." Documentation of his real identity had finally arrived. An was

certified as a "thirty-year revolutionary man"—the term used to describe those who had fought foreign invaders for the past three decades. An was officially switched over to the winning side, which became obvious due to his increase in food rations and his new wardrobe, the military uniform of a North Vietnamese colonel.

The new regime had a problem with An's actions on April 30 when he helped Dr. Tuyen make the last helicopter from 22 Gia Long. An provided an accounting to security, saying it was a humanitarian gesture. Tuyen's family had already departed Vietnam, and the war was about to end. That explanation sat well with members of An's own southern intelligence network, but it was met with doubts by security. What did An mean when he said he and Tuyen were friends? Was it personal or business?

An was required to write a "confession" concerning the details of Dr. Tuyen's escape and instructed to disclose the names of his contacts and sources during the war, obtained while working as a *Time* journalist. As noted earlier, he provided the details as best he could recollect about Tuyen, but said his memory was very bad about his contacts over the past fifteen years. "I told them I could not remember and gave them very little," said An, a man who I know possessed extraordinary recall of details from decades earlier.

The more security thought about An, the more questions they had about how he had survived for so long as a spy. "They thought I was being protected by someone in the CIA because no one could be that lucky." Interestingly, both Bob Shaplen and Hanoi's security had the same questions: "I wondered, for example, why he had bothered having his family moved back and forth in the first place, with the help of the American publication he had worked for. Had he really been a communist all along, or had he decided to become one only after April 30, 1975, for one reason or another...could he have been working as a double agent, or even a triple, and before

throwing in his lot with the communists had he wanted to make sure that he had covered all his tracks? There was some reason to believe that this was possible," wrote Shaplen.[11]

In late March 1976, An was told to recall his family. This was the first signal to many friends and former *Time* employees that An had been working for the other side. Saying good-bye to their new American friends was difficult for the An family. Germaine Loc Swanson remembers saying to Thu Nhan that they would soon meet on the diplomatic side, believing that An might be the ideal first Vietnamese ambassador to America or press attaché in the embassy.[12] When I later shared this with An, he smiled, saying, "Only if Germaine was party secretary, otherwise not too likely."

Thu Nhan had her own concerns about their return. She had received only a short message saying, "Please return home." She did not know anything about An's status in Vietnam and had to figure out a way to take her family back without arousing too much suspicion. People in the south were fleeing Vietnam in makeshift boats, choosing to face Thai pirates on the high seas rather than the Communist regime in Vietnam.

Thu Nhan first went to the United Nations in order to request permission to travel to France as a tourist. The family then flew from Washington to Paris, but they were detained there for three months because Vietnam was allowing no direct flights from Paris to Hanoi and nothing into Saigon. Once in France, Thu Nhan requested permission to return to Vietnam with her four children "in order to reunite with my husband as peace was then established in the country." She then informed *Time* magazine about her decision and spoke with Germaine Loc Swanson again, who offered to take two of Thu Nhan's children as a precaution against a Communist trap awaiting them in Saigon. Germaine Loc Swanson had no idea whether or not An was safe. Stanley Cloud recalled that Thu Nhan called him from

Paris to seek his advice on whether or not she should return to the United States. In the end, Thu Nhan decided not to divide the family and return to her homeland, hoping that An's message was an authentic one and that he was safe.

The family flew from Paris to Moscow and then on to Hanoi, from which they traveled by car to Ho Chi Minh City.

BY SEPTEMBER 1976, word on An's secret life was out, evidenced by Lou Conein telling Neil Sheehan that he had "heard that Anh [*sic*] had sent for his wife and that she had returned without any trouble through Paris and Moscow and Hanoi to Saigon, the indication being that her lack of trouble in returning was evidence that Anh [*sic*] was a VC or that at the very least he had been a sympathizer and the Communist Party looked with favor on him."[13]

An was invited to attend the Fourth Party National Congress in December 1976 in Hanoi, where he received his Hero commendation and was photographed with Bui Tin, General Giap, and other Heroes of the war against the Americans. After this Congress, all offices of foreign companies operating in Vietnam were shut down. "That was my end of going to work at *Time*," said An.

Elevation to status of Hero was not enough to prevent An from escaping a year of "detoxification" near Hanoi.[14] Spending so much time with the Americans was just part of An's problem. He kept compounding things by speaking so highly of Vietnam's vanquished enemy. The war was over, his country unified, and he admired the Americans. The new regime did not question their hero's loyalty to the homeland, but they were very concerned about how dangerous it would be for people to hear what he was saying. An needed to be reprogrammed to think like a Vietnamese, not an American.

In August 1978 An departed for the "high-level political science

An received his Hero award from General Giap, with Bui Tin looking on. PHAM XUAN AN PERSONAL COLLECTION

institute" in Hai Duong, about thirty kilometers outside of Hanoi, where he remained until June 1979. His complete disappearance from public view actually led to the mistaken perception that he had gone undercover in the United States, leading Nguyen Cao Ky to promise to "cut An's throat" if he found him in the States.[15] An has always downplayed the significance of his time at the center, and he never once called it "reeducation" in any of our conversations. "This was not really reeducation like so many others who had it very hard," An told me. "It was a political institute. I needed to go there because I knew nothing about Marxism-Leninism and dialectical materialism. I had led one life during my mission, and that life was now over. I knew more about the American system than this one, so I needed to read all those classics of Russian economic thinking," An said, unable to contain a smile, giving away his sarcasm. "This was the year my way of thinking was expected

to change. I really tried to be a good student, but I already knew too much to change."

An didn't particularly object to his year away. He met interesting people who were curious about his experiences, and he enjoyed sharing stories with many of his fellow students. Still, he remembers being ridiculed as "an American boy."[16] There was no one else like him. He had more experience with Americans than most ARVN officers, who spent just one month training in the United States. An had lived there freely for two years. "I was considered 'too American' and 'bourgeois' by the new regime, and they expected me to speak like a Marxist after a few months of lectures and confession sessions," An told me. An did have lots of time to think. "You know, this was my first time living under Communism. I had so much to learn and tried to adjust everything, my way of thinking, acting, even joking. I understood what they wanted and I tried."

With his reeducation studies finished, An returned to Ho Chi Minh City, where he was happy to no longer endure the north's cold evenings and where his friends would soon be emerging from their own much more brutal reeducation. The new government offered An a job in the censorship office, which he declined. He was then asked to train Communist journalists, but he thought it was a practical joke: "Anyone I trained would lose their red card. What could I possibly teach Vietnamese journalists about my profession? If they practiced it the way I believed, they would be sent to reeducation, so I was really saving them a lot of expense and problems."

And so the reeducated An had trouble fitting in and being trusted. That is why whenever a friend from the old days arrived in Ho Chi Minh City, officials said either that An did not want to see them or that he was out of town. "In 1982, I was in Saigon for a few days on my way to Cambodia," recalled Dan Southerland. "In those days

any reporter passing through Saigon ended up with a Viet Cong 'handler.' Mine was an old cadre, Phuong Nam. I asked him if I could see An. Phuong Nam told me that he'd check, and then came back with the answer: 'He's not seeing foreign visitors.'" Thirteen years later Southerland finally got to see An. "He lied to you," An told Southerland at their first meeting in thirty years. "I did want to see you."[17]

Stanley Karnow related a similar story about a visit in 1981:

"I asked a communist official to schedule a meeting for me with him.

"'Forget it,' the official snapped. 'Colonel Pham Xuan An doesn't want to see you or any other Americans.'

"'Colonel?'

"'Yes,' the official said. 'He was one of us.'"[18]

An had no choice but to become what he described as "a house-husband" and jokingly referred to himself as a "collective million-aire," spending his days reading, listening to the BBC, and running errands for his wife.[19] He also became renowned as one of Saigon's best trainers of fighting cocks, a practice the new regime had out-lawed but which still flourished underground.

Meanwhile, An's old friend Phong was released from his five years in prison. Two "brother enemies" now living in a unified Vietnam pooled their talents: "During twenty years, from 1980 to 2000, An and I used to get together several times a week, most of the time sit-ting by the side of the road sipping coffee on Dong Khoi Street to relax and forget the past. We even got photographed by the security guys, trying to find out what plots we were cooking up!"

One thing that An learned from observing his unified country was that Vietnamese leaders' adherence to the Soviet model was doomed to fail. "Everything was burned after the fall of Saigon—medical

books, government documents—now they regret it—it's too late—everything [is now] from Russia—so naive," An told Sheehan. "I was depressed by what they did; I couldn't stop it—maybe because I was on this side too long I knew the value; they were so badly indoctrinated, like a horse with blinders; if you talk to them they think you're a reactionary and that's a big crime, even now. I'm born in Vietnam, I'm Vietnamese, but civilization I learned from the Americans. This is my problem."[20]

When I showed An copies of Sheehan's 1989 interview notes, he shook his head, "You see how stupid they were. When the Berlin Wall fell and then the Soviet Union crumbled, the United States finally won the war. It is easy to see." An later told his former bureau chief, Stanley Cloud, "If I had known during the war that we would just be trading the Americans for the Russians, I'd have stuck with the Americans."[21]

With An no longer allowed contact with his former colleagues, wild rumors about his position with the new regime circulated among them. David DeVoss, the former *Time* bureau chief for Southeast Asia who had flown with Thu Nhan and the four children from Los Angeles, was in Ho Chi Minh City in 1981. Afterward he wrote colleague Karsten Prager, "Cigarettes is about the only thing Vietnam still can produce. Beggars everywhere, only this time they're Khmer. The incompetence of the VC cadre is staggering. Men who joined the revolution at age 12 are in charge of land management, social welfare programs. Nothing works. The old *Time* office in the Continental Palace is now occupied by a pig Cuban who jives down Tu Do at night wearing a tee shirt silkscreen with a crippled eagle. 'The eagle can't fly' is the caption...Sorry to say that Pham Xuan An is a high-ranking cadre in the Ministry of Interior [this was incorrect]. Seems he was a VC Lt. Col. all the time he was working for the weekly magazine. I tried to see him during my five

days in Saigon but he refused. No (stress) contact is allowed with people known prior to liberation."

Prager forwarded DeVoss's letter to Frank McCulloch, attaching a note, "Dear Bro . . . sad commentary from DeVoss who's just back from Viet Nam. Thought you'd like to see, particularly the part about An. Can't win 'em all, I guess; I always liked An but never quite trusted him."[22]

In February 1982 *Time's* Donald Neff wrote directly to McCulloch, "I know the stuff about An is not new but I gotta admit it hurts every time I read it. (It also pisses me off that one time I gave him a very expensive set of bird call records.)"[23]

DeVoss later made the startling claim that An had asked him in 1981 to help smuggle his family out of Vietnam:

My goal was to find An, but that was no easy task. Old city maps had been confiscated and burned. All but the major streets had new names. Houses still had numbers, but they were not in sequence, making it nearly impossible to locate a home even if you had the address. Finally, in desperation, I bribed a Hanoi official with baby vitamins and disposable diapers brought in from Bangkok and got An's phone number. I called and we arranged to meet at the Bird Market. 'I'll be walking my dogs,' he said.

An warned me not to say or do anything when we saw each other because police would be watching. Apparently, not even a decorated hero now in charge of diplomatic intelligence for the government could escape surveillance. The Bird Market actually was a sidewalk both sides of which were stacked high with bamboo cages filled with twittering birds that could be taken home as pets or simply released to improve one's karma. An had come with his German shepherd, and we passed each other with barely a nod. An and I got into separate cyclos, each pedaled by an im-

poverished veteran of the South's defeated army, and I followed him home.

Once inside the house, An expressed great sadness over what had become of his country. 'Why did we fight a war just to replace Americans with Russians?' he sighed. He confided that twice in the past he had tried unsuccessfully to smuggle his family out of the country. The first time the boat had had an engine problem. The second time, the boat had appeared to be seaworthy but the captain had failed to show. An escape was even more critical now, he said, because his son soon would be sent away to school in Moscow. An asked me to go to Singapore and seek out a mysterious man at a Chinese hotel who could arrange passage on a boat if paid the right sum of money. An said he was desperate.[24]

I was stunned by this story, especially given De Voss's 1981 letter to Karsten Prager. I then asked An Pham for his assessment: "We are not worried by his article because what he wrote could be verified easily by people here, and we never did that."

Isolated from his American friends, An found ways to help Vietnamese colleagues on the losing side. In April 1985 Donald Kirk returned to Vietnam for the first time since the war. In the 1960s and 1970s, Kirk wrote from Southeast Asia for *The New York Times Magazine*, *The New Leader*, and *The Reporter*. While in Ho Chi Minh City he met with a former close friend and colleague, Le Viet. Kirk later learned that his colleague had been detained in jail for five months for "meeting with a foreigner." He was put into a prison cell with sixty people. His wife visited once a week with food and medicine. "Every day they questioned me about relations with American journalists. They said almost all American journalists worked for the CIA. They wanted to know about the packages I give you. They said I am an American spy and you are CIA. I told them I worked

for foreigners a long time ago but in the war, not in politics," Le Viet explained to Kirk.[25]

Here is how Kirk related the rest of the story: "Still, Le Viet's agony could have been worse. He got a break when the police chief asked Pham Xuan An, a Viet Cong colonel who had attained that rank in secrecy for his services as a spy while laboring diligently as a political expert for the proverbially gullible *Time-Life* correspondents in their bureau in the Continental, to question him." The police chief was hoping that An would extract some type of confession from Le Viet. "An, by now a deputy secretary of the Ho Chi Minh People's committee, a position equivalent to a vice mayor," refused to betray a colleague and friend, relaying word to the police that "it's not necessary to make bad for me," said Le Viet. When I asked An about this episode, he sighed, "The security people think everyone CIA, they trusted no one, even me." An never actually held any position with the local party administration or committee.

THE SLOW WINDS OF CHANGE would eventually reach Vietnam in 1986 when the Sixth National Congress launched Doi Moi, an economic renovation program to reform Vietnamese society and stimulate economic growth, thereby abandoning efforts to build a fully Communist society. Party leaders declared their intention to bring about a mixed economy, involving a combination of state, collective, and private ownership. Foreign investment would be encouraged, and a more tolerant attitude would prevail with respect to contact with the West and toward expression of opinion in the country.

In 1988 Bob Shaplen was in Ho Chi Minh City and asked to meet with An. For the very first time, security permitted the meeting, so long as a member of the foreign ministry was present. As their reunion was coming to an end, An asked a favor from his ministry

friend: Could he and Shaplen go to dinner alone? Permission was granted. "We went to the Majestic Hotel," recalled An. "I think it was the first time I was allowed to speak alone with an old friend since the war ended. I did not want the evening to end."

When Shaplen returned to the United States he passed the word that perhaps the government was loosening up on contact with former colleagues. Within months, Neil Sheehan, Stanley Karnow, Robert Sam Anson, and Morley Safer would be allowed visits. It is within this context that a remarkable story unfolded involving bonds of friendship between former colleagues, a father's dream for his eldest son, and reconciliation between the two countries Pham Xuan An loved.

IN 1983, AN'S ELDEST SON, An Pham, went to the Soviet Union on a five-year undergraduate diploma program. Studying first at the state Foreign Languages Institute in Minsk and then at the Moris Thorez School of Professional Translation at the Moscow State Institute of Foreign Languages, An Pham graduated with honors, mastering the English language and writing his linguistic thesis on a translation from Russian into English of an excerpt from A. A. Kurznetsova's book *On the Banks of the Mekong and Red Rivers.*

With his undergraduate studies finished, An Pham returned home. "My heart would almost jump out of my chest as the plane was landing. Oh, my beloved city. Six summers had passed since the day I left this land," An Pham later wrote about his return. "The gate opened. I felt the August heat warming up my Moscow-winter-colded-heart. A soft breeze caressed my skin. And here again I bathed in the sunshine and green. My eyes were looking for some familiar faces. There were my dearest mom, sister and brother. Time had left its trace on my mom's gray hair and her wrinkled face. But thank God she looked healthy and happy. Tears. Kisses. And my mother's arms... The bell was ringing. I saw a huge barking shepherd rush-

ing towards the gate. My dad appeared on the threshold. He went hastily to the door and swung it open. He did not look older, but much thinner. His back was curved more than before under the burden of hard and busy life.... Joy and happiness filled my whole body and soul, at this reunion."[26]

Pham Xuan An had lived and worked with Americans before there was an American war in Vietnam. He held Americans in high regard. After the war, it was natural that he would want the same for his son. "The party could only teach me ideological things," explained An. "From the Americans I learned other important things about journalism, about another way of thinking. This is what I wanted for my son. I wanted him to have American friends."

An also believed that his son could represent a new bridge between the Vietnamese and American peoples in the postwar period. "In my life I had only two responsibilities. One was to my country as an obligation, the other one was to my American friends who taught me everything from A to Z, particularly American people. My wish is this. To fight until the country recovers independence and then renewal of diplomatic and normalization relations between the Vietnamese and American people, and then I will die anytime smiling."

An anticipated that his American friends would assist him because they would remember him as a colleague, not as the enemy of their country or as someone who betrayed their trust. "They knew me as someone who always helped them and I was not their enemy. I fought for my country, not against the Americans," said An in a way intended to deflect recall that he had been a master spy for the other side. "If ever there was a man caught between two worlds, it was An. It is very hard for anyone who did not serve in Vietnam in those years to understand the complexity," said David Halberstam.[27]

No formal diplomatic relations existed between Vietnam and the United States in 1989. There was no embassy or consulate. Only a handful of Vietnamese students were receiving visas to study in the United States. Cooperation had just started to address the fate of American servicemen missing in action (MIA); not until the spring of 1991 would a U.S. office in Hanoi be established for resolving MIA issues. None of this was going to be a deterrent to Robert Sam Anson and Frank McCulloch, who would take charge of the American campaign to bring An Pham to the United States and to the young man's father, who would orchestrate much of the effort from Vietnam.

For Anson, this was an opportunity to repay a life debt. For Frank McCulloch, then managing editor of the *San Francisco Examiner*, it was out of respect for An as well as a profound belief in the future. Frank shared An's hope for reconciliation between former enemies and saw An Pham's education as a key component of that dream. "We could not have raised this money for Thieu's or Ky's kid. It was a sign of the respect and admiration people held for An," McCulloch explained to me. "Also, the one stipulation we all had was that he would have to return to Vietnam after his education was done."

McCulloch had every reason to believe in the character of the young man he was representing. An Pham's admission essay to the University of North Carolina revealed a mature understanding of the reconciliation process: "We are living in such a time when no country is able to survive alone, isolated from the rest of the parts of the world. It is time of cooperation to coexist. I don't see why there is an exception for Vietnam. After numerous events in Eastern Europe, I'm happy that Vietnam has worked out its 'open policy' earlier than those in the eastern block. Thanks to this, we are now on the more or less right way to get rid of poverty. I have the advantage of being in both the Soviet Union to study and the United States when I was

a teenager.... I wish I could go to the U.S. to study journalism and economics and to absorb the essence of the American society. Then later, when I come back home, I can tell my people about the people, history, culture as well as the latest achievements in the fields of economy, science and technology of this advanced super-power. By doing this, I hope to set up a bridge linking the two peoples in order to erase our misunderstandings and prejudices...My aspiration is my people's happiness and prosperity."

Perhaps the largest obstacle for the success of the plan was fallout from publication of Morley Safer's *Flashbacks: On Returning to Vietnam*.[28] The book was drawing wide attention primarily because of a chapter that featured a remarkably candid discussion with An. The *New York Times Magazine* for Sunday, March 11, 1990, included an excerpt from the book, titled "Spying for Hanoi," with the attention-getting subtitle: "For 10 years, Pham Xuan An Was a Valued Reporter for *Time* Magazine in Saigon. What His Editors Didn't Know Was That All Along He Was 'Spying For Hanoi.'"

A year earlier, in *War News*, Bob Anson had published his account of An's role in securing his release from captivity. Now living in Bangkok, Anson received a copy of Safer's unedited manuscript, sent to him by a fellow journalist in New York who knew both An and Anson.

As Anson read the attributions to An, he felt his friend was now in great jeopardy. Anson was incensed by Safer's admission that he took no notes when speaking with An. Safer, accompanied by his assistant and with An's help, had polished off a complete bottle of White Horse whiskey during their conversation.[29] Anson was worried that the man who had saved his life was going to suffer on account of the interview. Anson applied for an expedited visa and was on the next available flight from Bangkok to Ho Chi Minh City for a meeting with An.

An told me that he thought the conversation with Safer was off the record; that is, they were two friends catching up and drinking a bottle of whiskey. "I never thought he would publish our conversation. I was just so happy to have colleagues to speak with again," said An. Anson and An went through each line of the manuscript dealing with the reconstructed conversation, editing things down to a level where An hoped his son's chances for a visa would not be endangered. He did not care about what might happen to him and "out of respect for my profession" An decided not to contest Safer's right to publish the interview. "I would be a censor and I could not do that, but I could try to show what I thought I said for the record," said An.

Safer's book was scheduled for publication by Random House, where Anson had recently published *Best Intentions: The Education and Killing of Edmund Perry*. Anson called his publisher. "I beseeched them via a phone call or three or eight and a detailed exegesis of Morley's reporting methods," says Anson. He told them the story of his recent visit with An and asked that Random House and Safer edit the attributions before publication, which they agreed to do.

The narrative that finally appeared in print was considerably toned down from the original, but still vintage frankness from An. In response to Safer's question concerning who he worked for: "'The truth? Which truth? One truth is that for 10 years I was a staff correspondent for *Time* magazine and before that Reuters. The other truth is that I joined the movement in 1944 and in one way or another have been part of it ever since. Two truths...both truths are true.'" In response to Safer's question about An's activities as a spy: "'The real work started in 1960, when I was working for Reuters. I held the rank of regimental commander.... During the years with *Time* I was made a colonel.... I had access to all the [South] Vietnamese bases and their commanders. My superiors wanted to know the strengths of various units. They wanted esti-

mates of the capabilities of commanders—who was corrupt and who was corruptible.'"

The questions and answers reached the sensitive stage when Safer asked why the revolution had failed. "'There were many reasons. So many mistakes were made out of sheer ignorance. Like every revolution, we called it a people's revolution, but of course the people were the first to suffer.... as long as the people sleep in the street, the revolution was lost. It is not that the leaders are cruel men, but the effect of paternalism and discredited economic theory is the same.'"

"'Aren't you worried about talking so bluntly? Isn't it dangerous?'" asked Safer. An's response was the same in 1990 as it would be in 2006: "'Everyone knows how I feel. I make no secret of it. I never have.... I'm too old to change. I'm too old to shut up.'" When Safer asked about recent economic reforms within Vietnam, An said, "'That's what breaks my heart. To see that spirit going crazy with delight over a few economic reforms. It gives a hint of what the possibilities are for this damn country if we could have not just peace, but freedom.'"

In one of his final questions, Safer asked if An had any regrets. "'I hate that question. I have asked it of myself a thousand times. But I hate the answer more. No. No regrets. I had to do it. This peace that I fought for may be crippling this country, but the war was killing it. As much as I love the United States, it had no right here. The Americans had to be driven out of Vietnam one way or another. We must sort this place out ourselves.'"

As the interview drew to a close, Safer asked, "'Will they let you leave?'"

"'I don't know. I'm not sure I want to,'" said An. "'At the very least, I would like my children to go to the States and study.'"[30]

With the Safer-An interview now public, all An could do was hope that those in authority would take no punitive action against

him, although one immediate result reported by his friend Douglas Pike was that surveillance had increased because authorities believed An had "revealed State secrets in the Safer interview."[31]

"I was worried because it would be easy for someone in security to say no to my son because of me. I was lucky this time. I think they thought we can shut him up by sending his son to the United States. So the opposite really happened of what I thought. It was their way of saying, 'Thank you, go home, read and be quiet.'" When I asked Frank why Hanoi would allow An Pham to leave, he said something very similar: "It makes perfect sense: let's favor the old man and see if we can shut him up by doing him a huge favor. I can't think of any other reason why they would have done it."

I remain puzzled as to why the United States government would allow the firstborn son of a prominent Communist spy into the country at a time when visas were so hard to come by. Was it possible that someone had called in an IOU or pressured someone in the state department or another government agency to help An's son? Did An still have that kind of influence with the other side? If so, what did it all mean? For example, why had William Colby asked to see An on both of his visits to Vietnam? "I could not accept the invitation because of the way it would look," An told me. "They already suspected me of being CIA." Did Colby merely want to see an old friend to tip his hat, one spook to another? Or is there a deeper layer, leading only to further questions that might never be answered?

Bob Anson had volunteered to use his family connections to see whether An Pham could be admitted into the school of journalism at UNC. Now remarried, Anson's new mother-in-law, Georgia Kyser, lived in Chapel Hill and had close ties with the university. Anson wrote to McCulloch, "Georgia is a wonderful southern lady and is

really connected with UNC and the community, so it should be an ideal situation."

Georgia was actually about as well connected as anyone could be within the UNC Chapel Hill community. She was the wife of famous bandleader and radio celebrity James Kern "Kay" Kyser, a North Carolina alumnus and one of the university's largest supporters.[32] In 1943 he met Georgia Carroll, a blonde fashion model who had appeared in several films, including playing Betsy Ross in James Cagney's 1942 musical *Yankee Doodle Dandy*. They were married a year later.[33] Georgia retired from her career in order to raise their three daughters—Kimberly, Carroll, and Amanda. The Kysers lived just across from the university campus in the oldest house in Chapel Hill.

Georgia agreed to house An Pham in a fully equipped basement apartment in her home. To this day, An Pham calls her *mamo*, meaning "second mom." An Pham is also proud godfather to Robert Sam and Amanda Anson's daughter Gigi. "He was one of the greatest things that ever happened to me," recalled Georgia. "Here we were, two people from different parts of the world and politics, and our countries had been at war in the past, and we connected as people. It was really the first time in my life that I had an Asian friend. He was a joy."

Getting An Pham admitted into the journalism program was going to be the easiest of the tasks involved. In a letter dated May 7, 1990, University of North Carolina president C. D. Spangler wrote to Anson that "the University of North Carolina at Chapel Hill will be pleased to admit Mr. An as a non-degree student in the School of Journalism."[34]

The one-year, nondegree program was useful to foreign students because they could explore classes without being tied to specific

requirements, although the nondegree program did not come with financial support of any kind. If An Pham did well in his first year of studies and then on the GRE exam, he could matriculate into the masters program in journalism.

Just prior to the Labor Day weekend of 1990, Anson received a letter from An, who was orchestrating things in Ho Chi Minh City. An Pham needed three items to secure an exit visa. The first, which he already had, was a formal letter of admission from the university; the second was an official sponsor while in the United States (also required by the university); the third was a U.S. entrance visa, which among other things, required a two-week security check by the U.S. Embassy in Bangkok. "I'm working on getting that done," Anson cabled to McCulloch, "and the Vietnamese, in the person of Nguyen Quang Dy, the local press attaché, have promised to do everything they can to help speed things along."[35]

The most immediate task at hand was to raise money. Since An Pham was receiving no financial support from UNC, it was up to An's former colleagues. It was Labor Day weekend, so on Tuesday McCulloch planned to kick things off. "Tell An to be of good faith. The wheels have begun to turn, however slowly," McCulloch cabled Bob Anson.[36]

In a "Dear friends" letter dated September 4, 1990, McCulloch wrote "My apologies for not personalizing this letter, but time is of the essence, and this seemed the most efficient way to go. Most of you, I think, know Pham Xuan An personally, and those who don't will remember him as a correspondent in the Saigon bureau of *Time-Life* and the subject of the poignant chapter in Morley Safer's book that ran as an excerpt in a recent *New York Times* Sunday magazine. The generations changeth, and now An's oldest son, Hoang, wants very much to come to the United States and study journalism—not as a means of getting out of Vietnam but, in his

An was thrilled when his friend and colleague Stanley Cloud visited in 1990. An's beat-up old Renault would soon be sent to Hanoi for museum restoration.

own words, to return there with his new skills 'to be in the service of my people.'"

McCulloch thanked Anson for obtaining the commitment from UNC, for making the housing arrangements with his mother-in-law, and for starting "the bureaucratic wheels turning in both the U.S. and Hanoi. What's lacking now is the ingredient that will bring all this together, and that's simply money," wrote Frank. "Our best estimate is that the bare bones minimum Hoang An will need for one academic year is $11,000. That covers everything from round trip air fare to tuition to books, food and shelter."[37]

Before the "official" campaign even got off the ground, $3,000 was raised—$1,000 from Neil Sheehan and $2,000 from President

Spangler, as a personal gift. "That leaves us with approximately $7500 to go," wrote Anson. "In the best case situation, Time Inc. would take care of all of it but, frankly, I don't think that's going to happen. According to Sheehan's wife, Susan, she and her husband raised the notion at a dinner with several Time, Inc. executives some months ago, and got a flat turn-down. In view of An's long years of low-paid service to the magazine, and the continuing help he provides to any and all *Time* correspondents who pass through Saigon, I find this grotesque, but there it is."[38]

Anson suggested that someone approach the *New Yorker* and get a donation in the memory of Robert Shaplen, who had died in May of 1988, but he worried that without corporate sponsorship, it was going to be a tough road with individual donors. He put together a list of those who should be tapped—"David Greenway, Dick Clurman, Murray Gart, and then the correspondents like Bill Stewart, the Hong Kong bureau chief whom An had also written directly for help; Stan Cloud who recently saw An; Laura Palmer, who was 'devoted to An.' Jim Willwerth in the LA bureau, Burt Pines of Heritage Foundation, Bill Marmon, Pippa Marsh, Jon Larsen, Jim Wilde, John Sarr, former *Life* in Saigon now with *People*, Dick Swanson and Germaine Greer [*sic*] of Germaine's...she's wildly anti-communist, so be prepared for a blast.... Beverly Deepe."

There were also problems communicating with An; surveillance had increased since the Safer interviews, and he had no access to a secure telephone or fax. "Till now, I've either gone into Saigon myself or pigeoned letters in with visiting correspondents," Anson explained to McCulloch, "Pigeons are also a problem, since so damn few correspondents are going in. Fortunately I've recruited at least one message carrier. That's Alison Krupnick of the U.S. State Department's Orderly Departure Program. A fluent Vietnamese speaker, Alison visits Saigon regularly, and is making her next trip

on 3 September. If you've got anything for An between now and then, please fax it to me as soon as possible. I'm hoping that Alison can function as a regular pigeon, but that hasn't been nailed down yet."

Alison Krupnick spent ten years as a Foreign Service officer and worked for ODP from December 1988 until July 1992. She probably made over thirty trips to Vietnam in that period. "At the height of our program (at least during my tenure) we ran two two-week interview trips each month.[39] Krupnick recalls making a visit to An's home, ostensibly to question him about whether or not young An Pham had been aware of his father's espionage role during the war. "I do remember being impressed with his dignity. Meeting him was yet another illustration for me of the complexities of the Vietnamese struggle for independence. So many journalists clearly respected and trusted Pham Xuan An. Yet he was a spy. It made me wonder whether he was a man following his conscience, a man struggling with his conscience or simply an opportunist... As a naïve, young American who had never experienced war first-hand, I could only imagine what I might have done had my principles or the security of my family been threatened. Pham Xuan An's story, like the stories of many people I met, was a reminder to me that things are not always black and white."[40]

"Alison Krupnick came to check on me," recalled An, "and wanted to know what my son knew during the war. I told her I had no network, there was no one else who helped me, and that I was a lone wolf. Therefore, my son didn't know anything; he was completely ignorant of what I did. He only learned in 1976 when I was made a Hero."

Somehow their conversation turned to astrology, and An discovered they were both Virgos. "I then loaned her my horoscope book in French. I told her I was very superstitious, born under star of

Virgo, but I also felt it was a good sign that a woman had come to check on all this. I felt protected by my sign." Krupnick confirmed this exchange, adding, "Yes, I'm a Virgo. I still laugh when I remember dignified Pham Xuan An asking me if I suffered from intestinal disorders because 'Virgos usually do.' It seemed such an improbable conversation to be having in Vietnam."

Krupnick also told An that she had lived in Monterey while learning Vietnamese at the Monterey Institute of International Studies, where she received her BA. An recalled for her the story of being offered a job in 1959 teaching Vietnamese to the first contingent of American advisors going to Vietnam and thought of the irony that if he had taken the job, he might have been her teacher.

By now Anson was working closely with Judith Ladinsky, who had outlined in great detail the procedures for getting An Pham's visa and who was willing to handle all of the paperwork between Hanoi and the United States State Department—once a guarantor had been identified.[41]

Ladinsky's work is legendary in Vietnam. She has helped the U.S. Committee for Scientific Cooperation build a thriving clinical infrastructure and establish joint research and primary care programs in pediatrics, corneal surgery, nutrition, and HIV/AIDS and cancer treatment. As part of her committee's mission to promote Vietnamese students' attendance at American universities, Ladinsky's Vietnam Educational Exchange Program (VEEP) administered the TOEFL (Test of English as a Foreign Language) exam twice a year in Vietnam. "My son would not have made it without Judith Ladinsky's help," An told me.

One of Ladinsky's most important recommendations was that a letter be written by someone of stature to Henry Dearman, dean of the graduate school, asking that the guarantor be waived so that the I-20 immigration form could be sent and the visa process could get

under way. Anson suggested a full court press be put on UNC, with name-dropping, including using the name of An's friend, CIA director William Colby, "since, clearly, they're never going to check."

Fortunately, Dean Dearman waived the requirement for a guarantor because of President Spangler's personal gift and presumably the link with the Kyser family to UNC. I asked Amanda Anson why Spangler had been so supportive. "He was a new president and lived just two houses away from my mother and had just replaced a very popular president, Bill Friday. Here was a case of the new guy helping a just cause and, as it turned out, he came to believe in An Pham as much as anyone. He later came to visit An's family three times in Vietnam, and An Pham's father had the opportunity to express his appreciation."

Frank McCulloch's efforts during this period become all the more remarkable when viewed within the context of his family crisis at the time. His own son was dying, and Frank needed to take leave to be with the family. Fifteen years later An asked me to carry the following taped message to Frank: "I would like to express my gratefulness to you for helping my son the best you could, particularly under the very hard conditions for you because you had only one son, a lawyer, who was in bed and wouldn't recover and to know that he would leave you and not live long.... under that kind of strain and pressure you spent a lot of time raising the money for my son. I really appreciate you very much."

With the assistance of Judith Ladinsky, An Pham signed his Vietnam Education Exchange Program application to study journalism in the United States. Ladinsky recalled her conversations with An Pham. "He was such an interesting and grateful young man, appreciative of everything his father and his father's friends were doing for him. I asked him about his father's role during the war. He spoke about the great pressure his father had been under

and how grateful he was to *Time* for everything they had done for the family. He told me he did not know how his father was able to live such a dangerous life for so long."[42]

Karsten Prager, who almost a decade earlier wrote McCulloch that "I always liked An but never quite trusted him," became the new communications link between Anson and An Pham in Frank's absence. Anson had already spoken with Vice Consul Larry Woodruff at the U.S. Embassy in Bangkok. "U.S. knows of An's wartime background and sees no special trouble for Hoang An from our end. Woodruff says that Hoang An should have no trouble getting U.S. entry visa, and has cabled Washington, setting the wheels in motion for this purpose."[43]

By Thanksgiving 1990 An Pham's security clearance was granted and the F-1 student visa issued. Pham Xuan An's friends and former colleagues raised enough funds to cover the cost of An Pham's two years at UNC. An cashed his *Time* pension and contributed $3,000 to the effort. Individual contributions by journalists were made by Neil Sheehan, Stanley Karnow, Jon Larsen, Johnny Apple, Morley Safer, John Griffin, Bill Plante, Don Moser, Stan Cloud, Dean Brelis, Lara Palmer, Dick Swanson, Jason Shaplen, Dick Clurman, plus corporate matching by Time, Inc. Most colleagues shared the sentiments of Jack Laurence, who wrote, "I am pleased to join the fund-raising drive.... am grateful to you for letting me know there was a cause in need."[44]

An Pham's paperwork was waiting in Bangkok at the U.S. Embassy. At the last minute, one final hitch developed. An Pham would have to first fly to Hanoi and present himself at the Thai Embassy for his entrance visa. "Judith Ladinsky was so helpful to me at this stage," An Pham told me. After a few days in Hanoi, An Pham returned to Ho Chi Minh City before flying to Bangkok,

where he was met by *Time* staff who had arranged for his hotel and took him to buy a new suit. The next day An Pham went for his visa and a brief interview at the U.S. Embassy. From Bangkok he flew to New York, where Anson picked him up at JFK Airport.

"I still recall how excited he was when he got to our house," recalled Bob Anson. "I picked him up, and he was still wearing that new suit *Time* had bought for him in Bangkok. He was like a little kid at Disneyland, so happy to be here."

An Pham spent two years at UNC. He worked part-time in the school library and had a brief newspaper internship, just as his father had done some thirty years earlier at the *Sacramento Bee*. In a manner that reminded me of his father, An Pham went to a different drawer in the family's library bureau and pulled out a sampling of his writing. The first one he showed me leaves little doubt that he is both living in his father's shadow but also forging his own way. It is a May 29, 1993, article in the Chapel Hill *Herald-Sun* titled "Animal Shelter Treats, Releases Injured Ducks," with the byline "An Pham, correspondent." [45]

As promised, An Pham returned to Vietnam in 1993 to begin work with the foreign ministry. In 1999 he secured a Fulbright Fellowship and attended Duke University Law School. When he needed financial support for his extra summer semester at Duke, President Spangler did not hesitate to provide the funds.

Although he lived in Durham during his three years of law school, An Pham would spend every Christmas with the Kysers. In a December 16, 2000, Christmas card to Georgia Kyser, Pham Xuan An wrote, "My wife and I are very grateful to you all to consider An Pham as a member of your own family. To him, your home is his second home and he is lucky to go back to North Carolina to further his education."

The friendship between Pham Xuan An and Le Cong Khanh, who was with me when I first met An, symbolizes the reconciliation between former brother enemies. AUTHOR'S PERSONAL COLLECTION

I close with a brief story related to me by my friend Captain Mark Clodfelter of the National War College, who took his class to Vietnam in the spring of 2006. They received a briefing from General Le Quoc Hung, director of the Foreign Ministry and An Pham's boss. An Pham was present, giving and taking comments during the Q & A. "He met with our group, which consisted of eight students (a mix of air force, army, navy, and marine officers, a member of the State Department, and a Department of the Air Force civilian) and two faculty members, on the morning of May 8, 2006. We were extremely impressed by his sophisticated knowledge of America's foreign relations as well as his fluent, nuanced English. When we left, we all remarked about how impressed we were with his superb understanding of American foreign policy."

During President George W. Bush's November 2006 visit to Vietnam, An Pham served as the translator for conversations

An Pham next to President George W. Bush at Ho Chi Minh City Securities Trading Center foyer. COURTESY OF AN PHAM

between President Bush and President Nguyen Minh Triet. An Pham told me, "I wish my dad were here to see these moments. My voice cracked at some point during my interpretation for the presidents, trying to hold back my tears."

Yes, his father would have been proud of his son, but I think even happier about relations between the two countries so close to his heart.

An Extraordinary Double Life

Final farewell to our dear brother, teacher and colleague, Hai Trung, a quiet Vietnamese hero who is so uncommon in qualities yet so human in nature that he is well respected by friends and foes alike, and standing out larger than life, almost a myth. Now that it's all over, may he rest in peace in the next life, with all its pains and ironies, all the mysteries and memories of the good old days that not all is well understood, that he could bring with him to the other world.

—Nguyen Quang Dy, inscription in An's memory book, September 22, 2006

I HAD COMPLETED CLOSE TO the final draft of *Perfect Spy* when Pham Xuan An died of emphysema on September 20, 2006, just eight days after his seventy-ninth birthday. For some reason when I learned of his passing, my thoughts flashed back to An's seventy-fourth birthday, "the worst day of my life," said An. The two planes had already hit the World Trade Center when on the other side of the international date line, An received a call to turn on his television.

"I went into traumatic shock. I could not speak, and I was depressed for a long time. I could not celebrate my birthday or do anything. I was so sad."[1]

That conversation occurred when we had just met. A few years later An had thoroughly digested the 9-11 Commission report. For two days he insisted that I hear his analysis of American intelligence prior to the attacks. Sitting in his living room, I wrote myself a note, "Too wild for words," meaning that Vietnam's top intelligence agent during the war was still holding court on the subject of human intelligence failures.

I later learned than An had never really retired from the spy business; he remained a "consultant" for Hanoi's General Department of Intelligence until six months prior to his death. "They are always asking me to read things and give my analysis. They know I will give them an honest assessment because I don't need anything from them. But I am so tired now and many times cannot find the time to read it all and then analyze it the way I should," said An.

Then I recalled the day I visited An with two friends. We had just returned from Khe Sanh, where thirty-five years earlier, PFC Michael Holmes, a member of the 9th Marines, "the walking dead," sustained life-threatening wounds. Michael carried in his pocket the Vietnam Cross of Gallantry "for achievements in support of the Armed Forces of Vietnam in their struggle against the communist insurgents." Captain H. M. Baker had served as an infantry advisor to the 9th ARVN Division from January to September 1969. Baker was in Saigon in April 1975 helping to evacuate Vietnamese friends and counterparts. Baker was also looking for memories of the past along the Mang Thit River and at Sa Dec; Michael was hoping to exorcise ghosts from the day his world changed, April 13, 1968, at Hill 861. This was their first time in Vietnam since the war.

An opened the green front gate of his home, welcoming the three

of us in and asking that we sit while his wife prepared tea. "Where did you both serve?" asked An. For the next two hours, An recounted in great detail strategic issues at Khe Sanh and Delta intelligence operations. An knew several of Baker's friends from the ARVN 9th Division. Major General Tran Ba Di had been commanding general of the 9th ARVN Division when Baker was there in 1968–1969. After the war, Di spent seventeen years and five days in Communist prisons. Baker had been trying to get a lead on Di's whereabouts, but kept coming up empty until he met the still well-connected An, who told Baker where to find Di in the United States. Di was now working in Disneyland. An's comments that day were analytic and objective; he never spoke in terms that might indicate he was on the winning side. He was still a master at his craft. I noted his recall of dates and personalities as well as that he was providing my friends with information they needed in their personal odyssey.

As we left An's home, Michael remarked, "When I came in 1968, no one ever told me why I was here. I did what I was ordered and never thought to know the enemy and why they were fighting back. Well, I just met the enemy and after thirty-five years finally understand." Baker remarked that "the general" was so modest and unassuming, yet so in control of the "briefing." It was vintage An.

The last time I saw An was in June 2006. We spent the morning discussing my previous day's interview with Tu Cang about the Tet Offensive. An began by saying, "I am feeling very weak and tired today, so maybe we will speak only for an hour." Four hours later An said it was time to lie down, always my cue to begin packing up. I was leaving for the States early the next day and said I would see him again in early October, just before the book went into production. "I hope so, but you have enough already, too much," he said, smiling.

When I visited in October, An's presence was still everywhere in

his home. In Vietnamese tradition the bureau had been converted to an altar to An's memory. There was a large picture of An in his general's military uniform, and his medals and certificates were on prominent display. A bowl of food was replenished regularly so that An would not go hungry in the next world. Another bowl held several burning joss sticks, next to which was An's coffee mug from OCC, the one that had been signed by his friends on the *Barnacle* staff. Four memory books were available for visitors to record their thoughts.

I was here to pay my respects to the family during their time of mourning. I asked a friend for the Vietnamese words to say "I share your sorrow." "*Chia Buon*" was my greeting to Thu Nhan. We sat and spoke about her husband. Later that day I went with An Pham to his father's grave to light joss sticks and reflect on all that had transpired between us for the past five years.

Over the next few days I was able to speak again with the one person who knew An better than anyone else, his wife. Thu Nhan understood that my book was finished, but that I still had questions remaining. Somehow she found the composure and cogency to assist me in ways I had not anticipated. She and An Pham tried as best they could to serve as a memory bridge. I was later taken to Long An for a meeting and lunch with An's longtime courier, Nguyen Thi Ba. I then interviewed the man who had raised the money to send An to the United States, General Mai Chi Tho, the younger brother of Le Duc Tho.

Throughout my visit, I met with An's two Vietnamese biographers as well as with the producer of the authorized Ho Chi Minh Television documentary on An's life. For the first time we were speaking of An retrospectively, that is, each of us was trying to find a place for him in our own first cut of history. As we swapped stories I wondered who, with the exception of his wife, really knew An? I had spent all this time with him, had so much information about

After two days of public viewing, An's funeral was held at the Funeral House of the Ministry of Defense. COURTESY OF AN PHAM

Note that An's OCC coffee mug signed by the *Barnacle* staff is amongst all the medals and military memorabilia.
AUTHOR'S PERSONAL COLLECTION

the interconnections in his life, yet knew only the part An decided he would let me into. How could I be sure I was not just getting the final spin from the master spy with the perfect cover? Perhaps An was again demonstrating the same mental discipline and compartmentalization he used during the war, when none of his American or Vietnamese friends really knew him either.

During one of our final sessions together, An surprised me by saying, "You almost have enough to write your book, but now you need to read this and we can talk tomorrow." An handed me a copy of *Past Continuous*, a book I had no knowledge of. In the early 1980s the political and security departments within Vietnam ordered the highly regarded writer Nguyen Khai to write a documentary novel about the lives of southern heroes who had dedicated themselves to the revolution.[2] Nguyen Khai later wrote in the memory book, "You will be in memory of the readers for good, and will be a Big Brother to me forever."

Published in 1983, the novel provided a look at the lives of three protagonists who fought for the National Liberation Front against the Americans and South Vietnamese: Quan, a secret agent; Vinh, a Catholic priest; and Ba Hue, a female battalion commander from an elite Viet Cong guerrilla unit. The character Quan, a secret agent placed into a key position in South Vietnam's Ministry of Information is based on the life of Pham Xuan An. An was interviewed extensively by Khai with the understanding that the author would intermingle real events with fictional names in order to disguise An's real identity—"a genre from the Soviet school of writing," said An, laughing.

The more I read of *Past Continuous*, the deeper my descent into Alice's maddening world. Here is how Nguyen Khai depicted Quan to the Vietnamese people in 1983:

Quan was a veteran of two wars of liberation, but for the entire thirty years of his military service he had never seen his own comrades' faces, only the faces of the enemy. He had been friends or acquaintances with many of the American advisors and high ranking offices of the Saigon government, from I Corps to IV Corps. He knew officers from the Special Forces, and from the top secret elite units of MACV general staff. He had been a special kind of soldier on a special kind of battlefield, isolated from his comrades, living with his enemies, breathing the same air, knowing that the one who looked at him as a close friend today could become his torturer tomorrow...

Every action, even the most minute, had to be seen in terms of its service to his mission. He had to live his cover as if it were his real life, in his thoughts as well as in his actions; he had to become his mask, only his mask, always his mask, nothing else. Fake but real, real but fake, for days and months and years, and at times, when it seemed the war was getting bigger and fiercer, it felt as if he would live that way forever.

But when the war was over, just like that, he had to return and live as ordinary people lived.... until then he had buried himself in a false life, lived the existence of a persona he had created, in order to fulfill his duty. How was he now to find his true personality? He couldn't continue to live the life he had lived for thirty years, and yet who was he before that time? Did that man still exist? Whenever I observed him in a new social situation, he seemed tentative, groping for the right words, somewhat shy and clumsy. When we spoke he would always preclude his sentences with tentative disclaimers: "In my way of thinking, perhaps...." Or, "In my experience, I think that." Yet none of the opinions that followed were at all mundane or banal. They were always

sharp, made a significant contribution to whatever was being discussed...

Quan had been an agent for thirty years, and had formed relationships within the top echelons of the Saigon regime, and yet his true allegiance had never even been suspected. He had developed many ways to double check and triple check his sources and agents, in order to keep himself alive. But as I listened to him, I could hear what he had lost as well.

The next day An showed me places in which names and events had been disguised, sometimes saying, "That was real, as depicted," but other times saying, "He changed the name, and that is really Peter Smark who told me that, not Rufus Phillips."[3]

"So," I asked, "how can I know what is real and what is not?"

"I will tell you, but only those things that pertain to your book. There's still much I cannot speak about," said An, no doubt taking his cue from the Mad Hatter.

It was then that An spoke at length about his loneliness and lost dreams. "The war was over, and all I wanted was to be like Tarzan in the jungle, free from all obligations. I would have liked to go to America and continue my work for *Time*, maybe as a West Coast correspondent based near Costa Mesa." I joked that he would at least be close to those seals on the 17-Mile Drive. "It is much better than Viagra, really," said An with a small laugh.

I suppose each of us will remember An differently. In looking over the obituaries and eulogies written by former colleagues, I was especially taken by three that went well beyond the standard biography. Writing in the *Independent*, Bruce Palling observed that "tricky while it is to attempt to quantify the impact of secret intelligence on the outcome of a prolonged war, Pham Xuan An deserves to be considered one of the greatest spies of the 20th century."[4] Palling

cited An's crucial role in the two turning points of the war—Ap Bac in 1963 and the Tet Offensive in 1968.

In the *Boston Globe*, David Greenway, who regularly brought An songbirds from Bangkok, asked: "Was An's friendship all a lie and a betrayal? There were so many lies and so much betrayal, so much conflicted loyalty in our ill-fated adventure in Vietnam that any sense of having been wronged has long since faded."[5]

And in *Time*, former bureau chief Stanley Cloud wrote, "I felt I knew him well, but I was wrong." Cloud viewed An as a nationalist who loved his country more than any ideology. "During the war a colleague of ours said to me, 'I think Pham Xuan An is the perfect example of the very best in Vietnamese society.' I felt that way, too. I still do."[6]

I am fairly certain that An's friends see him the way Jolynne D'Ornano did: "I am in great admiration how you managed your multiple lives so successfully and, I believe, very sincerely," she wrote in a letter near the end of An's life. "Your family aside, you had two loyalties—your country and your love for the U.S. and those Americans you befriended. I am unable to see any conflict in what you did. You can love another country for what it represents and oppose its policies especially when they are devastating your country and its people. It is not in your nature to sit by, do nothing and let nature and its events take their course. The role you played in shaping history took not only great conviction but great courage and I admire you for it."[7]

All An ever wanted for the Vietnamese people was the chance to determine their own future, free from foreign interference. He joined the revolution imbued with nationalist ideals to fight against colonialism with hopes of creating a new society based on social justice and economic equality. When the Americans came with their advisers and money, followed by their military, An accepted his

national obligation to work in espionage. He did not enjoy being a spy, and when the war was over, he took special pains to downplay his accomplishments.

Forty years after last seeing Lee Meyer, the young newspaper editor he had fallen in love with at Orange Coast College, An wrote her a lengthy e-mail: "Now it's time to summarize what I've done since I left Orange County. In the summer of 1959 I did my internship at the *Sacramento Bee* then it took me seven days to cross the country alone in my twelve-year-old Mercury to New York City to observe the press in activities at the United Nations and returned to Vietnam. I worked for Vietnam Press Agency in 1960 and then Reuters Ltd. Agency till summer 1964 to pick up a treat with the *New York Herald Tribune* until the national edition was folded in the summer 1965. So I was hired by *Time* magazine and I worked for them until the end of the war and then *Time* magazine office was closed in the summer of 1976 by the new regime. My dear profession was ended and the new regime made me a jack of all trades consultant."[8]

That was it. No mention of spying; of being a Hero or even a general. An was doing what he had done for five decades, presenting himself to others as he wanted to be seen by that person. So much remained secret to so many, yet he seems to have been friends with almost everyone. It was as if he still lived the compartmentalized life from the war, a journalist to the Americans; a hero to his nation. When the war was over, someone who thought he knew An as well as anyone, wondered how it was possible that the person whose advice he had relied on for so long had been a Communist agent without ever giving him the Communist line. "He was surely one of the best informed men in town and had countless news sources that no one else seemed to have," wrote Bob Shaplen. "In our conversations over the years, often lasting for hours, I discovered that the

facts and opinions he furnished about the Communists, the government, and the many contending individuals and groups—including Buddhists and Catholics who opposed both sides of the conflict—were more on the mark than anything I could obtain from other sources, not excluding the American Embassy, which often knew surprisingly little about what was going on among the non-establishment Vietnamese."[9]

How did An see himself? An's Confucian values may provide the key to understanding the man. "An was deeply Confucian—of this I am sure," wrote his friend Douglas Pike. "He was a moral person, so regarded himself, and consistently acted on the basis of Confucian values. One of these values concerns rules of friendship. It stresses loyalty and precludes any exploitation of a friend."[10]

I never heard An speak of being a spy as anything except an assignment that would end with unification. When An spoke of his job at *Time* or the *Barnacle*, there was always excitement in his tone. Perhaps most telling is that prior to his death, the walls of An's home had no medals or certificates of service as a Hero; indeed he kept all these in drawers or on the walls upstairs in the bedroom. During the entire time I knew An, I never once saw a single photo of him in uniform anywhere downstairs. In the homes of Heroes Nguyen Thi Ba and Tu Cang, pictures of Ho Chi Minh, medals, ribbons, and certificates adorn the walls.

An's most visible possessions were the books that overflowed from his library onto several adjacent tables and the stack of *Time* magazines that arrived weekly. Visitors knew the way to An's heart was to bring him new books. He was a voracious reader. Those who took the time to listen could learn.

In the immediate aftermath of the American War, An was probably the sole member of the victorious side who held no bitterness toward an enemy who had wrought so much death and destruction

in his country. "I had lived and worked with Americans for so long. I knew them as good people. Most Americans believed what their government told them; they did not know the real Vietnamese. I had no reason to dislike the Americans, just as the Americans who knew me before the war had no reason to dislike me."

The new regime discovered that their reprogramming did not work because An's mind could not survive in a closed society. Germaine Loc Swanson told me that "An was always a nationalist. He was a Communist by obligation." Yet, despite what some commentators have written, An did not rail against rampant corruption in Vietnam or even against the system more generally. Whenever asked, he spoke the truth, just as he had done throughout the war. He spoke cynically of "red capitalists," or "green Communists," telling me and others, "I didn't fight for any of this." He never wrote anything publicly critical of the government. He just spoke his mind about a different vision of the future. He always regretted the senselessness of the war with its numbing casualties on both sides. In December 1969, An wrote to Rich and Rosann Martin "Concerning the war in Vietnam, it is a very sad thing."

I once asked An Pham what he thought my book about his father should be called. He thought for awhile and suggested *Friends and Spies* because "somehow, for my dad, two things that don't usually go together in spying did. I hope he is always remembered for being loyal, to his friends and to his country. Sometimes in life you need to choose between interests. In Vietnamese the word *tam* means '*heart.*' My father was always guided by heart, not self-interest. When you feel no remorse in your heart, you did the right thing. My father feels no remorse."

During the 1975–1986 period when An was being closely watched, he spent quite a bit of time reading with his children, trying to impart to them a core set of values he had learned from so many of

his friends. "I wanted them to respect humanity and to know that knowledge is more valuable than money. An Pham learned this from his family here and his second family in Chapel Hill, the same way I learned American culture from California. The Americans were so human, they knew how to laugh and be so free, that is special."

It was widely reported that in 1997 that the Vietnamese government denied An an exit visa that would have permitted him to appear on a panel with other journalists in New York City to discuss the legacy of Vietnam. "As far as we know, due to his old age and weakening health, Mr. Pham Xuan An did not request an exit visa," said the Foreign Ministry.[11]

This was not true. "I wanted to attend that meeting very much," An told me. "They do not understand me, so they are afraid. I understand why no one wants to sign my exit visa and be responsible for letting me out. It could ruin their career if I said or did something wrong."

Then he joked, "What if I found another girlfriend in America?"[12]

Yet, there is still so much anger from those who see An as responsible for the deaths of not just hundreds but thousands of Americans. "He cannot have done what he did without costing American lives," said his former dorm mate former California state senator Ross Johnson. "Anyone who says he didn't is naive."[13]

It's hard to disagree with the conclusion that many died because of the success of this master spy, but I think this anger obscures the fact that An was defending his country. Wendy Larsen, who spent time with An while her husband, Jon, was *Time*'s bureau chief, wrote me to say, "I like to think that were the situation reversed, I might have showed one hundredth of the courage An did for his country." After learning of An's death, Jul Owings, the daughter of Mills Brandes, wrote me about the "passing of one of my family's

best friends. It does not surprise me that Mr. An's first loyalty was to his country. Wouldn't we do the same?"

An lived long enough to see a new chapter open between the United States and Vietnam. Indeed, he became part of the broader reconciliation process between former enemies, and here I believe An's life came full circle. When Raymond F. Burghardt's tenure as ambassador came to an end, An was invited to a reception to welcome the new diplomatic mission and to bid farewell to the departing ambassador. A few days prior to the event, An was bitten by his pet falcon and was unable to attend; An Pham represented the family.

When the ambassador learned that An was home, he asked to be driven there to personally say good-bye. "I did not want to leave Vietnam without saying good-bye to An," Ambassador Burghardt told me. "His story, his life are just so incredible, but even more than that he is an important symbol of the new friendship between our two countries. And his son is just such a remarkable man as well."

Several weeks later United States Consul General Emi Lynn Yamauchi spent Tet, the traditional Vietnamese New Year, at the home of the An family. "We wanted her, as our friend, to be with a typical Vietnamese family at this time of year," said An Pham. "It is important that we understand each other's cultures and traditions."

Several wreaths at An's funeral spoke volumes about his role in the process of reconciliation: "To our beloved teacher Pham Xuan An, we will always cherish your wisdom and friendship," from the Vietnam Project, Harvard University; "With our deepest gratitude for your counsel and encouragement," from the Fulbright Economics Teaching Program; and, of course, from a dear friend: "In admiration and loving memory of Phan Xuan An," from Neil, Susan, Catherine, and Maria Sheehan.

An is venerated and beloved in Vietnam for his contribution to

PHAM XUAN AN PERSONAL COLLECTION

the Vietnamese people's victory. When he died on September 20, 2006, his coffin lay in state for two days of public tribute before a funeral with full military honors. He is buried beside Ba Quoc and other espionage agents in a special area of the Ho Chi Minh City national cemetery.

A story in the newspaper *Thanh Nien* noted that An "did things that very few spies could do. It is easy to understand why An was chosen by the Viet Cong but it will take us time to properly assess the man and what he leaves behind." Tu Cang wrote the following poem to commemorate An's passing, which serves, I think, as a metaphor for a war and a life so few understood:

And so this is the end of the life of a spy,
One who loved the People, was loyal to the Party, and fulfilled
 his Debt to the Nation,
You were a man who lived through a time of turmoil
You are truly worthy of the title "Hero."
Xuan An, from now on you will truly be "An" [hidden, secret],
Your friends will always mourn your loss.

ACKNOWLEDGMENTS

~~~~~~~~~~~~~~~~~~~~~~~~~~~~~~~~~~~~~~~~~~~~~~~~~

MY LARGEST DEBT IS TO Pham Xuan An for allowing me to write about his extraordinary life. I already miss our long conversations. I owe much to An's wife, Thu Nhan, for speaking with me during her own time of mourning. An Pham and I spoke several times during the last five years, but he went the extra mile by agreeing to read and comment on the final draft. He never once asked me to change a sentence about his father and frequently remarked, "I did not know that about my dad."

I have come to understand why journalists consider Frank McCulloch the very best of his profession. Frank spent hours speaking with me about the man he hired to work for *Time* as well as An's professionalism. Robert Sam Anson reconstructed events surrounding his capture and release and provided important documents pertaining to An Pham's study in the U.S. Stanley Karnow shared his views about An, Dr. Tuyen, and plots within plots that characterized Saigon in the early 1960s. Dick Swanson and Germaine Loc Swanson each guided me at the very start of this book and later reviewed key parts of the manuscript. I especially benefited from

Germaine's perspective on friendships, loyalties, and the war. Dick was extremely helpful in answering so many questions about photos and linking me with his colleagues. Dan Southerland reconstructed April 1975, when he and An helped get Dr. Tuyen out of the country and he brought a careful eye to the manuscript. Ron Steinman, NBC bureau chief in Saigon, read the entire manuscript and provided valuable insights. Ambassador Bui Diem advised me on Saigon politics and his interactions with An. Ambassador Nguyen Xuan Phong spent hours speaking with me about An and the concept of brother-enemies. Nguyen Thai provided invaluable insights about his relationship with An and the Ngo family.

I benefited from exchanges with several of An's former colleagues and/or personal friends: David Lamb, George McArthur, Horst Faas, Eva Kim, Jolynne D'Ornano, Bernard Kalb, Neil Sheehan, David Halberstam, David Burnett, Judith Ladinsky, Gerald Hickey, Nick Turner, Ted Thai, Rufus Phillips, Jon Larsen, Stanley Cloud, David DeVoss, Alison Krupnick, and Wendy Larsen.

I have three special intellectual debts for the final ledger. Merle Pribbenow, a former language officer, operations officer, and staff officer for the CIA from 1968 to 1995 regularly provided me with English translations of almost anything published in Vietnamese about An and his espionage network. Lien-Hang T. Nguyen at the University of Kentucky translated several articles and read the entire manuscript and page proofs. Edward Miller at Dartmouth read several early drafts, secured a copy of David Butler's extensive interviews with Dr. Tuyen from the Butler Papers at Dartmouth, and provided me with the transcript of his own interview with An. Hang and Ed supported me during moments of doubt and confusion. I asked my junior colleagues to be tough and they spared nothing. Ed and Hang represent the very best in the next generation for Vietnamese studies.

It is a pleasure to acknowledge the support and friendship of James Reckner, Steve Maxner, and Khanh Le at Texas Tech University's Vietnam Center. Thanks to Jim, I was able to meet An; Khanh introduced me to Vietnam; Steve provided access to primary source materials and images. As with my previous books, by deed of gift all my research materials will be deposited in the Vietnam Archive.

Several colleagues and friends provided invaluable advice. Kathy Olmsted, Nguyen Ky Phong, Fred Brown; Nguyen Manh Hung, Andy Birtle, David Seerman, Bill Laurie, Mark Clodfelter, David Biggs, John Prados, Anhthu Lu, and Sedgwick Tourison helped whenever I asked. Stephen Routh, Myrna Rothstein, and H. M. Baker read the entire manuscript and offered many helpful suggestions.

An's friends from his two years at Orange Coast College, Rosann Rhodes (Martin), Judy Coleman (Lanini), Ross Johnson, Pete Conaty, and Bruce Nott provided me with their recollections. Rosann read the final draft of my chapter about OCC. Bruce, who reconnected with An, always tried to help me in ways that went far beyond anything I could expect. Pete provided me with his original copies of the *Barnacle*. Jim Carnett, Douglas C. Bennett, and Mary Roda at Orange Coast College were very helpful during my visit to OCC.

I thank Jul Owings and Jud Brandes for providing so much information about their father and their family's relationship with An.

My research assistant, TiTi Mary Tran, translated the entire text of An's Vietnamese-language biography as well as numerous essays and articles. TiTi later went to Saigon and conducted two valuable solo interviews with An. I benefited from a two-hour video interview with An by Sean McMorris. Tracy Eckard did a masterful job translating from French into English.

I am grateful to my friends at the American Consulate in Ho Chi Minh City. Consul General Seth Winnick, Deputy Consul General

Kenneth Chern, and Public Affairs Officer Kimberly Gillen. Jim Nach, formerly the NGO liaison officer at the U.S. Consulate General, helped secure the photo of An aboard the U.S.S. *Vandegrift*. Former U.S. Ambassador to the Socialist Republic of Vietnam Raymond Burghardt spoke at length with me about An.

During my many visits to Saigon I benefited enormously from interactions with Hoang Hai Van, Le Phong Lan, Nguyen Thi Ngoc Hai, Nguyen Van Lang, and Nguyen Thi Xuan Phoung. My research associate and translator in Saigon, Nguyen Thi Thanh Phuong was indispensable in so many ways, but especially when translating during interviews with Nguyen Thi Ba and Tu Cang. Dang Dinh Quy at the Embassy of Vietnam in Washington, D.C., was always helpful as I prepared for my many trips. My friends at Que Huong—Liberty 2 made sure that coffee or tea was delivered at 4 a.m., so that I could start writing. Whenever I needed materials copied, they did this with great care.

I conducted research in several archives and appreciate the assistance from Jacquelyn Sundstrand at the University of Nevada, Reno Manuscript/Archives, Carol Leadenham at the Hoover Institution Archives, and the staff at the Wisconsin Historical Society Archives.

A special thank you to Georgia Kyser and her family, Kimberly, Amanda, Clayton, and Jay Bryan for speaking with me. Mrs. Gerald Barrett, who visited An twice in Saigon, provided keen insights.

Chi Ha and Anh Nguyen of Minh's in Arlington provided the perfect environment for lunch and dinner conversations with An's friends and colleagues. John Shelton ensured that I was never late for any interview.

My agent, John Wright, was the first to believe in my idea for the book, and in Smithsonian Books he found a perfect fit. My editor, Elisabeth Kallick Dyssegaard, helped me understand the importance

of visualizing and writing about An's life as dramatic narrative. She came closer than anyone to *feeling* the story, and I could not ask for a more engaging relationship with an editor.

Dan Crissman, editorial assistant at Smithsonian Books, was extremely helpful with all matters having to do with manuscript preparation and photo logs.

Raymond Tse designed the Web page www.larrybermanperfect spy.com

At UC Davis, Wayne Fischer and Hielam Chan saved me more than once when the computer did not do what it should have. I appreciate the staff support at UC Davis from Kelly Ramos, Gloria Castillo, Cindy Koga Simmons, Sande Dyer, and Micki Eagle. In Washington, Mary Byrne, Karen Akerson, Rodger Rak, Mike Sesay, and Sara Lombardo helped in many ways throughout this project.

My colleagues, Miko Nincic, Don Rothchild, Emily Goldman, Ed Constantini, James Desveaux, and Larry Peterman were supportive in ways that friends understand.

For the past five years I have usually been somewhere other than home; even in Davis, my mind was always on this book. My appreciation for Nicole's understanding is immeasurable.

# NOTE ON SOURCES

<sub></sub>

The Neil Sheehan Papers located in the Library of Congress contain interview notes with An as well as with Lou Conein, David Halberstam, and key figures from the period; they are cited as "Sheehan Papers." An's closest working relationship was with Robert Shaplen, the *New Yorker*'s Far East correspondent. Shaplen's papers are deposited in the Wisconsin Historical Society on the campus of the University of Wisconsin. I made extensive use of Shaplen's original handwritten and typed notes from dozens of meetings with An and others; they are cited as "Shaplen Papers." An was hired to work for *Time* magazine by Frank McCulloch. An credits McCulloch with teaching him how to be a good journalist. McCulloch's papers are deposited at the University of Nevada, Reno; they are cited as "McCulloch Papers." One of An's first contacts in Vietnam was with the legendary Colonel Edward Lansdale. The Lansdale Papers at the Hoover Institution Library contain correspondence about An and Robert Shaplen (a close personal friend of Lansdale), as well files of the history of counterinsurgency in Vietnam; they are cited as "Lansdale Papers." Also located in

Hoover are the papers from the Staley Mission. At the Sacramento Archives and Museum Collection Center microfilm collection from the *Sacramento Bee* I found articles written by An during his summer internship of 1959 as well as a feature story about An that helped establish his cover. At Orange Coast College, I had access to all of An's columns in the *Barnacle*. The National Archives, Records of the United States in Southeast Asia, 1950–1975, Records Group 472, contains important holdings for the war. The David Butler Papers at Dartmouth contain a lengthy interview with Dr. Tuyen. Unless otherwise noted, all quotations of conversations are attributed to my interview with the individual.

Prior to 1975, South Vietnamese spelling utilized hyphens. The hyphen is no longer used. I have used the hyphen whenever it appears in the original source. Vietnamese words have one syllable, so the proper spellings are written as Viet Nam, Sai Gon, Da Nang and Ha Noi. During the war, Americans merged these two words into one. To avoid confusion, I have used the forms most often found in official U.S. documents for Saigon, Vietnam, and Hanoi, but wherever possible have tried to use the single syllable for other cities or villages that appear in the narrative, such as Can Tho. Vietnamese names are written last name, middle name, then first name. The Vietnamese people are referred to by their first names, hence Pham Xuan An is identified as An.

# NOTES

<hr />

## PROLOGUE: "I CAN DIE HAPPY NOW"

1. A sampling of these articles include Stanley Karnow, "Vietnamese Journalist's Divided Allegiance: After Nine Long Years a Double Agent Explains the Mystery of His Actions," *San Francisco Chronicle*, May 30, 1990; Morley Safer, "Spying for Hanoi," *New York Times Magazine*, March 11, 1990; Robert D. McFaddden, "The Reporter Was a Spy from Hanoi: Life and Legacy of a Paradox," *New York Times*, April 28, 1997; Douglas Pike, "My Friend An," in *The Vietnam Experience, War in the Shadows* (Newton, MA: Boston Publishing, 1988); Laurence Zuckerman, "The Secret Life of Pham Xuan An," *Columbia Journalism Review*, May/June 1982, 7–8.

2. H. D. S. Greenway, "Shadow of a Distant War," *Boston Globe*, April 30, 2000. See also H. D. S. Greenway, "A Glimpse of the Boxes Within Boxes of Vietnam," *Boston Globe*, January 5, 1990.

3. http://vnexpress.net/Vietnam/Xa-hoi/2003/06/3B9C8E01/Thieu tuong tinh Pham Xuan An lam trong benh.

4. Nguyen Thi Ngoc Hai, *Pham Xuan An: Ten Nguoi Nhu Cuoc Doi* (Hanoi, 2002). Cited as *His Name Is His Life*." Nha Xuat Ban Cong An Nhan Dan. (Hanoi: 2002).

5. Hoang Hai Van and Tan Tu, *Pham Xuan An: A General of the Secret Service* (Hanoi: The Gioi Publishers, 2003). Cited as *A General of the Secret Service*.

6. An later told me: "I had many friends who faced real problems if they

stayed. I could not stop them from leaving because that made no sense, so I advised them on the safest way to reach the open sea and get picked up. Many of them never made it, but the war was over and I had no new instructions."

7. Sherman Kent, *Strategic Intelligence for American World Policy*, rev. ed. (Princeton, NJ: Princeton University Press, 1966).

8. *A General of the Secret Service*, 80.

9. Ernest Volkman, *Warriors of the Night: Spies, Soldiers, and American Intelligence* (New York: Morrow, 1985), 15.

10. Pham Vu, "Pham Xuan An—The Legends He Left Behind." *Tien Phong* newspaper, October 2, 2006, p. 3. An told me the same, many times.

11. Sheehan unpublished interview with Conein, Sheehan Papers, September 22, 1976, Box 62, Folder 9.

12. Laura Palmer, "Mystery Is the Precinct Where I Found Peace" in *War Torn: Stories of War from the Women Reporters Who Covered Vietnam* (New York: Random House, 2002), 269.

13. *A General of the Secret Service*, 131.

## Chapter 1: *Hoa Binh*: Spy and Friend

1. Documents would later show "loss coordinates" in Cambodia as 12°04′00″ North, 105°04′00″ East. I am grateful to Robert Sam Anson and Pham Xuan An for reconstructing these events.

2. http://www.pownetwork.org/bios/s/s602.htm. See Richard Dudman, *Forty Days with the Enemy: The Story of a Journalist Held Captive by Guerrillas in Cambodia* (New York: Liveright Press, 1971); Kurt Volkert and T. Jeff Williams, *A Cambodian Odyssey and The Deaths of 25 Journalists* (Lincoln, NE: Writer's Showcase Press, 2001). http://www.mekong.net/cambodia/missing.htm.

3. Robert Sam Anson, *War News: A Young Reporter in Indochina* (New York: Random House, 1989), 27. This chapter draws from Anson's account in *War News* as well as extensive discussions with both Anson and An.

4. Ibid., 15.

5. William Tuohy, *Dangerous Company* (New York: Morrow, 1987), 117.

6. Larry Berman, *Lyndon Johnson's War: The Road to Stalemate in Vietnam* (New York: W. W. Norton, 1989), 194–97.

7. See Larry Berman, *No Peace, No Honor: Nixon, Kissinger and Betrayal in Vietnam* (New York: Free Press, 2001), 49–50.

8. *War News*, 38–40.

9. *War News*, 70.

10. *War News*, 64; personal interview with Anson.

11. *War News*, 64.

12. Jason Felch & Marlena Telvick, "Unsung Hero," *American Journalism Review*, June/July 2004. http://www.ajr.org/Article.asp?id=3699; see also http://www.muckraker.org/content/news_events/McCullochBio.pdf#search='Frank%20McCulloch'; Wallace Terry, "*Time*'s Frank McCulloch: In the Eye of the Hurricane," http://www.vva.org/TheVeteran/2002_11/mcculloch.htm.

13. Cited in David Halberstam, *The Powers That Be* (New York: Knopf, 1979), 472.

14. Ibid; 475

15. When McCulloch left Vietnam in late 1967, *Time*'s office manager, the same Mr. Dang who had given Anson such a hard time, wrote a personal letter to Frank: "I assure you that you have our admiration, love, respect and gratitude. I don't know what to say more at this moment but express our deepest gratitude to you, the most respected one we have ever met in our life. Once again, I'm with you forever." December 13, 1967, 96-39 Box 6, Press Correspondence, McCulloch Papers.

16. Sydney Schanberg excerpt, http://www.crimesofwar.org/thebook/cambodia.html

17. Ibid; see also Henry Kamm, *Dragon Ascending: Vietnam and the Vietnamese* (New York: Arcade Publishing, 1996),121–122.

18. *War News*, 138, 164; See Robert Sam Anson, "Apocalypse Then," *Washington Monthly*, October 1, 1989.

19. *War News*, 138.

20. See T. D. Allman, "Massacre at Takeo"(Cambodia: April 1970), in *Reporting Vietnam*, vol. 2, *American Journalism 1969–1975* (New York: Library of America, 1998), 129.

21. *War News*, 140.

22. *War News*, 141; interview with Bernard Kalb.

23. *Cambodian Odyssey*, 46–47.

24. Ibid.

25. *War News*, 233, 242.

26. *War News*, 249.

27. "Lessons about Hai Ba Trung, Ba Trieu, Dinh Tien Hoang, Tran Hung Dao, Ngo Quyen, or Le Loi, Nguyen Trai, Nguyen Hue, Quang Trung, or Hoang Hoa Tham, Phan Dinh Phung, Nguyen Thai Hoc." She recalled such songs that kindled and glorified patriotism as "Bong Co Lau," "Thang Long Thanh," "Du Kich Quan," "Kim Dong," "Diet Phat Xit"; the rhyme "Di Quyen Gop Vang"; the poems "Nguyen Trai–Phi Khanh," "Ngay Tang Yen Bai."

28. Interview with Thu Nhan.

29. At the time she received this award, Ba was a captain in intelligence. She is a native of Hau Thanh village, Duc Hoa district, Long An province. She joined the armed forces in 1961 and was promoted to her highest rank, major, in 1993. She joined the Vietnamese Communist Party in 1936.

30. Interview with Nguyen Thi Ba.

31. *Military Encyclopedia of Vietnam [Tu Dien Bach Khoa Quan Su Viet Nam]*. Compiled by the Military Encyclopedia Center of the Ministry of Defense; Chief Editor: Senior Colonel Tran Do (Hanoi: People's Army Publishing House, 1996), 567.

32. *Vietnamese Intelligence and Some Strange Stories.* Quan Doi Nhan Dan, 22 October 2004. *http://www.quandoinhandan.org.vn./news.php?id_new=52089&subject=2* [Tình Bao Viet Nam va Nhung Cau Chuyen Lạ] This is the Internet edition of The People's Army newspaper. See also Chapter 29, "Ba, A Heroine," in *A General of the Secret Service*.

33. Interviews with both An and Tu Cang.

34. Notes of interviews file, April 15, 1972, *New Yorker*, Box 1-2, Shaplen Papers. This also appeared in the magazine.

35. See Tom Mangold and John Penycate, *The Tunnels of Cu Chi* (Cavaye Place, London SW. Pann Press, 1985). First published by Hodder and Stoughton, Ltd.

36. Interview with Ha Thi Kien.

37. *War News*, 263.

38. *War News*, 270.

39. *War News*, 311.

CHAPTER 2: THE APPRENTICESHIP OF A SPY

1. Interview notes, Box 91 Folder 10, April 1975, Shaplen Papers.

2. Upon their arrival in Saigon, Lansdale gave the Brandes family a dog named Chautaulle, and every weekend they were invited to swim at the Lansdale residence. The children still refer to Conein as "Uncle Lou."

3. Known by friends as "Black Luigi," "Three-Finger Lou," and "Lou-Lou," Conein was a "tough, hard-drinking, and outspoken officer...straight from the pages of an adventure novel." See Howard R. Simpson, *Tiger In The Barbed Wire* (Washington, D.C.: Brassey's, 1992), 125. Also see Kenneth Conboy and Dale Andradé, *Spies and Commandos: How America Lost the Secret War in North Vietnam* (Lawrence, KS: University Press of Kansas, 2000), 3.

4. After I returned her father's correspondence, Jul sent the following message for An: "Mr. An, I love you...you were my best friend when we lived in Vietnam. I'm so sorry [my father] is not alive today to say hi to you."

5. Mills also tried convincing An that he should write a letter to the *Washington Post* in response to a recently published letter by Thiem Kim, a "little Vietnamese girl" whose critical questions about United States foreign policy had been published in the paper on February 25 (personal letter, March 24, 1958).

6. *A General of the Secret Service*, 30.

7. *Dragon Ascending*, 40.

8. *No Peace, No Honor*, 63–4. Also Luu Van Loi and Nguyen Anh Vu, *Le Duc Tho–Kissinger Negotiations in Paris* (Hanoi: The Gioi Publishers, 1996).

9. Interview with An; this episode originally reported in *A General of the Secret Service*, 27.

10. *Dragon Ascending*, 37; interview with An.

11. David G. Marr, *Vietnam 1945: The Quest for Power* (Berkeley: University of California Press, 1995).

12. Ibid., 534.

13. Ibid., 532.

14. Southerners like the Cao Dai and Hoa Hao would become very disillusioned with the Viet Minh. Less than a week after Ho's speech in Ba Dinh Square, fighting broke out between Viet Minh and Hoa Hao units at Can Tho. The Hoa Hao founding prophet, Huynh Phu So, was captured and executed by the Viet Minh.

15. *Vietnam 1945*, 535.

16. See Mark Bradley, *Imagining Vietnam and America: The Making of Post-colonial Vietnam, 1919–1950* (Chapel Hill: University of North Carolina Press, 2000).

17. Ibid.

18. See Xuan Phuong and Danièle Mazingarbe, *Ao Dai: My War, My Country, My Vietnam* (Great Neck, NY: EMQUAD International, 2004) 5.

19. *Dragon Ascending*, 40. Confirmed in my interviews with An.

20. "She visited Saigon, Indochina, 16–23 March 1950, and witnessed operations of Viet Minh forces against French authorities," http://www.vietnam-project.ttu.edu/dd786/ship's.htm.

21. *His Name Is His Life*, 20–1; *A General of the Secret Service*, 25.

22. The "stool pigeon" reference first appeared in Kamm, and I later confirmed with An that this was how he felt at the time.

23. *A General of the Secret Service*, 25–6.

24. James Lawton Collins Jr., *The Development and Training of the South Vietnamese Army, 1950–1972* (Washington, D.C.: Department of the Army, 1975).

25. http://www.army.mil/cmh/books/Vietnam/FA54-73/ch2.htm, "The Advisory Effort, 1950–1965." See Ronald H. Spector, *Advice and Support: The Early Years of the U.S. Army in Vietnam, 1941–1960* (New York: Free Press, 1985), 289. I make extensive use of Spector's superb book.

26. At an NSC meeting in late October 1954, President Eisenhower said what was needed in Vietnam "was a Vietnamese force that would support Diem. Therefore, let's get busy and get one." Cited in David M. Toczek, *The Battle of Ap Bac, Vietnam: They Did Everything but Learn from It* (Westport, CT: Greenwood Press, 2001), 6; *FRUS, 1952–1954*, vol 13. XIII, Indochina, 2156–2157, 2161; Advice and Support, Chapter 6.

27. Interview with An.

28. Richard Pyle, "During the War, Vietnamese Journalist-Spy Lived in Two Worlds," AP, April 28, 2000.

29. Interview with Nguyen Thai.

30. On Lansdale see Jonathan Nashel, *Edward Lansdale's Cold War* (Amherst: University of Massachusetts Press, 2005).

31. Sedgwick Tourison, a leading authority in the intelligence field, wrote that in 1954 "Pham Xuan An, a youngish-looking Vietnamese, was in contact with Colonel Lansdale and his staff ... Unknown to Lansdale's team was the

fact that Pham Xuan An was a decade-long Communist intelligence officer with an intense interest in Lansdale's operation." *Secret Army, Secret War: Washington's Tragic Spy Operation in North Vietnam* (Annapolis: Naval Institute Press, 1995), 8.

32. Interview with Phillips.

33. In 2002 Phillips returned to Vietnam for an emotional meeting with An, highlighted by their dinner at the Majestic Hotel.

34. Interview with Mai Chi Tho.

35. See Memorandum from the Central Intelligence Agency to the 303 Committee, Department of State, INR/IL Historical Files, Minutes of 303 Committee, June 22, 1966, Eyes only. FRUS, LBJ document 132.

36. "IRC Program Planning Brings Diplomat to OCC," *Barnacle*, December 19, 1958.

37. Diem arrived in Paris from the United States in May 1953, a full year before his appointment, specifically to lobby Bao Dai. By October, the two had met in Cannes, where they discussed the possibility of Diem taking the premiership, a full six months before Dien Bien Phu and the opening of the Geneva conference. See the authoritative source: Edward Miller, "Vision, Power and Agency: The Ascent of Ngo Dinh Diem, 1945–54," *Journal of Southeast Asian Studies*, 35, no. 3 (October 2004: ) 433–458; Also, Edward Miller, "Grand Designs: Vision, Power and Nation building in America's Alliance with Ngo Dinh Diem, 1954–1960" (PhD dissertation, Harvard, 2004), 89.

38. "The French hadn't counted on an operator like Lansdale," wrote Zalin Grant. "Underlying Lansdale's actions, and a reason he was able to operate so freely, was the belief of most American officials going back to Franklin Roosevelt's time that nothing could be accomplished in Vietnam until the colonial French were removed from the picture." Zalin Grant, *Facing the Phoenix: The CIA and the Political Defeat of the United States in Vietnam* (New York: W. W. Norton, 1991), 103.

39. See Edward Lansdale, *In the Midst of Wars* (New York: Harper & Row, 1972), 171.

40. With Hinh's tanks poised just a few blocks away, rumors were rampant that Hinh, a French citizen with the rank of general in the French air force, was about to make a move against Diem. Employing a series of clever schemes to stall decisive action by Lt. Cl. Hinh, Lansdale went so far as to arrange sudden "study trips" to Manila for counterinsurgency lessons from the Filipinos and meetings with President Magsaysay. Nguyen Thai

was on those trips as a representative of Diem, and he told me that "in all those trips Lansdale made sure that Captain Man and Captain Vuong, who were the right-hand man and planning head for Hinh, were included in the party going to Manila. Without Captain Man and Captain Vuong in Saigon, there was no way Hinh could stage a coup d'état against Prime Minister Ngo Dinh Diem."

41. See J. Lawton Collins, chapter 19, "Mission to Vietnam," in *Lightning Joe: An Autobiography* (Novato, CA: Presidio Press, 1979).

42. Foreign Relations of the United States, 1955–1957, Vol. 1: *Vietnam* (Washington, D.C.: U.S. Government Printing Office, 1985), 292–293.

43. Kent to Dulles, April 23, 1955; ibid.

44. In a Memorandum for the Record dated April 27, 1955, Kent wrote: "General Collins reviewed the situation in south Vietnam. He said that after months of attempting to work with Ngo Dinh Diem he had reached the conclusion that the Premier did not have the executive ability to handle 'strong-willed men,' that he concerns himself with minor matter[s] and has not originated a single constructive idea since he came to power." Collins was equally determined that Lansdale be replaced, telling Secretary of State Dulles that Lansdale was mad to believe he could save South Vietnam with Diem in charge.

45. See Neil Sheehan, *A Bright Shining Lie* (New York: Random House, 1988), 140–1; also Philip E. Catton, *Diem's Final Failure: Prelude to America's War in Vietnam* (Lawrence, KS: University Press of Kansas, 2003) 10–11.

46. State to Saigon, May 1, 1955, FRUS, 1955–1957, vol. 1, 344–45.

47. *Tiger in The Barbed Wire*, 151; *Edward Lansdale's Cold War*, 64

48. John Osborne, "The Tough Miracle Man of Asia," *Life*, May 13, 1957, 156–76.

## CHAPTER 3: CALIFORNIA DREAMING

1. Thanks to Rosann Martin for providing these personal letters and photographs.

2. Referring to these visa problems, Brandes wrote to An, December 18, 1957: "Dear Mr. An. We are very pleased that you have been able to come to the states for schooling. Even as we left you at the airport at Saigon we were not sure you would make it."

3. Nguyen Thai, *Is South Vietnam Viable?* (Manila, Philippines: Carmelo and Bauermann, 1962), 209; William Colby, *Lost Victory: A Firsthand Account of America's Sixteen-Year Involvement in Vietnam* (New York: Contemporary Books, 1989), 39.

4. Robert Shaplen, *The Lost Revolution* (Revised edition, Harper & Row) 158.

5. A. J. Langguth, *Our Vietnam: The War, 1954–1975* (New York: Simon & Schuster, 2000), 105.

6. "It is good that you were not able to leave Saigon earlier, because in that case you would not have seen your father before he died," Mills Brandes wrote to An on December 18, 1957. "You have told us of your respect for your father. We have this respect with you. We hope that his death will not press undue hardship on you and your family."

7. Interview with Mai Chi Tho. An thought that the money was borrowed from a wealthy rubber plantation owner. An also cashed a modest pension from the Customs House and received support from his sponsors at the Asia Foundation.

8. In fact, when the student newspaper listed the names of all new international students enrolled at OCC for fall semester 1957, there was no mention of Pham Xuan An from Vietnam. "Orange Coast Gains Students from Many Other Countries," *Barnacle*, October 11, 1957.

9. See Jim Carnett, "OCC Journalism Major Was *Time* Magazine Reporter and Hanoi Spy," September 28, 2006, Orange Coast College, *Orange Slices*, alumni newsletter.

10. "For a Student from Vietnam It's Been a Year of Learning," *Barnacle*, June 6, 1958.

11. The story was confirmed in interviews with both An and Pete Conaty.

12. An's e-mail to Lee Meyer, December 23, 2000.

13. http://www.ocregister.com/ocregister/news/abox/article_1293310.php; Vik Jolly, "A Spy on Campus—and a Mystery Still." *Orange County Register*, September 30, 2006.

14. Ibid.

15. "Vietnamese Student Tells of Life in OCC Dormitory," *Barnacle*, November 22, 1957, 3.

16. "Foreign Group Presents Show," *Barnacle*, May 23, 1958, 3.

17. Personal letter from Richard and Rosann Martin, June 8, 1961.

18. "You have been in my heart and thoughts," An wrote Lee in December 2000. "I like to observe you every time you accomplished something you

expressed your happiness by raising your cheerful voice while clinching the fingers of your both hands."

19. See "Lee Meyer Assumes Duty As New *Barnacle* Editor," *Barnacle*, January 31, 1958, 1.

20. E-mail from Lee Meyer to An, May 25, 2001.

21. "Spring Semester '58 *Barnacle* Wins First Class Honor Rating, " *Barnacle*, November 4, 1958.

22. "Finals—A Couple of Views," *Barnacle*, January 17, 1958.

23. "Who Said Our English X Was for Dummies Only?" *Barnacle*, February 14, 1958.

24. "Students Seek Diet Aids," *Barnacle*, February 28, 1958.

25. The theme of healthy eating continued in An's next article about Mrs. Yvette Coltrin, who ran the cafeteria enterprise at OCC. "Preparing scientific and appetizing substitutes is not an easy job. Mrs. Coltrin has to think about food continuously." Drawing from his brief military experience, An compares her job within the university hierarchy with "the Division Commander [who] has trouble finding an Assistant G-4 or supply officer...she's a rare bird." "Cafeteria Head Acclaimed," *Barnacle*, March 7, 1958."

26. "Quiet American—Film Gives Unjust View of Asian Life," *Barnacle*, March 14, 1958.

27. Graham Greene, *The Quiet American* (New York: Viking, 1956).

28. "Quiet American Makes Noise on Opening Night in Viet Nam." The other change was inspired by revelations of Lansdale's ties to the CIA, unknown in 1958. This review was published in Hanoi by the BBC.

29. Johnson would later represent California's Thirty-fifth District in Orange County, becoming the first California legislator to serve as party leader in both the Assembly and the Senate.

30. "Dorm Tropical Paradise Lacks Vital Ingredient," *Barnacle*, March 28, 1958, 3.

31. "Eggheads! 13 Straight A Students; 190 Bucs on Honor List," *Barnacle*, February 27, 1959, 3.

32. "New Foreign Student Club Now Being Formed at OCC," *Barnacle*, October 24, 1958, 2

33. "World Affairs Seminar Has Problematical Topic," *Barnacle*, April 18, 1958.

34. "Beverly Stafford Honored by IRC," *Barnacle*, November 21, 1958.

35. "Paper staff will attend Conference," *Barnacle*, March 6, 1959.

36. "Coast Sends Delegation," *Barnacle*, January 16, 1959, 3.

37. Letter to the editor, *Barnacle*, April 17, 1959.

38. Interview with Bruce Nott.

39. August 11, 2005, Ho Chi Minh City.

40. See Herbert Coleman with Judy Lanini, *The Hollywood I Knew: A Memoir, 1916–1988* (Lanham, MD: Scarecrow Press, 2003).

41. Interviews with An and Judy Coleman.

42. Based on interviews with An, Bruce Nott, and Ross Johnson.

43. "For a Student from Vietnam It's Been a Year of Learning."

44. http://www.monterey.org/langcap/dli.html.

45. "Assign Rhodes Fall Editorship," *Barnacle*, September 26, 1958.

46. Editorial, "Take That Trash," *Barnacle*, May 8, 1959.

47. "A Foreign Student Bids Coast Farewell," *Barnacle*, June 5, 1959, 6

48. An seems to have misremembered or have been misinformed. The saying is attributed to Louis XV.

49. When the new snack bar opened in April 1959, a front-page photograph showed An eighth in line! *Barnacle*, April 10, 1959.

50. An kept the book in his home library.

51. Richard Rodda, "Brown, Kozlov Chat 2 1/2 Hours, Trade Smiles and Wisecracks," *Sacramento Bee*, July 4, 1959, 1. Additional documentation on 'Kozlov's visit, including memoranda of his conversations with state and local officials outside the Washington, D.C., area, are in Department of State, Conference Files: Lot 64 D 560, CF 1408–1409, and Central File 033.6111.

52. Pham Xuan An, "Vietnamese Takes a First Look at County Fair Art—Likes It," *Sacramento Bee*, June 20, 1959, A2.

53. "Vietnamese Journalist Aims to Fight Red Propaganda," *Sacramento Bee*, July 5, 1959, B4.

54. Rev. Emmanuel Jacques, a Belgian priest who had lived in Vietnam was the camp organizer.

55. I am grateful to Judson Brandes for recalling these details.

56. An said he was tipped off by an Indian correspondent whose source was French intelligence, which had connections with the North Vietnamese. The correspondent had been asked by the Asia Foundation to take care of An while he was in New York. Each day An would visit the Press Trust of India office in New York as part of his internship.

57. "Terrorist Kills 2 US Advisors in Viet Nam," *Sacramento Bee*, July 9, 1959, 1.

58. Dale Brix, "Viet Nam Puts Closer Guard on Americans," *Sacramento Bee*, July 14, 1959, A2; *Advice and Support*, 329.

CHAPTER 4:
THE EMERGENCE OF A DUAL LIFE

1. After Action Report, Box 86, Ap Bac folder, Sheehan Papers.

2. *Lost Victory*, 39.

3. Interview with Nguyen Thai.

4. Ibid.

5. Peter Smark, "Death and Vomit: The Real Meaning of War," *Sydney Morning Herald*, July 12, 1990.

6. Nick Turner, "Media and War: Reflections on Vietnam—Nick Turner Recalls His Experience as a War Correspondent During the Vietnam War," *New Zealand International Review* 28, no. 4 (July/August 2003).

7. Ronald Seth, *Anatomy of Spying* (New York: Dutton, 1963). Halberstam does not recall giving the book to An.

8. *His Name Is His Life*. Translation provided by Merle Pribbenow and Ti Ti Mary Tran.

9. *Anatomy of Spying*, 57.

10. Beginning February 21, 2004, the *Thanh Nien* newspaper Web site printed a series of articles on Ba Quoc with the title "The Mysterious Intelligence General and Incredible Spy Missions," March 11, 2004, issue, accessed on March 11, 2004, at http://www.thanhnien.com.vn/TinTuc/Xa-Hoi/2004/3/10/10518; Translation by Merle Pribbenow.

11. Quoted in "The Legends He Left Behind."

12. I am grateful to Merle Pribbenow for this insight.

13. Muoi Nho was An's direct supervisor 1961–1965, followed by Tu Cang 1966–1972 and Ba Minh 1972–1975. Interestingly, after the 1968 Tet Offensive, it was too risky for leaders to enter Saigon. "Therefore, we only made contact through letters and didn't meet in person until after liberation day," said Ba Minh. *A General of the Secret Service*, 118.

14. *Strategic Intelligence*; https://www.cia.gov/csi/books/shermankent/toc.html

15. See *Anatomy of Spying*, chapter 2.

16. Roger Trinquier, *Modern Warfare: A French View of Counterinsurgency* (New York: Praeger, 1961), 4. The book was first published in France in 1961, which was the edition used by An. He later studied *Counterinsurgency Warfare: Theory and Practice* by David Galula (New York: Praeger, 1964).

17. T. R. Phillips, ed. *Roots of Strategy: A Collection of Military Classics* (Harrisburg, PA: Military Service Publishing Co., 1940), 36–7.

18. William Prochnau, *Once Upon a Distant War* (New York: Times Books, 1995), 154.

19. CIA Current Weekly Intel Summary, March 17, 1960, *Advice and Support*, p. 349.

20. "Country Team Study Group Report on Internal Security Situation in Vietnam," *Advice and Support*, 330–31.

21. Estimates Products on Vietnam, 1948–1978 (Washington, D.C.: Government Printing Office, 2005), August 23, 1960, Special National Intelligence Estimate (SNIE) 63.1–60.

22. See James Lawton Collins, Jr., *The Development and Training of the South Vietnamese Army* (Washington, D.C.: The Department of State, 1975), 5; also *Advice and Support*, 365.

23. Ibid, *Advice and Support*, 365.

24. "First Twelve Month Report of Chief, MAAG, Vietnam." September 1961. The plan was a blueprint for the reorganization of the Armed Forces of the Republic of Vietnam, containing McGarr's recommendations for integrating ARVN and Civil Guard/Security Defense Forces in a common chain of command.

25. Draft Notes of Meeting, April 24, 1961. FRUS, 1961–1963. Vol. 1, Vietnam, 78; Chapter 6, "The Advisory Build-Up, 1961–1967," in *The Pentagon Papers*, Gravel Edition, vol 2 (Boston: Beacon Press, 1971), 408–514; Section 1, 408–457.

26. http://www.statecraft.org/chapter8.html.

27. Paul M. A. Linebarger, *Psychological Warfare*. (Washington, D.C.: Infantry Journal Press, 1948).

28. *A General of the Secret Service*, 83–4.

29. Quoted in *The Legends He Left Behind*.

30. Lansdale to Shaplen, June 8, 1982, Box 1, Folder 14, Lansdale Papers. See Stanley Karnow, "In Vietnam, the Enemy Was Right Beside Us," *Washington Star*, March 22, 1981.

31. Stanley Karnow, *Vietnam: A History* (New York: Viking, 1983), 214; see also Saigon, Viet Nam, Memorandum for Record, September 9, 1963, Box 22, Folder 1, UPI, Sheehan Papers.

32. R. B. Smith, *An International History of the Vietnam War*, vol. 2 (New York: St. Martin's, 1985), 58.

33. FRUS, 1961–1963, Vol. 1, Vietnam, 179.

34. See Andrew Preston, *The War Council: McGeorge Bundy, the NSC, and Vietnam* (Cambridge, MA: Harvard University Press, 2006), 91.

35. Maxwell Taylor, *Swords and Plowshares* (New York: Perseus Books, 1990), 228–229.

36. "Taylor to Kennedy," November 3, 1961, *FRUS 1961–1963*, Vietnam, vol. 1:478; see 477–532 for the entire report.

37. These new requirements would alter the commitment from a purely advisory role. In February 1962 a new Military Assistance Command, Vietnam (MACV), replaced MAAG. This new command structure recognized the growing military role of the United States in advising ARVN.

38. "The Staley-Taylor plan was the plan of a 'special war' conducted by the Saigon army under the command of U.S. advisors." *The Failure of 'Special War,' 1961–65.* No. 1, Vietnam Studies (Hanoi, Xunhasaba, 1965).

39. http://www.medaloffreedom.com/JohnPaulVann.htm.

40. *Once Upon a Distant War*, 214–219.

41. *A Bright Shining Lie*, 205–6; Sheehan explained that "the battle was to become known as the battle of Ap Bac rather than the Battle of Bac because the news dispatches of the fighting included the word *ap*, which means 'hamlet,' as part of the place name."

42. I draw extensively from Toczek's *The Battle of Ap Bac, Vietnam* and Sheehan's *A Bright Shining Lie*.

43. *Once Upon a Distant War*, 224.

44. *A Bright Shining Lie*, 277.

45. Ap Bac folder, Box 86, Sheehan Papers.

46. *The U.S. Army in Vietnam.* Extracted from Revised Edition of American Military History Army Historical Series, United States Army Center of Military History, 634; The U.S. Army's assessment of Ap Bac noted that "Ap Bac's significance transcended a single battle. The defeat was a portent of things to come. Now able to challenge ARVN units of equal strength in quasi-conventional battles, the Viet Cong were moving into a more intense stage of revolutionary war."

47. VC Document on Ap Bac Battle, January 2, 1963, Ap Bac folder, Box 86, Sheehan Papers.

48. A Bright Shining Lie, p. 277–8.

49. E-mail, October 10, 2006

50. See David Halberstam, *The Making of a Quagmire* (New York: Ballantine Books, 1968).

51. Quoted in *Once Upon a Distant War*, 13.

52. *The Powers That Be*, 450. See Daniel C. Hallin, *The "Uncensored War": The Media and Vietnam* (Berkeley: University of California Press, 1989), 41.

53. Sheehan once asked Madame Nhu if she thought the American press has been infiltrated by Communists. "That's for sure," said Nhu. The Communists "always choose the most famous or the most serious institutions such as Harvard University or the *New York Times*." She said, "*Time* magazine usually flattered her." *Once Upon a Distant War*, 121, 122.

54. Quoted in Thomas B. Morgan, "Reporters of the Lost War," *Esquire*, July 1984, 52.

55. An said, "I knew him as Nguyen Van Ta, an officer of the Central Intelligence Organization." *Thanh Nien* newspaper Web site, March 21, 2004, issue, accessed on March 21, 2004, at http://www.thanhnien.com.vn/TinTuc/Xa-Hoi/2004/3/21/11594/. Translation by Merle Pribbenow.

56. Robert Shaplen, *The Road from War* (New York: Harper & Row, 1970). See Shaplen's March 20, 1965 essay, pp. 1–9.

57. "In Vietnam, the Enemy Was Right Beside Us" *Washington Star*, March 22, 1981.

58. Truong Nhu Tang, A Vietcong Memoir (New York: Vintage), 60.

59. Box 8, Vietnam, McCulloch Papers. These are McCulloch's interview notes.

60. Shaplen's 1975 notes record the following answer by Tuyen to the question of what had prison been like: "Tuyen: arrested, put in solitary, naked, 5 weeks, 2 dishes of rice a day, half cooked, no other food, small bottle tap water, vomited blood, very sick. Spent 73 days in jail, let out Nov. 2." Box 93, Shaplen Papers.

61. See Larry Berman, *Planning a Tragedy* (New York: W. W. Norton, 1982).

62. "AN: The NLF "proposed same thing to Nguyen Khanh in 1964 (participation in government) and Khanh was willing to do it, wrote to Nguyen Huu Tho. CIA intercepted it—second letter—and got rid of Khanh. At that point Khanh was willing to talk." Shaplen Papers, interview notes. Box 93

63. *Planning A Tragedy*, 109

64. An said this to photographer Ted Thai. Author's interview with Thai.

CHAPTER 5: FROM *TIME* TO TET

1. In 2006 Tu Cang was elevated to the status of Hero for his exploits. My interview with him occurred shortly after he had received the award.

2. Tran Van Tra, *Concluding the 30-Years of War*, in 1247; *Vietnam: History Of The Bulwark B2 Theatre, Vol 5.* (Combat Studies Institute, Southeast Asia Report No. 1247, February 2, 1983), 5–335, http://cgsc.leavenworth.army.mil/carl/resources/csi/tra/csirp_vhbbt.html.

3. Ibid., 43.

4. "The Legends He Left Behind," p. 2. http://www.tuoitre.com.vn/Tianyon/Index.aspx?ArticleID=164857&ChannelID=89.

5. Details provided in interviews with Tu Cang and An.

6. "Mystery Is the Precinct Where I Found Peace," 269.

7. David Lamb, *Vietnam Now: A Reporter Returns* (New York: Public Affairs, 2002), 81; also personal interview.

8. *Dragon Ascending*, 35–42.

9. "Conversation with David Halberstam, My House," January 28, 1975, Box 67 Folder 4, Sheehan Papers.

10. See "Testimony of Arnaud de Borchgrave," "Terrorism: Origins, Direction and Support." Hearings before the Subcommittee on Security and Terrorism of the Committee on the Judiciary, U.S. Senate, April 24, 1981. Serial No. J-97-17.

11. Ibid., 85.

12. Roy Rowan, "Saigon 25 Years After the Fall," *Fortune*, May 1, 2000.

13. Interview with An.

14. Gerald C. Hickey, *Window on a War: An Anthropologist in the Vietnam Conflict* (Lubbock, TX:, Texas Tech University Press, 2002), 292.

15. Neil Sheehan conversation with Conein, September 22, 1976, Box 62, Folder 9, Sheehan Papers.

16. Sheehan made a note to himself to check if An influenced *Time* and Shaplen at the end in April 1975. "Anh [*sic*] would have known all of the American moves as well through Shaplen," wrote Sheehan.

17. *A Bright Shining Lie*, 187.

18. "Media and War: Reflections on Vietnam."

19. Correspondence with Nick Turner.

20. Interview with An.

21. Correspondence with Nick Turner.

22. Bev Keever, *Adventures of a Young Journalist*, remarks to University of Nebraska students and alumni. Author's transcript copy.

23. "Self Reliance in Saigon," *Time*, Jan. 8, 1965; Michael O'Sullivan, "History in the Newsmaking," *Washington Post*; June 8, 2001.

24. "The Press: Self-Reliance in Saigon," *Time*, Jan. 8, 1965. "Femininity at the Front," *Time*, Oct. 28, 1966.

25. Ron Steinman, former head of the NBC News bureau in Saigon, recalled Vuong as "the most interesting reporter and the most complex person I worked with in Vietnam." Whenever Shaplen was in Hong Kong, Vuong worked for Steinman. "Vuong would fill me in on the Vietnamese and U.S. political activity of the past week. Then he would tell me what he viewed in his crystal ball for the weeks and months ahead. Real time had no place in his life. His stories were labyrinthine and lovely, almost dreamlike, filled with convoluted patters, deceit, and evil . . . He told me about people, places and events—even whole periods of history—not recorded in books, much of which I had difficulty understanding . . . His stories were sometimes confusing, but strangely, after months of listening to him, their meaning became clear." Steinman, *Inside Television's First War: A Saigon Journal* (Columbia, MO: University of Missouri Press, 2002), 79–80.

26. I sent several e-mails with questions, but Deepe chose not to answer.

27. "Unsung Hero," http://www.ajr.org/Article.asp?id=3699; see also http://www.muckraker.org/content/news_events/McCullochBio.pdf#search='Frank%20McCulloch'; Wallace Terry, "*Time*'s Frank McCulloch: In the Eye of the Hurricane," http://www.vva.org/TheVeteran/2002_11/mcculloch.htm.

28. "To: All Corrspondents From: Don Bermingham May 25, 1966, Confidential to Time–Life News staff . . . ." 96-39 Box 1, *Time Life* 11/27/67 from Moser to Lang . . . . 96-39 Box 10, McCulloch Papers.

29. Interview with Frank McCulloch.

30. *War News*, 310–12.

31. Interview with John Larsen.

32. Joseph and Stewart Alsop, *The Reporter's Trade* (New York: Reynal, 1958).

33. Ibid., 6–7; in the course of discussing *The Reporter's Trade*, An advised me to read another book by the Alsop brothers, titled *We Accuse! The Story of the Miscarriage of American Justice in the Case of J. Robert Oppenheimer*

(New York: Simon & Schuster, 1954). He said this book showed what good reporters the Alsops were because they understood that Oppenheimer's involvement with the Communist Party never included becoming a member. He told me that Oppenheimer knew Lansdale.

34. Robert Shaplen, "We Have Always Survived," *New Yorker*, April 15, 1972.

35. *Vietnam Now*, 87.

36. "A Writer Denies CIA Influenced His War Reports." *New York Times*, December 1, 1977, B-15. See Box 15, Folder 11, Shaplen Papers.

37. Jean-Claude Pomonti, *Un Vietnamien bien tranquille*. (Paris: Équateur, 2006).

38. Taped message from Pham Xuan An to Frank McCulloch, November 8, 2005.

39. Interviews with Stanley Cloud and Frank McCulloch.

40. "Un Vietnamien bien tranquille," chapter 6.

41. *His Name Is His Life*, author's translated copy.

42. The Legends He Left Behind.

43. Interview with Tu Cang and An.

44. Interview with Rufus Phillips; confirmed with An. "When I saw An in 2002, Mark was one of the people he asked to be remembered to."

45. Interview with An.

46. *Dangerous Company*, 118.

47. Don Oberdorfer, *Tet! The Turning Point in the Vietnam War* (Baltimore: The Johns Hopkins University Press, 1971, 2001), 140.

48. *The Legends He Left Behind*.

49. *Two Gunshots to Open an Escape Route*; Quan Doi Nhan Dan, October 22, 2004. Translation by Mark Pribbenow. Interview with Tu Cang.

50. A *General of the Secret Service*, 132. In the final Ho Chi Minh campaign of 1975, Tu Cang was political commissar of Commando Special Task Force Brigade 316, *A General of the Secret Service*, 94.

51. *Bulwark B2*, Vol. 5, 48.

52. *Tet!*, 140.

53. See James J. Wirtz, *The Tet Offensive: Intelligence Failure in War* (Ithaca: Cornell University Press, 1991), 1.

54. Shaplen and An went to Cho Lon, where the heaviest sources of infiltration occurred. "An—Two kinds of police informants. VC agent acting as double agent. Civilians with access to VC and we check what they say

vs. their reliability, etc.... How many legal cadre? None because we're do-ing special penetration ops vs. VC agents, including attempts to penetrate political groups and unions in district. They are in Quan B, sub-station B. Parallel to Special Police is people G-2 networks, run by chief of Special Police in sub-stations... when recruited, each informant is carefully checked out and this report goes to Special police at precinct level, which runs its own G-2 check. If information is good, he will be transferred to special G-2 network and comes under Special police section. Under the one cell system, each agent has a limited knowledge of whole organization and is kept to this limit. Complete files of each informant, finger prints, past history of family and friends, previous conviction and his info in writing will be cross-checked with other sources. Close watch on his VC contacts. They will use double agents themselves. If his loyalty is too pro-VC, then he's arrested (or will lead to others, who will be arrested.)" Robert Shaplen, Letter from Vietnam, *New Yorker*, March 2, 1968, reprinted in *The Road from War*, pp. 188–205.

55. Ibid., 198–9; See Michael A. Rovedo, "The Tet Offensive of 1968," http://www.geocities.com/militarypoliceofvietnam/Tet.html.

56. *Tet!*, 142: "A twelve-man unit of the C-10 battalion arrived at the main gate of the Vietnamese Navy headquarters at 3 am in two civilian cars. Ac-cording to a surviving member of the team, the sappers were told to take the headquarters and await the arrival of two battalions of Viet Cong troops moving in from positions across the Saigon River. The attackers blew a hole in the wall of a sentry post, but were quickly stopped inside. All but two of them were killed in the first five minutes. The enemy battalions just across the river apparently were a myth. There was no trace of them."

57. *A General of the Secret Service*, 96.

58. Interview with Tu Cang; This story also appears in *A General of the Se-cret Service*, 96–7.

59. *Dangerous Company*, 138–9.

60. "Reds Showed No Mercy in Slaying 4 Newsmen." *Time*, May 10, 1968. One reporter, Frank Palmos, twenty-eight, a freelance Australian journalist, escaped to tell the story.

61. Ibid.

62. Interview with An corroborated by Rufus Phillips.

63. William C. Westmoreland, *A Soldier Reports* (New York: Doubleday, 1976), 103.

64. An told Bob Shaplen in March 1965: "An—out of 260 strategic hamlets in

Long An, only 30 or so left that are of any good. Stillwell thinks it will take six months to clean up Long An alone and that's optimistic." Notes 1965-February-March trip, Box 91, Shaplen Papers.

65. Zalin Grant, letter to the editor, *New Yorker*. July 4, 2005, 6. Conservative bloggers charged that An "took American money and helped kill Americans." He was "a traitor and a spy whose devious efforts helped to cause the death and the maiming of thousands."

66. "As to Mr. Grant, he shares one distinction with An: I hired him, too, for the Saigon bureau. Given Mr. Grant's own experience as an Army intelligence officer in Vietnam, I'm puzzled when he writes that 'An transformed Time correspondents into inadvertent worldwide network of spies for Hanoi.'" McCulloch letter, unpublished.

67. This case is also discussed in *"The Stature of Revolutionary Intelligence Agent Pham Xuan An."* "Every day, the tapes they recorded were sent back to the CIO headquarters, but they were unable to hear anything besides An's loud curses." http://www.vnn.vn/psks/2005/04/412007.

68. *Lost Over Laos*, 69.

69. Others Tuyen included were Nguyen Be Vuong, Le Van Tu, and Nguyen Van.

70. In reaction to Nixon's 1970 Cambodian incursion, Congress had legislated against any cross-border action involving U.S. ground troops, which meant that any invasion into Laos would be an ARVN operation supported only by U.S. air and artillery located in South Vietnam. With the success of the Cambodian operation and the closing of the port of Sihanoukville, the Ho Chi Minh Trail in Laos became the next target of ARVN and U.S. battle plans to disrupt the flow of supplies and men into Vietnam. The Ho Chi Minh Trail was a network of 1,500 miles covering the Laotian Southern panhandle North to South, and running parallel to 640 miles of common border. North Vietnam's infiltration and supply route into South Vietnam's central highlands went through Laos and Cambodia on the Trail.

71. *Lost Over Laos*, 99.

72. "Notes," Box 91, Folder 20, Shaplen Papers.

73. Cao Van Vien and Dong Van Khuyen, *Reflections on the Vietnam War* (Washington, DC: U.S. Army Center of Military History, 1980), pp. 100–1.

74. Box 93, Shaplen Papers.

75. "In 1964 they had the same decision. When Diem overthrown they thought that US would make a compromise to end the war but we didn't

do that. At end of 1964 Central Committee met and debated and decided to launch 1965 offensive, not expect US to react as we did rather than compromise. They saw their chance to negotiate then or US brings in combat troops, which we did. Then they saw prolonged war, limited war, or larger war.... so when we brought in combat troops in May 1965, they knew it would be a long expanded war..." Box 93, Shaplen Papers.

76. "In Lam Son 719 they learned that South Vietnam committed 30,000 there, 400 hellies, etc. tactical air and B-52. So they learned how to fight against all that. They found out we were ready to use max air (so they weren't surprised this time, except maybe by effectiveness of Smarts and TOWs.) But they assume, say their documents, that we might even use tactical nukes and invade NV with two divisions. Divide US AF into supporting numerous fronts was aim. Then they take several GVN fighting battalions, dividing them and they figured they'd fight several Lam Sons, while spreading our air over as many areas as possible. Other aim was where to attack pacification and achieve the political aims—10 pts.... US may sooner or later make enough concessions to end war so they have to get their cadre in place in countryside... Communist Party fills countryside vacuum and that's this summer's program and next years. PT" (meaning "point!"). Box 93, Shaplen Papers.

77. "An says they are using more modern weapons, artillery, etc. but have still not committed all their strength despite what Abe says." PT "We again misconstrued their strategy and they more properly assessed ours. (So they weren't surprised)." PT "Viets keep their objectives open-ended. We ascribe motives to them, even specific ones, like Hue etc., and that's a mistake. They remain open–ended. Communist Party weren't stupid at Hue, in not pushing on. They were too smart to do it, they had to select terrain and get ready. This then is not so totally conventional as we say it is.... People can't uprise now with bare hands. CP must have military in place, enough to protect the uprising when it comes, they learned that at Tet. PT" "Meanwhile—legal approach, end of war, US withdrawal, right to live movement, but don't take to the streets. In cities the 4th, 5th, 6th and 7th districts, the poor ones, cache stuff now to prepare for main force attack later." PT "Again, he says, they did indeed expect everything including the nukes and the NV invasion. Still preparing long term battlefield. This year—one year of fighting maybe equals ten years worth." "They do know that VC was weaker and they had to calculate this in the balance of force aim they sought to achieve." PT "That was one reason for attack now."

78. David DeVoss, "The Quiet Vietnamese: Journalist and Spy Pham Xuan An Led a Life of Ambiguity," *Weekly Standard*, October 9, 2006.

CHAPTER 6:
THE BLURRING OF ROLES: APRIL 1975

1. Box 91 Folder 6, Shaplen Papers.

2. The chapter draws extensively from Dung's *Our Great Spring Victory* (New York: Monthly Review Press, 1977).

3. Arnold R. Isaacs, *Without Honor: Defeat in Vietnam and Cambodia* (Baltimore: The Johns Hopkins University Press, 1983), 340.

4. Ibid., 340–342.

5. *Our Great Spring Victory*, 36. The meetings were December 9 and 10, 1974.

6. *A General of the Secret Service*, p. 119.

7. *Our Great Spring Victory*, 19; James H. Willbanks, *Abandoning Vietnam: How America Left and South Vietnam Lost Its War* (Lawrence, KS: University Press of Kansas, 2004), 221.

8. *The Vietnam Experience—The Fall of South Vietnam*, by Clark Dugan, David Fulghum, and the editors of Boston Publishing Company (Boston: Boston Publishing Company, 1985), p. 8.

9. Bui Tin, *Following Ho Chi Minh: Memoirs of a North Vietnamese Colonel* (Honolulu: University of Hawai'i Press, 1995), p. 71.

10. Box 93, Folder 3, Shaplen Papers: An told Shaplen the aim "was to kill whole Politburo. Actually, 75% of Lao Dong house was hit and destroyed but it fell short of total aim."

11. Conversation with Negroponte, Negroponte folder, Sheehan Papers.

12. Le Duc Tho's assessment was that "we must limit the fighting in 1975 in order to save our strength for 1976, when we will launch large-scale attacks." Tran Van Tra, Bulwark B2 Theater, 93, 96–98. *Abandoning Vietnam*, 208, 218, 221.

13. Fall 1973 notes, Box 93 Folder 5, Shaplen Papers.

14. An was much closer to the accurate number of North Vietnamese troops in the South when he told Shaplen, "AN: he figures 170,000 NVA....60,000 military force....from 60,000 to 110,000 including village guerrillas."

15. "VN Notes" Nov-Dec 1972 Trip, Box 91 Folder 11, Shaplen Papers.

16. *Time* went with a story on October 16 (a week before *Newsweek*'s story) titled "Light at Last," which contained virtually all the details of the draft treaty but refrained from making any grandiose statements.

17. Quoted in *The Fall of South Vietnam*, 17; *Abandoning Vietnam*, 222.

18. *Abandoning Vietnam*, 225.

19. Harry G. Summers Jr., "The Fall of Phuoc Long," in *Historical Atlas of the Vietnam War* (Houghton Mifflin, 5)1999, 192.

20. Ibid.

21. Denis Warner, *Not Always on Horseback* (Sydney, Australia: Allen & Unwin, 1997), 2–3; Warner considered An the "ace of spies."

22. The new strategic plan was implemented on December 13, 1974, when the North Vietnamese launched their attack.

23. "An Market file," Box 91 Folder 6, Shaplen Papers; author interview with An.

24. A mild version of this appears in Robert Shaplen's *Bitter Victory* (New York: Harper & Row, 1986).

25. Bulwark B2, Vol. 5.

26. *Our Great Spring Victory*, 25.

27. Ibid., 40. Dung arrived with a new license plate number on his car, repainted and with the letters TS and the number 50, "which meant that our car had top priority in the Truong Son zone." *Without Honor*, 340–1.

28. *Without Honor*, p. 341.

29. "Giap and Dung: A Change in Command," *The Fall of South Vietnam*, 15.

30. Ibid.

31. Ibid., 341.

32. *Reflections on the Vietnam War*, 128.

33. Memorandum for the President from Weyand, April 4, 1975, NSC Convenience files, Ford Library.

34. George J. Veith and Merle L. Pribbenow II. "Fighting Is an Art": The Army of the Republic of Vietnam's Defense of Xuan Loc, 9–21 April 1975", *Journal of Military History* 68, no.1 (January 2004): 163–213.

35. "The Fall of Phuoc Long," 200.

36. Folder 3 Box 93, Shaplen Papers.

37. Ibid.

38. Circa April 1975, Folder 3 Box 93, Shaplen Papers.

39. "She died in my arms in my home in 1995," An told me.

40. Box 7, Lansdale Papers.

41. *A General of the Secret Service*, 200.

42. Ibid.

43. *Dangerous Company*, 252

44. "How much I miss you for over thirty years," An said in a taped "farewell" that I gave to Jolynne.

45. Jolynne recalled driving for the weekend from Saigon to Dalat. Roscoe's paw was injured when a piece of metal went through the car bottom. An American doctor in Dalat was able to fix him up; upon the D'Ornanos' return to Saigon, An told them that "Pierre's ancestors did something good in past."

46. An used this "grill my dogs" reference with many people.

47. "April 1975 file," Shaplen Papers.

48. "Mystery Is the Precinct Where I Found Peace," 269.

49. "A Glimpse of the Boxes Within Boxes of Vietnam."

50. Saigon 25 Years After the Fall," *Fortune*, May 1, 2000.

51. Dick Swanson with Gordon Chaplin, "Last Exit from Saigon: A Tale of Rescue," plus personal interviews with Dick Swanson and Germaine Loc Swanson. *Washington Post*, June 8, 1975; accessible online at The Digital Journalist http://digitaljournalist.org/issue9904/exit1.htm.

52. David Butler, *The Fall of Saigon*. New York: Simon & Schuster, 1985. pp. 392-3,

53. Dirck Halstead, *White Christmas: A Photographer's Diary: April 20–30, 1975*; http://digitaljournalist.org/issue0005/ch1.htm

54. *Our Vietnam*, 660.

55. "Tuyen interview notes," Butler Papers.

56. *Our Vietnam*, 181, 660–1.

57. "April 1975 file," Box 91, Folder 6, Shaplen Papers.

58. The Butler interview has this as "father," but clearly it is "mother" since Tuyen knew An's father was dead. *The Fall of Saigon*, 423; author interview with An.

59. *The Fall of Saigon*, 423. Years earlier Tuyen helped to free Cao Giao when he was being tortured by security as a suspected VC sympathizer.

60. Interview with Dan Southerland.

61. Fox Butterfield with Kari Haskell, "Getting It Wrong in a Photo," *New York Times*, April 23, 2000.

62. *The Fall of Saigon*, 425.

63. This is Frank Wisner's account as told to Neil Sheehan, June 7, 1975, Box

82, Frank Wisner folder, Sheehan Papers.

64. Ron Moreau and Andrew Mandel, "The Last Days of Saigon" *Newsweek*; 5/1/2000

65. Tuyen interview, Butler Papers.

66. Ibid.

67. *Dragon Ascending*, 41.

68. November–December 1970 file, Box 93, Folder 6, Shaplen Papers.

69. Dan Southerland, Vietnam Diary 5: "The Perfect Spy," Radio Free Asia, July 29, 2005, http://www.rfa.org/english/features/blogs/vietnam-blog/2005/07/29/blog5_vietnam_southerland/.

70. Letter, Box 2, Folder 3, Shaplen Papers.

71. April 1975, Box 93, Folder 3, Shaplen Papers.

## CHAPTER 7: IN HIS FATHER'S SHADOW

1. January 18, 1975, "Letters," Box 7, Lansdale Papers.

2. Tim Bowden, *One Crowded Hour: Neil Davis, Combat Cameraman 1934–1985* (Sydney, Australia: Collins, 1987), 347; Tiziano Terzani, *Giai Phong! The Fall and Liberation of Saigon* (New York: St. Martin's, 1976).

3. Neil Davis with Robert Shaplen edits for the *New Yorker*, Shaplen Papers. See notes and draft, Letter from Saigon, Neil Davis in Box 95, Notes: Folder 30, Shaplen Papers.

4. "The Quiet Vietnamese: Journalist and Spy Pham Xuan An Led a Life of Ambiguity."

5. Nguyen Xuan Phong, *Hope and Vanquished Reality* (Philadelphia: Xlibris, 2001), pp. 152–7.

6. Ibid. Author interview with Nguyen Xuan Phong.

7. After the war, Tran Van Tra's high praise for his own B-2 southern forces, as well as his honest and critical assessment of his Communist superiors, brought government sanctions against him, and he briefly lived under certain restrictions.  http://lists.village.virginia.edu/sixties/HTML_docs/Texts/Narrative/Ott_Tran_Van_Tra.html.

8. *Hope and Vanquished Reality*, 259.

9. *Dragon Ascending*, 194. Cao Giao used to joke that he knew almost every prison from the inside "and sacrificed a lifetime in the struggle for this unfortunate Vietnam." 196.

10. Oliver Todd, *Cruel April* (New York: W. W. Norton, 1987), 253. Vuong, Cao Giao, and An were referred to by Saigon reporters as "the Three Musketeers," wrote Todd. p. 25.

11. *Bitter Victory*, 11.

12. Interviews with Germaine Loc Swanson, Bui Diem, and Dick Swanson.

13. Box 62, Folder 9, Sheehan Papers.

14. This is An's term; also told to Sheehan, "After the War Was Over" folder, Sheehan Papers.

15. In 2006 An had dinner with Ky in Ho Chi Minh City.

16. Interview with An and "Notes," Box 55 Folder 12, Sheehan Papers.

17. "The Perfect Spy."

18. Stanley Karnow, "Vietnamese Journalist's Divided Allegiance: After Nine Long Years, a Double Agent Explains the Mystery of His Actions." *San Francisco Chronicle*, May 30, 1990.

19. See Box 155, Folder 12, Sheehan Papers.

20. Ibid; I showed these notes to An and he confirmed the views.

21. Stanley Cloud, "The Journalist Who Spied." Sep. 21, 2006; *Time*.

22. Both letters are located in "1980s," McCulloch Papers, Box 3.

23. Ibid; Box 3, "Items Not Foldered—Mainly 1982." Feb. 10, 1982.

24. "The Quiet Vietnamese: Journalist and Spy Pham Xuan An Led a Life of Ambiguity.

25. Donald Kirk, *Tell It to the Dead: Stories of a War*. (Armonk, NY: M. E. Sharpe, 1975), 28–9.

26. Admission essay to the University of North Carolina, courtesy of Robert Sam Anson and An Pham.

27. Obituary, Pham Xuan An, 79, "Vietnamese Journalist and Spy" *Associated Press*, September 21, 2006.

28. Morley Safer, *Flashbacks: On Returning to Vietnam* (New York: Random House, 1990).

29. *Flashbacks*, 175 and 184.

30. Correspondence exists as early as May 1990 from Betty Medsger, chair of the journalism department at San Francisco State University to Frank about Pham Xuan Hoang An's essay. "It is clear that he has a keen mind and a desire to communicate. That sounds like a journalist on the way." 96-39 Box 11, McCulloch Papers.

31. Douglas Pike was then a foreign service officer posted to Saigon with the U.S. Information Agency. Pike was going to be "absolutely astonished

if either of two things happen: Hanoi grants a visa or the U.S. approves it." Pike had been unable to get his own students out of Vietnam ("running into a stone wall") and reported that "surveillance of Pham Xuan An has tightened appreciably in recent weeks and [this] portends nothing good for Hoang An's prospects." 96-39 Box 4; September 10, 96-39 Box 11, McCulloch Papers.

32. During World War II Kay Kyser did more USO shows than any entertainer, including his good friend Bob Hope, who later came to UNC to help Kay raise money that built the university's hospital. Kyser gave generously to the university that gave him his musical start. He wrote a song for UNC, "Tar Heels on Hand" in 1937. Through the Kyser Foundation, established in 1941, he gave UNC scholarships for students in music and dramatic art.

33. http://www.parabrisas.com/d_carrollg.php.

34. May 7, 1990; signed Dick to Robert Sam. May 3, 1990.

35. The entire An Pham file is located in Box 11, McCulloch Papers; Dy would later write the touching tribute in English in An's memorial book that opens the next chapter.

36. August 31, 1990, 96-39 Box 11, McCulloch Papers.

37. Anson to McCulloch, Box 11, McCulloch Papers, undated.

38. "Then there is Morley. Sheehan approached him on this subject several months back, and got a turn-down, coupled with a promise that he would reconsider the matter after his book was out. God knows, he's swimming in dough, and with his book a best seller principally because of the An chapter, he ought to come across. However, I. for one, will be quite startled if he does." Ibid.

39. See Alison Krupnick, "The Benefit of the Doubt" (Vietnamese People), *Harvard Review*, June 1, 2005.

40. Interview with An and author's correspondence with Krupnick; Krupnick recalls An Pham as "articulate and intelligent and it was clear he would go far."

41. "Had a long telephone chat with Judith Ladinsky, who outlined all the procedures for getting Hoang An out of Vietnam and into the States. Actually, it's not all that tricky, once Carolina sends along confirmation that Hoang An has a financial guarantor and the dough. Anyhow, Judith will handle all the paperwork between State, the University and Hanoi." 96–39, box 11

42. Interview with Judith Ladinsky. In his statement of purpose accompanying the application to study in the United States, An Pham wrote, "In the present context of the global economy, no country can survive and develop,

isolated from the rest of the world, neither can Viet Nam. I think, therefore, to establish good links with any countries, including the U.S.A., is one of Viet Nam's important targets. Viewing from this point, normalization of VN-US relationship is only a matter of time. And the sun is rising on the horizon. What we need now is more communication and closer contacts. To me, a newsman can do this best. That's why I wish to study journalism in the U.S.A.... It's the best way to immerse myself into the essence of American life, to gain some useful knowledge for my country's economy, to make a considerable contribution to VN-US development and, on the whole, to see more clearly the east-west perspectives."

43. Box 11, McCulloch Papers.

44. November 1, 1990; the entire contribution list is in Box 11 of the McCulloch Papers.

45. Another of An Pham's articles is "Restoring a Gem: Ex-Actress seeks to Return Theatre to its Former Glory," focusing on the restoration of Forest Theatre. Vol. 6, No. 65, Durham A. 10, August 9, 1993.

EPILOGUE: AN EXTRAORDINARY DOUBLE LIFE

1. Interview with An; also in letter to Jolynne D'Ornano.

2. Nguyen Khai, *Past Continuous* (Willimantic, CT: Curbstone Press, 2001). Khai began publishing in 1951, had written over thirty novels and short stories. He is former deputy general secretary of the Vietnam Writers' Association and received the ASEAN prize for literature in 2000.

3. Here is the excerpt in question: "Early in 1961, I was speaking with Colonel Edward Geary Lansdale, the 'hero' of the Philippines who had helped bring Magsaysay to power. In the course of our conversation, Lansdale mentioned that the Americans had just established a dairy farm in Ben Cat to help boost the economy of the Republic of South Vietnam. Was the chief of American intelligence operations in South Vietnam, the former OSS agent, suddenly interested in developing the economy? Had he mentioned the farm to me just as a casual aside, coincidentally, or did he have another goal? I let the remark pass as nonchalantly as he said it, and didn't ask any questions. But some days later, during a meeting with Rufus Phillips, Lansdale's assistant, I happened to mention that Tran Chanh Thanh had asked me to go to Ben Cat and do an article on the living conditions in that area.... 'Don't you know that we

helped your government start a dairy farm there?' Phillips said. 'Australian cows.' When I asked him which American company was in charge of the project, he told me it was under an Australian businessman, a Mr. Arthur, who had run some dairy businesses in Saigon," pp. 58-9.

4. Bruce Palling, "Pham Xuan An: Vietnam War Journalist and Spy," *Independent*. September 22, 2006.

5. H. D. S. Greenway, "My Friend the Spy," *Boston Globe*, September, 26, 2006.

6. Stanley Cloud, "The Journalist Who Spied," *Time*, September 21, 2006.

7. February 2006 personal letter to Pham Xuan An.

8. Correspondence provided by An to author.

9. *Bitter Victory*, 11.

10. "My Friend An." Pike wrote this in 1988: "Because reasonable doubt remains, I am not prepared to condemn An. Perhaps I am only avoiding the bruised ego that would come if I acknowledged that I was fooled for fifteen years."

11. "Vietnam: Time's Spy-Correspondent Too Ill to Leave," *Associated Press*. AP May 2, 1997; see also Robert D. McFadden, "Wartime Journalists Fondly Recall Vietnamese Double Agent," *Dallas Morning News*, May 3, 1997, 47A.

12. "American humor is the sap on the American people's happiness," wrote An in "Foreign Students Impart Persian Humor to School," *Barnacle*, April 18, 1958.

13. Ross Johnson interview.

# INDEX